FLIGHT

VOLUME EIGHT

Ⓥ

Villard Trade Paperbacks • New York

A Villard Books Trade Paperback Original

Compilation copyright © 2011 by Flight Comics LLC
All contents and characters contained within are ™ and © 2011 by their respective creators.

All rights reserved.

Published in the United States by Villard Books, an imprint of The Random House
Publishing Group, a division of Random House, Inc., New York.

VILLARD BOOKS and VILLARD & "V" CIRCLED Design are registered trademarks of Random House, Inc.

Published by arrangement with Flight Comics LLC.

ISBN 978-0-345-51738-8

Printed in the United States of America

www.villard.com

9 8 7 6 5 4 3 2 1

Illustration on pages ii–iii by Kazu Kibuishi
Illustration on page 283 by Matthew S. Armstrong

Editor/Art Director: Kazu Kibuishi
Assistant Editors: Kean Soo, Phil Craven, and Jason Caffoe
Our Editors at Villard: Chris Schluep and Erich Schoeneweiss

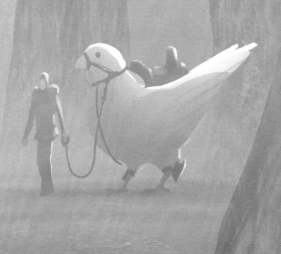

CONTENTS

FLIGHT

VOLUME EIGHT

encore

BY
KOSTAS
KIRIAKAKIS

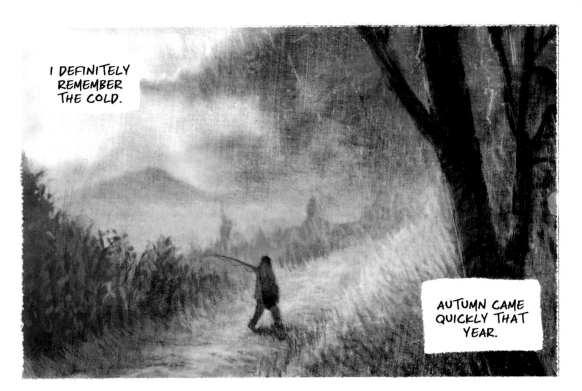

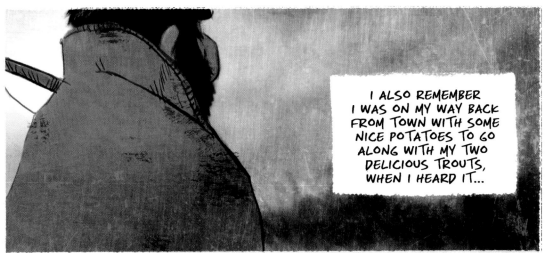

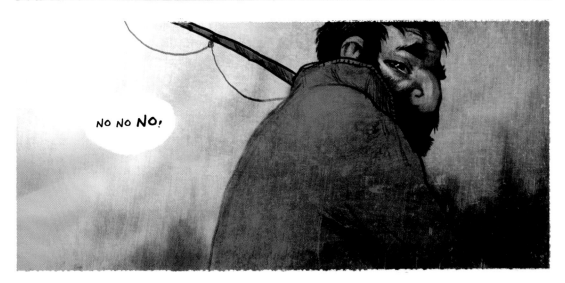

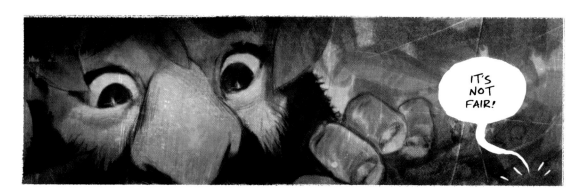

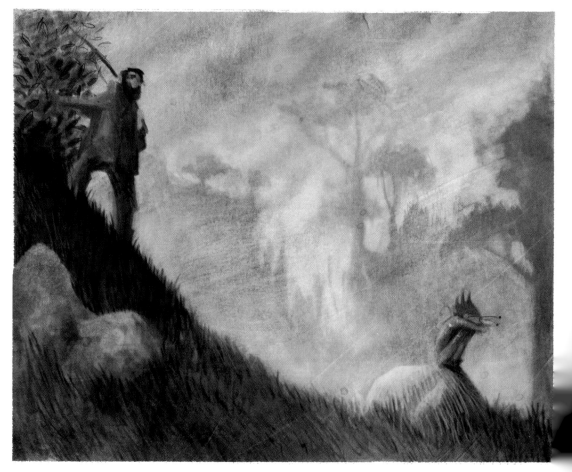

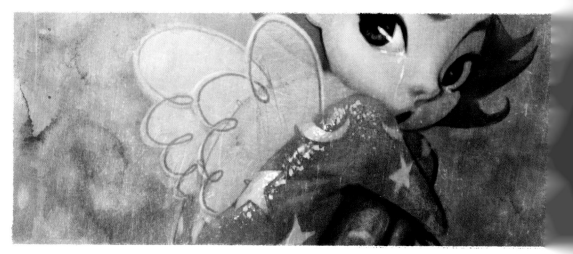

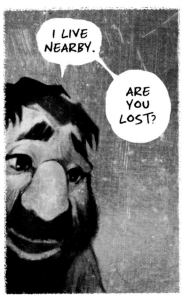

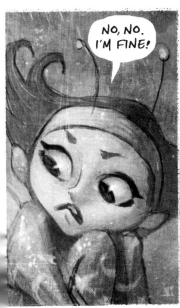

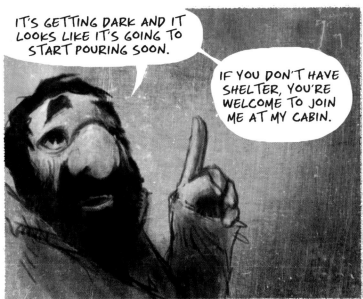

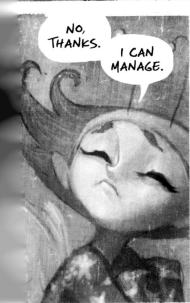

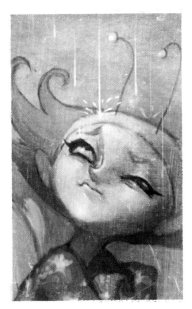

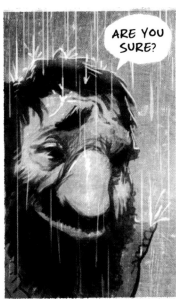

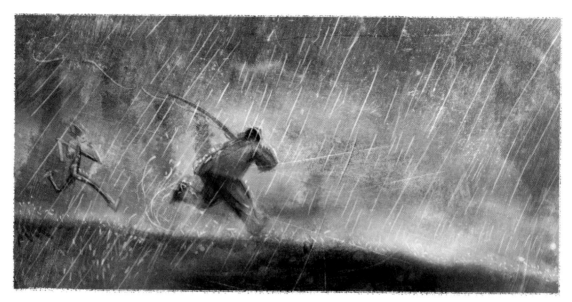

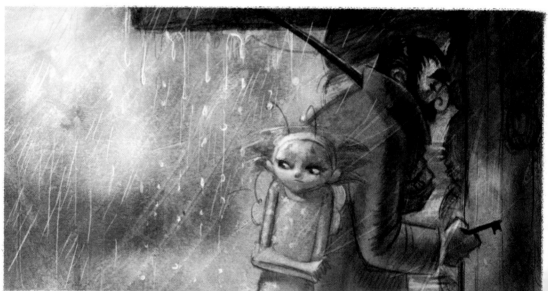

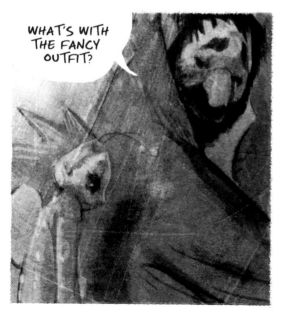

WHAT'S WITH
THE FANCY
OUTFIT?

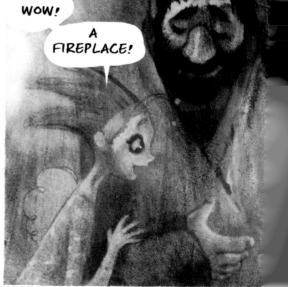

WOW!

A
FIREPLACE!

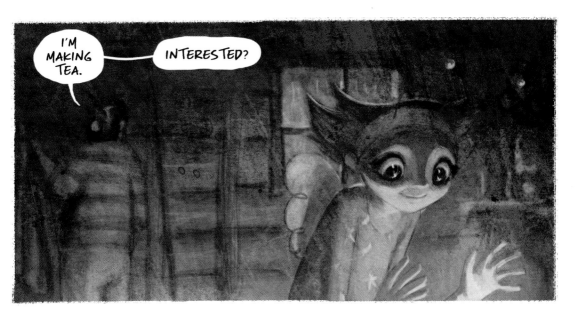

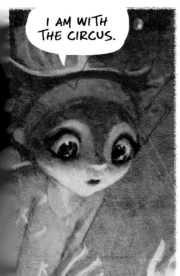

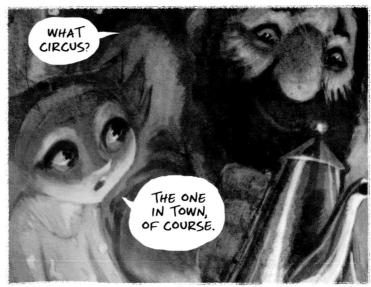

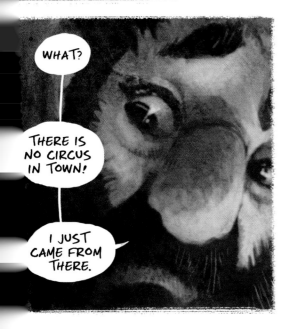

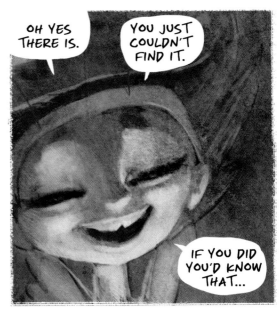

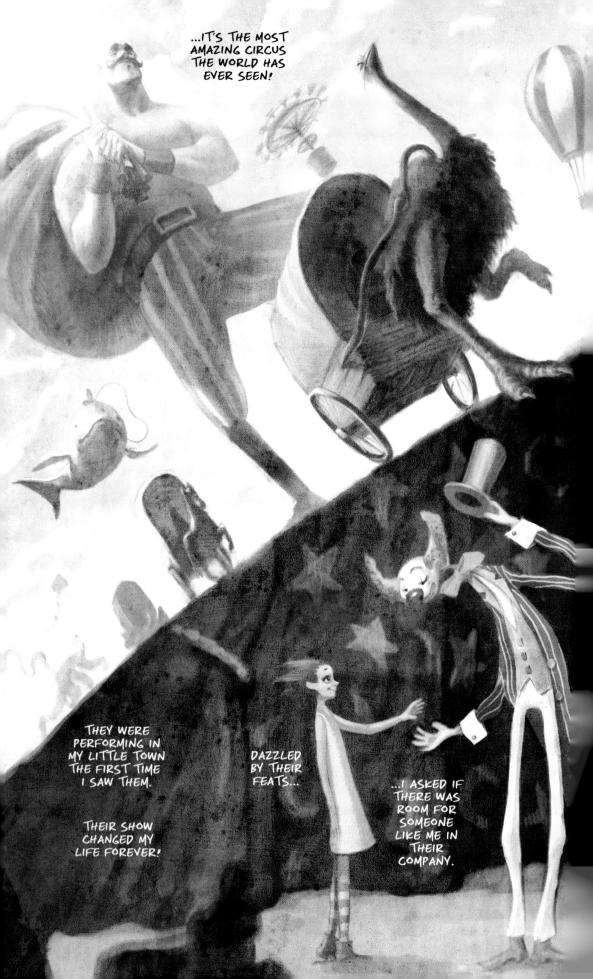

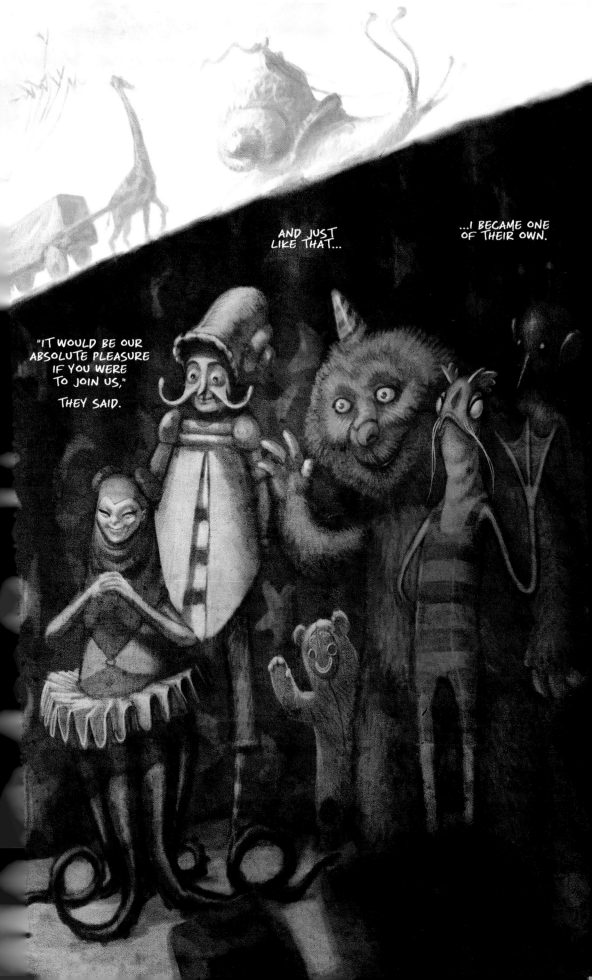

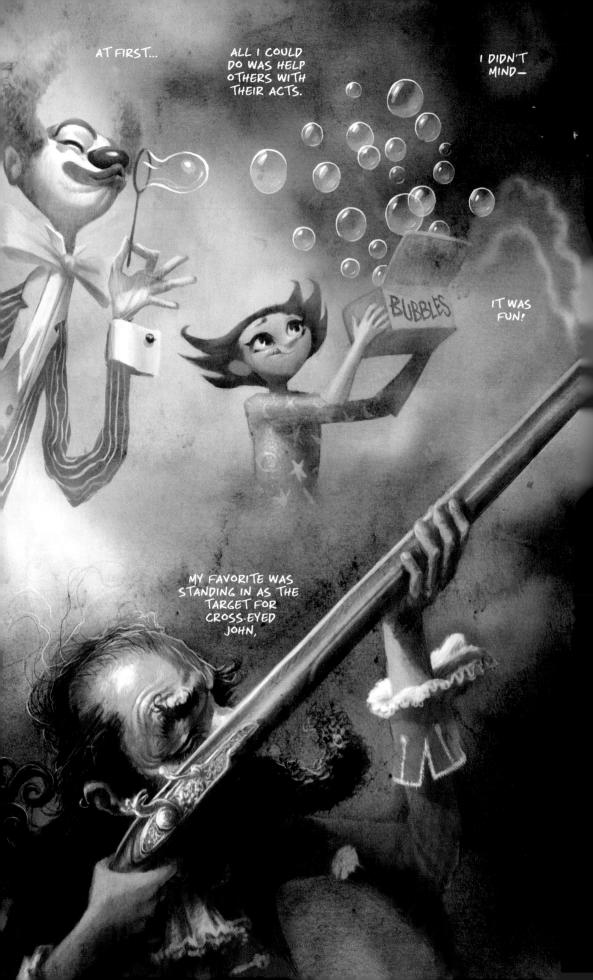

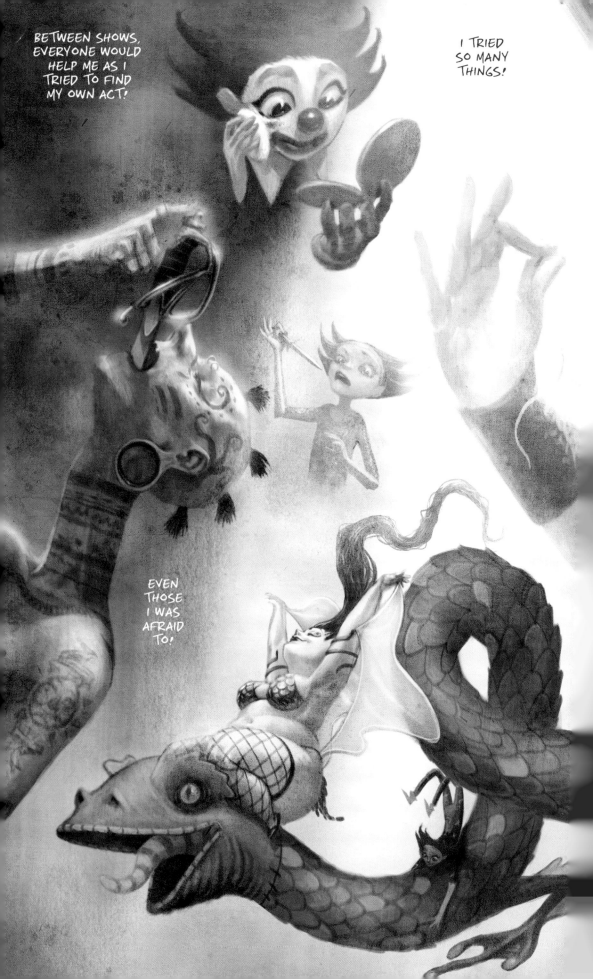

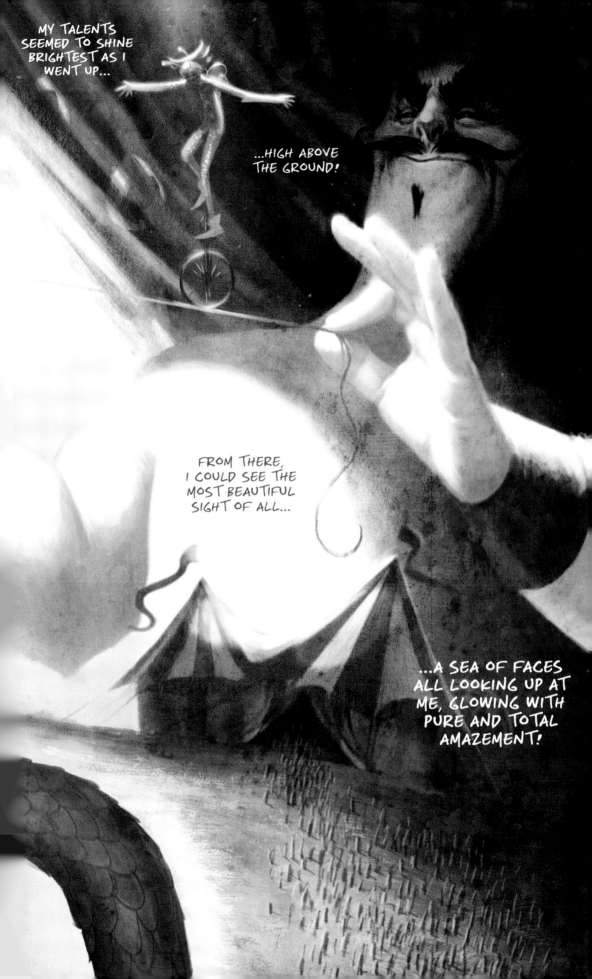

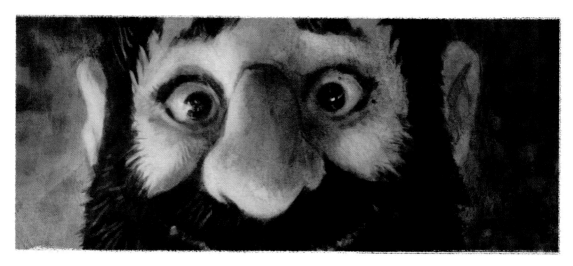

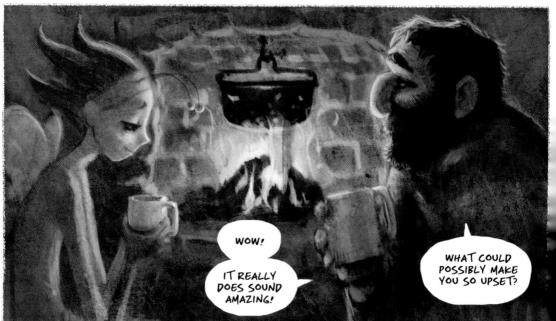

WOW!

IT REALLY DOES SOUND AMAZING!

WHAT COULD POSSIBLY MAKE YOU SO UPSET?

THAT'S... NONE OF YOUR BUSINESS!

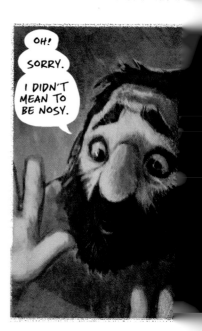

OH!

SORRY.

I DIDN'T MEAN TO BE NOSY.

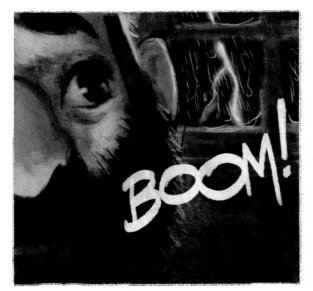

BOOM!

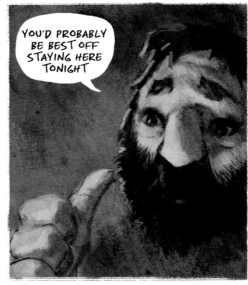

YOU'D PROBABLY BE BEST OFF STAYING HERE TONIGHT

NOW LET'S SEE...

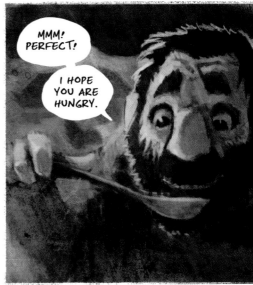

MMM! PERFECT!

I HOPE YOU ARE HUNGRY.

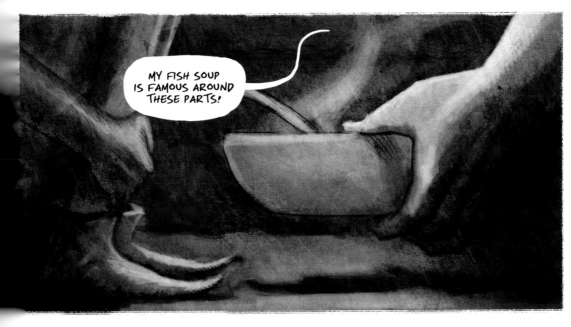

MY FISH SOUP IS FAMOUS AROUND THESE PARTS!

THEY ARE CLOSING IT DOWN.

THE CIRCUS.

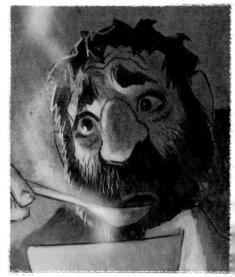

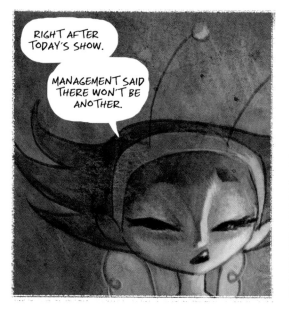

RIGHT AFTER TODAY'S SHOW.

MANAGEMENT SAID THERE WON'T BE ANOTHER.

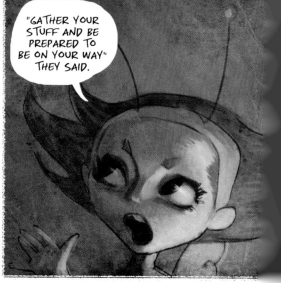

"GATHER YOUR STUFF AND BE PREPARED TO BE ON YOUR WAY" THEY SAID.

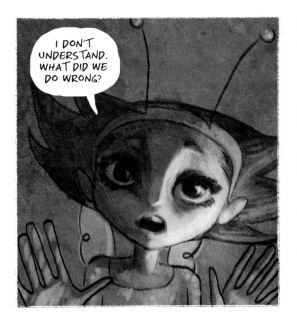

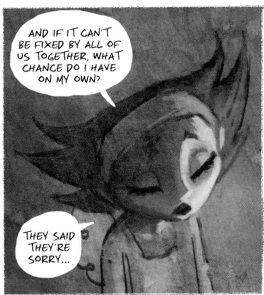

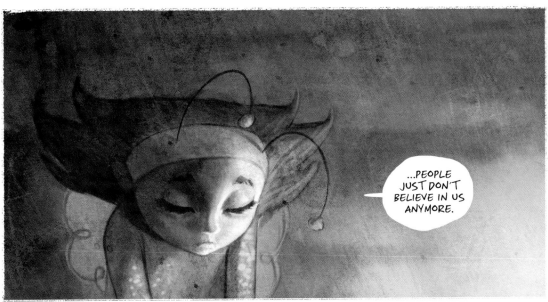

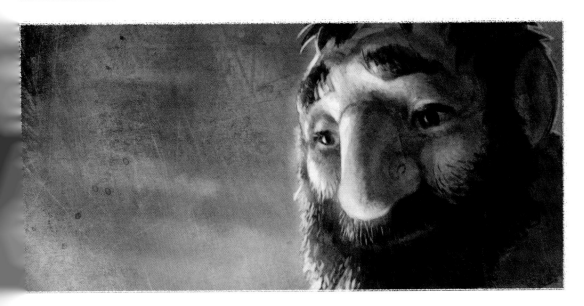

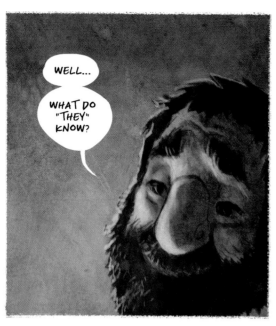

WELL...

WHAT DO "THEY" KNOW?

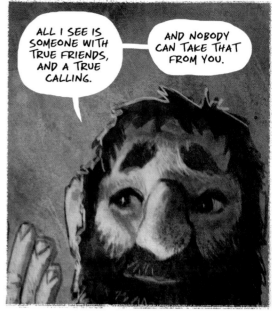

ALL I SEE IS SOMEONE WITH TRUE FRIENDS, AND A TRUE CALLING.

AND NOBODY CAN TAKE THAT FROM YOU.

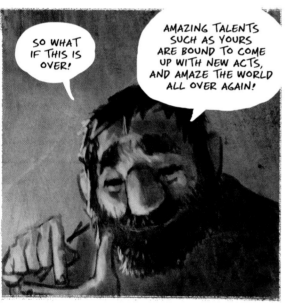

SO WHAT IF THIS IS OVER!

AMAZING TALENTS SUCH AS YOURS ARE BOUND TO COME UP WITH NEW ACTS, AND AMAZE THE WORLD ALL OVER AGAIN!

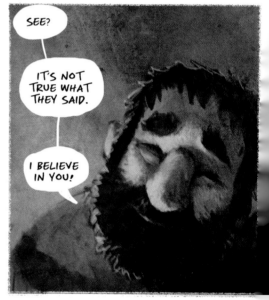

SEE?

IT'S NOT TRUE WHAT THEY SAID.

I BELIEVE IN YOU!

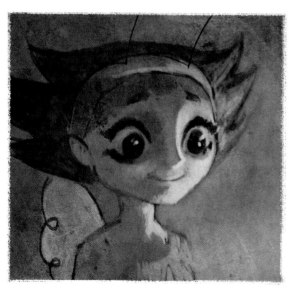

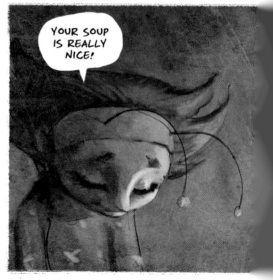

YOUR SOUP IS REALLY NICE!

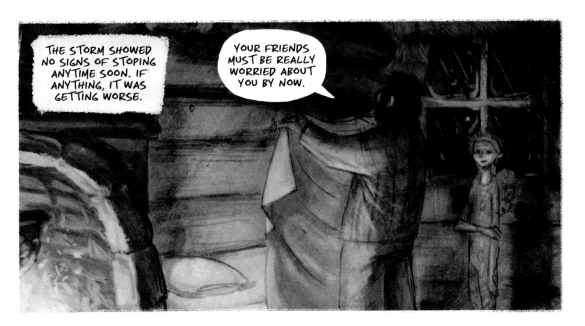

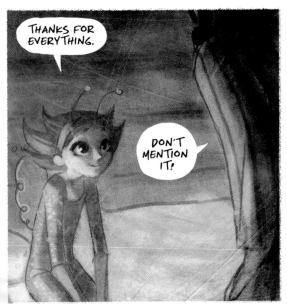

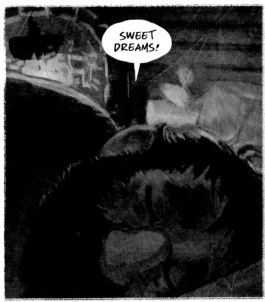

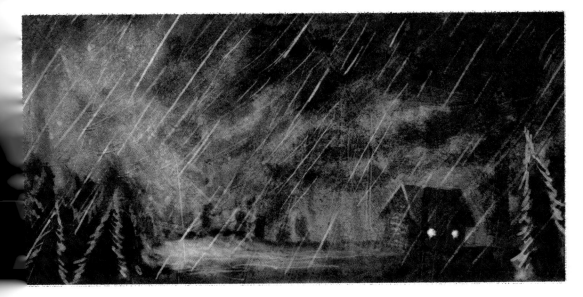

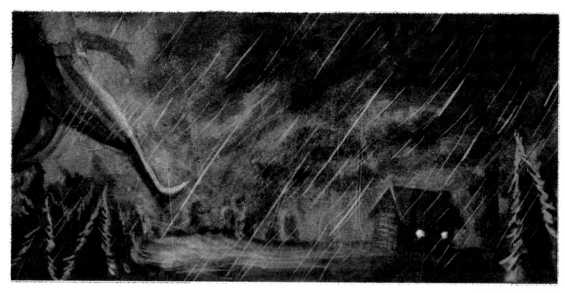

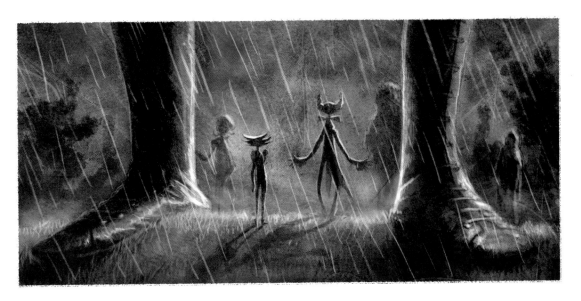

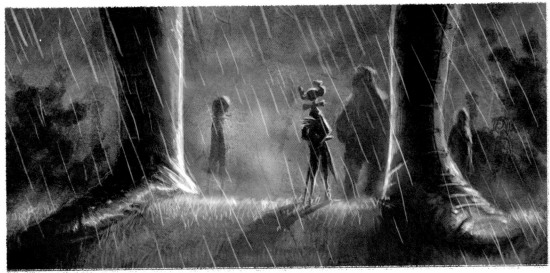

I NEVER GOT A CHANCE TO THANK HER.

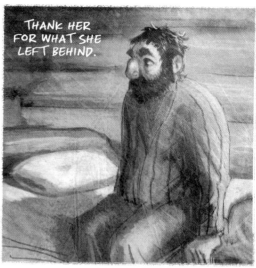

THANK HER FOR WHAT SHE LEFT BEHIND.

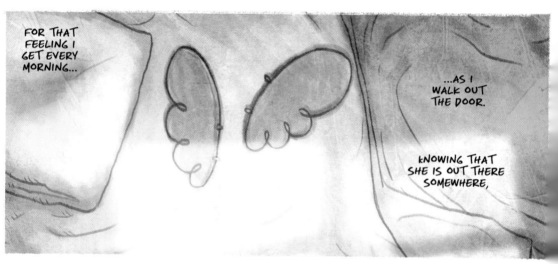

FOR THAT FEELING I GET EVERY MORNING...

...AS I WALK OUT THE DOOR.

KNOWING THAT SHE IS OUT THERE SOMEWHERE,

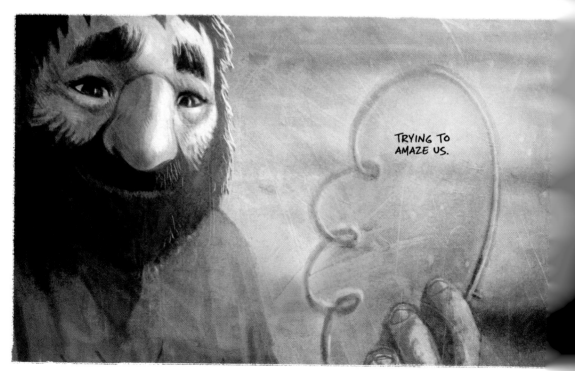

TRYING TO AMAZE US.

For Lida

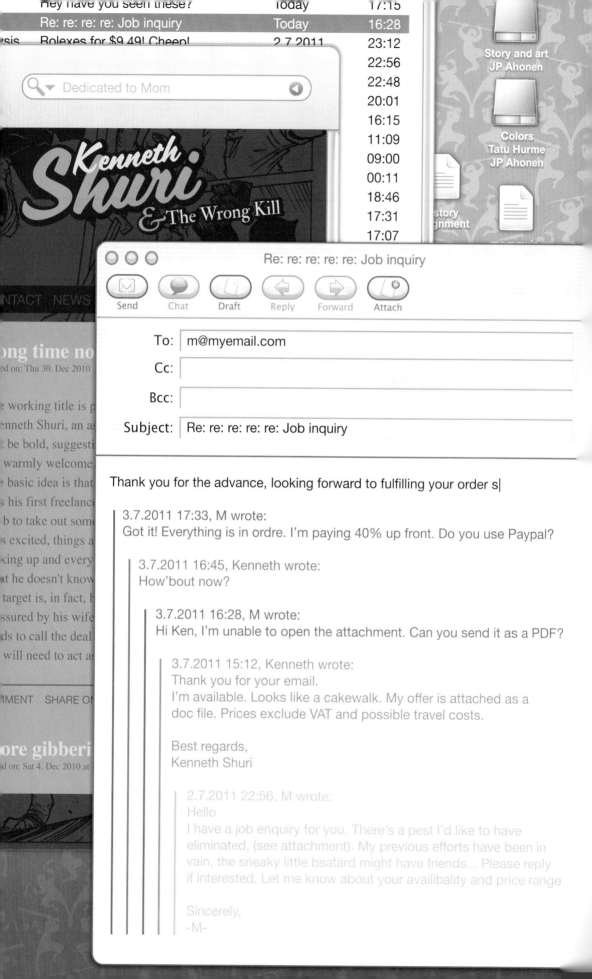

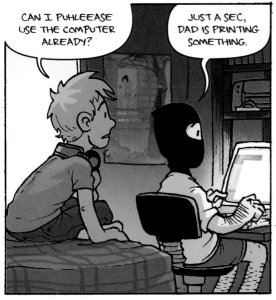

CAN I PUHLEEASE USE THE COMPUTER ALREADY?

JUST A SEC, DAD IS PRINTING SOMETHING.

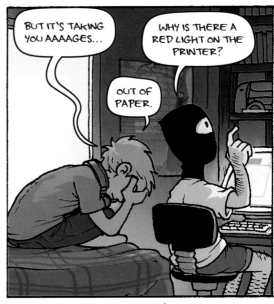

BUT IT'S TAKING YOU AAAAGES...

WHY IS THERE A RED LIGHT ON THE PRINTER?

OUT OF PAPER.

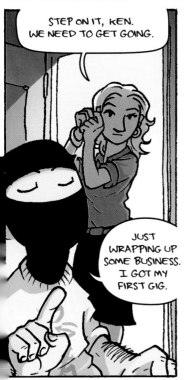

STEP ON IT, KEN. WE NEED TO GET GOING.

JUST WRAPPING UP SOME BUSINESS. I GOT MY FIRST GIG.

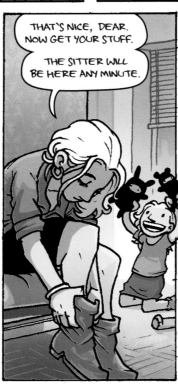

THAT'S NICE, DEAR. NOW GET YOUR STUFF.

THE SITTER WILL BE HERE ANY MINUTE.

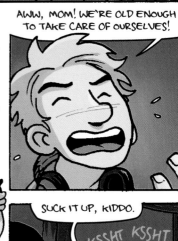

AWW, MOM! WE'RE OLD ENOUGH TO TAKE CARE OF OURSELVES!

SUCK IT UP, KIDDO.

KSSHT KSSHT

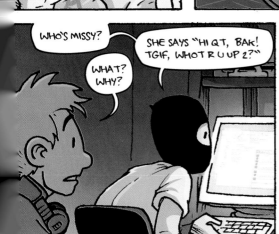

WHO'S MISSY?

WHAT? WHY?

SHE SAYS "HI QT, BAK! TGIF, WHOT R U UP 2?"

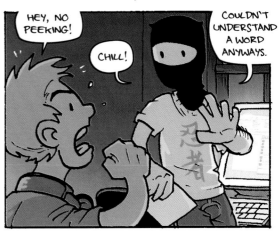

HEY, NO PEEKING!

CHILL!

COULDN'T UNDERSTAND A WORD ANYWAYS.

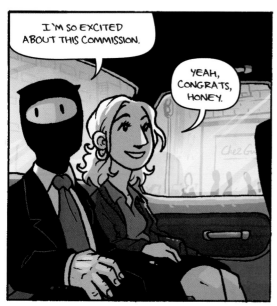

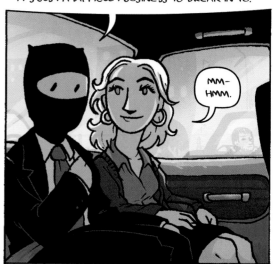

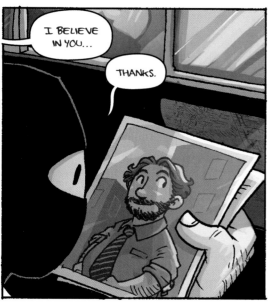

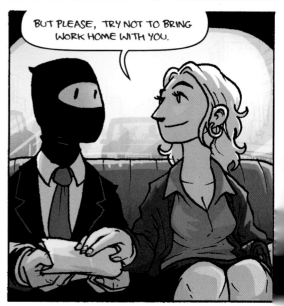

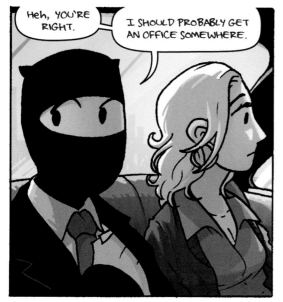

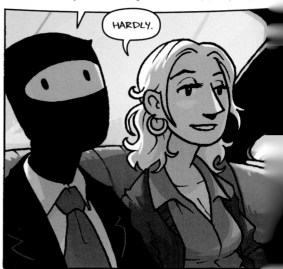

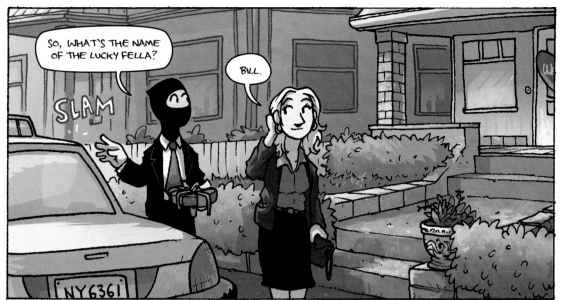

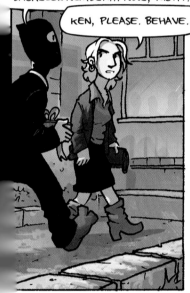

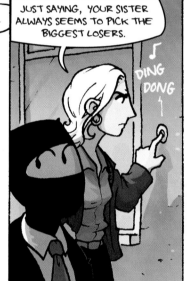

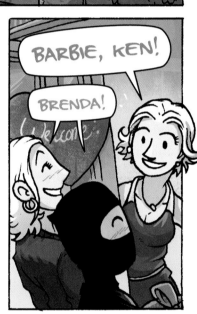

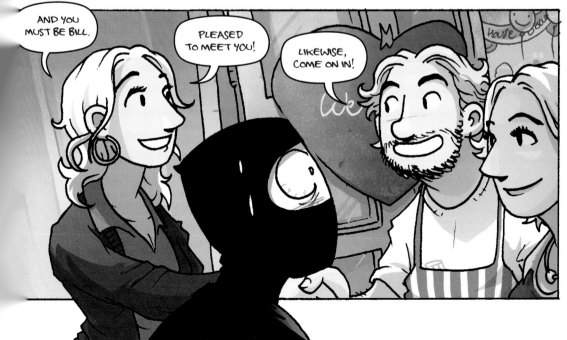

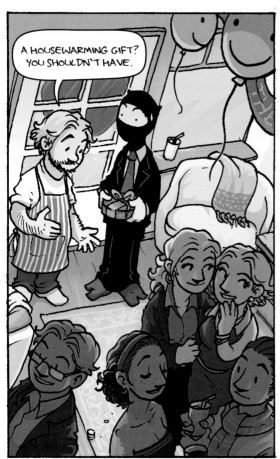

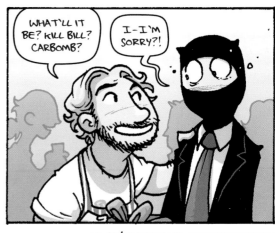

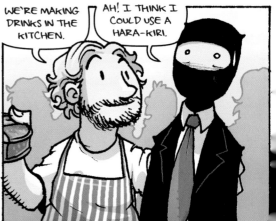

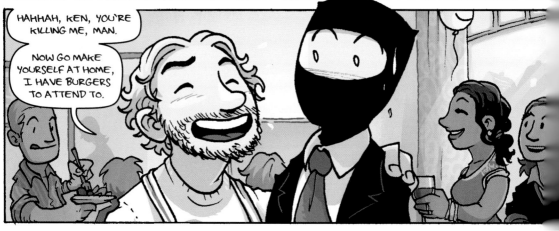

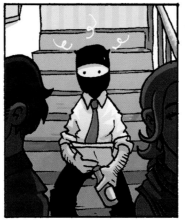

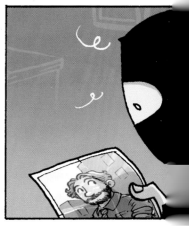

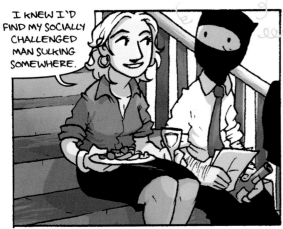

I KNEW I'D FIND MY SOCIALLY CHALLENGED MAN SULKING SOMEWHERE.

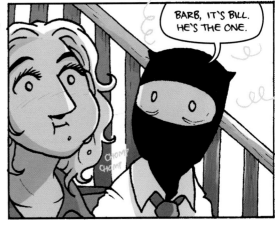

BARB, IT'S BILL. HE'S THE ONE.

CHOMP CHOMP

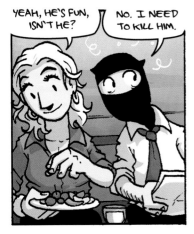

YEAH, HE'S FUN, ISN'T HE?

NO. I NEED TO KILL HIM.

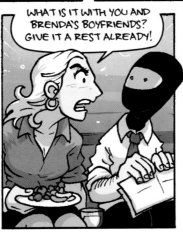

WHAT IS IT WITH YOU AND BRENDA'S BOYFRIENDS? GIVE IT A REST ALREADY!

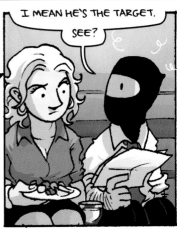

I MEAN HE'S THE TARGET.

SEE?

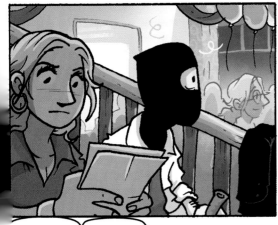

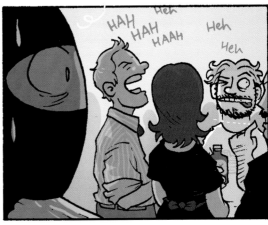

HAH HAH HAAH Heh Heh Heh

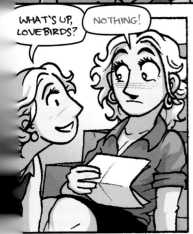

WHAT'S UP, LOVEBIRDS?

NOTHING!

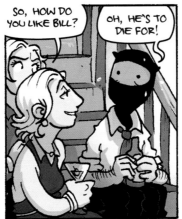

SO, HOW DO YOU LIKE BILL?

OH, HE'S TO DIE FOR!

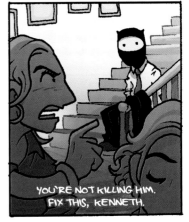

YOU'RE NOT KILLING HIM. FIX THIS, KENNETH.

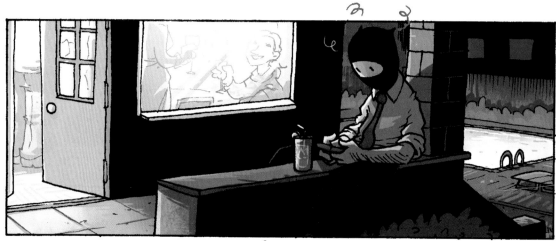

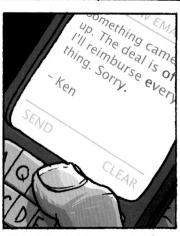

Something came up. The deal is off I'll reimburse every thing. Sorry.

— Ken

SEND

CLEAR

PUNT PUNT
PUNT

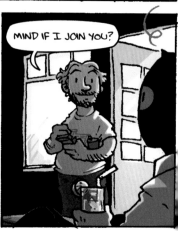

MIND IF I JOIN YOU?

I SWEAR, THESE THINGS'LL BE THE DEATH OF ME BUT HEY, ONE'S GOTTA LIVE DANGEROUSLY, RIGHT?

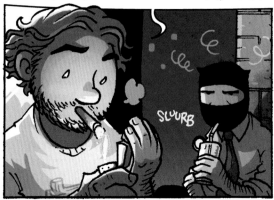

SLUURB

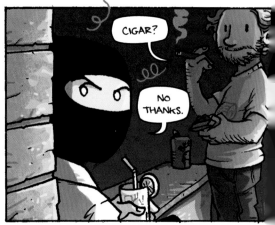

CIGAR?

NO THANKS.

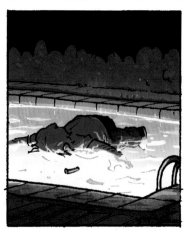

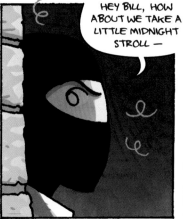

HEY BILL, HOW ABOUT WE TAKE A LITTLE MIDNIGHT STROLL —

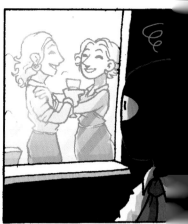

NEVER-MIND.

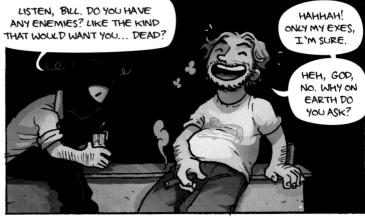

LISTEN, BILL. DO YOU HAVE ANY ENEMIES? LIKE THE KIND THAT WOULD WANT YOU... DEAD?

HAHHAH! ONLY MY EXES, I'M SURE.

HEH, GOD, NO. WHY ON EARTH DO YOU ASK?

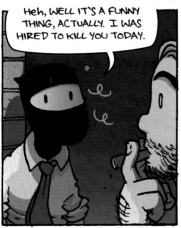

Heh, WELL IT'S A FUNNY THING, ACTUALLY. I WAS HIRED TO KILL YOU TODAY.

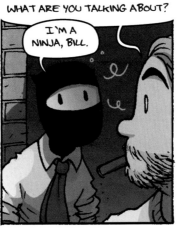

WHAT ARE YOU TALKING ABOUT?

I'M A NINJA, BILL.

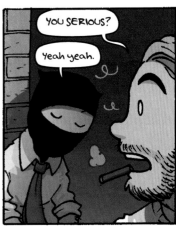

YOU SERIOUS?

Yeah yeah.

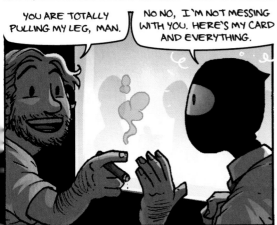

YOU ARE TOTALLY PULLING MY LEG, MAN.

NO NO, I'M NOT MESSING WITH YOU. HERE'S MY CARD AND EVERYTHING.

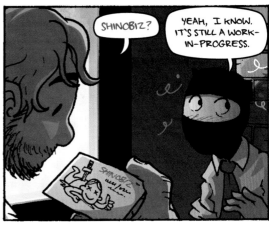

SHINOBIZ?

YEAH, I KNOW. IT'S STILL A WORK-IN-PROGRESS.

SHINOBIZ

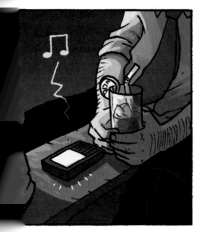

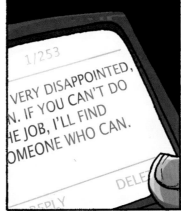

1/253

VERY DISAPPOINTED, N. IF YOU CAN'T DO HE JOB, I'LL FIND OMEONE WHO CAN.

DELE

REPLY

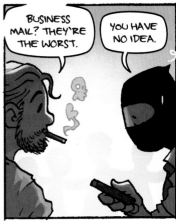

BUSINESS MAIL? THEY'RE THE WORST.

YOU HAVE NO IDEA.

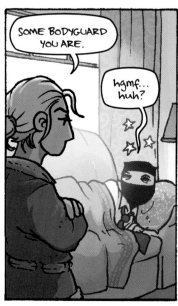

SOME BODYGUARD YOU ARE.

hgmf... huh?

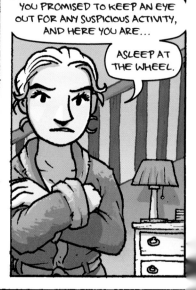

YOU PROMISED TO KEEP AN EYE OUT FOR ANY SUSPICIOUS ACTIVITY, AND HERE YOU ARE...

ASLEEP AT THE WHEEL.

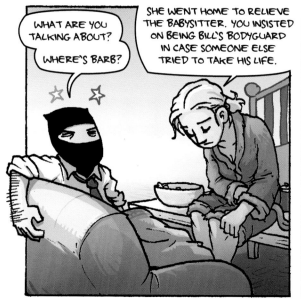

WHAT ARE YOU TALKING ABOUT?

WHERE'S BARB?

SHE WENT HOME TO RELIEVE THE BABYSITTER. YOU INSISTED ON BEING BILL'S BODYGUARD IN CASE SOMEONE ELSE TRIED TO TAKE HIS LIFE.

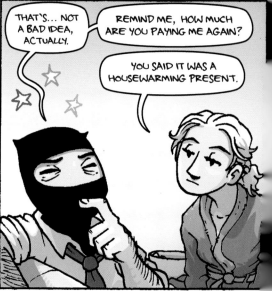

THAT'S... NOT A BAD IDEA, ACTUALLY.

REMIND ME, HOW MUCH ARE YOU PAYING ME AGAIN?

YOU SAID IT WAS A HOUSEWARMING PRESENT.

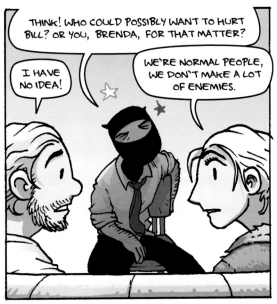

THINK! WHO COULD POSSIBLY WANT TO HURT BILL? OR YOU, BRENDA, FOR THAT MATTER?

I HAVE NO IDEA!

WE'RE NORMAL PEOPLE, WE DON'T MAKE A LOT OF ENEMIES.

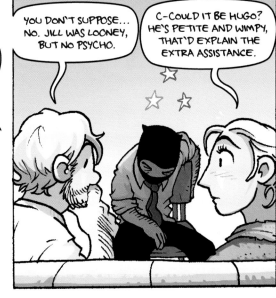

YOU DON'T SUPPOSE... NO. JILL WAS LOONEY, BUT NO PSYCHO.

C-COULD IT BE HUGO? HE'S PETITE AND WIMPY, THAT'D EXPLAIN THE EXTRA ASSISTANCE.

THE THING IS, KEN, BILL AND I SORTA HOOKED UP WHILE STILL DATING OUR PREVIOUS MATES.

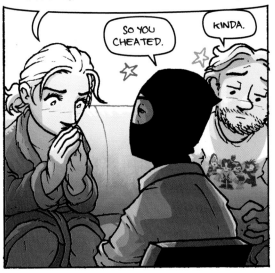

SO YOU CHEATED.

KINDA.

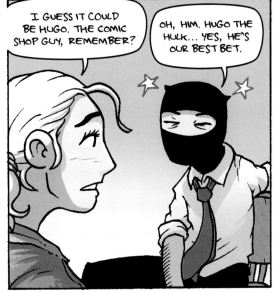

I GUESS IT COULD BE HUGO. THE COMIC SHOP GUY, REMEMBER?

OH, HIM. HUGO THE HULK... YES, HE'S OUR BEST BET.

I'D ADVISE YOU TO GIVE HIM A CALL. MAYBE HE'LL GET THE SHAKES AND BACK OFF. IF NOT, WE COULD ALWAYS JUST TAKE HIM OUT.

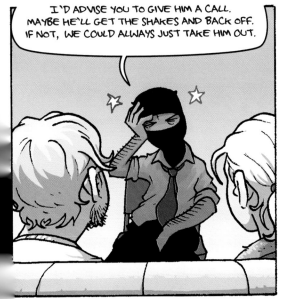

OUT OF THE QUESTION! WE DON'T WANT TO KILL ANYONE.

IT'S PEOPLE LIKE YOU THAT ARE PUTTING ME OUT OF BUSINESS.

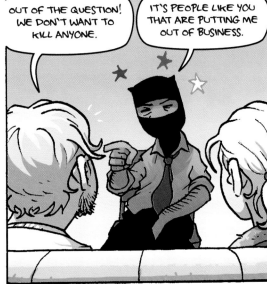

I'LL CALL HUGO.

THANKS, BRENDA.

YOU LOOK TERRIBLE. HOW ABOUT BREAKFAST? BACON AND EGGS?

THAT'D BE GREAT.

THANKS FOR HELPING US OUT, MAN. WE REALLY APPRECIATE THIS.

DON'T WORRY ABOUT IT. I JUST HOPE WE GET EVERYTHING SETTLED SO I CAN GO HOME.

HOPEFULLY BRENDA CAN MEND THINGS WITH HUGO. MEANWHILE WE JUST NEED TO STAY ALERT IN CASE OF —

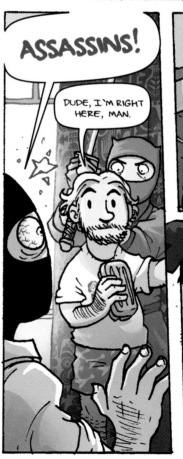

ASSASSINS!

DUDE, I'M RIGHT HERE, MAN.

STOMP

VHRRR

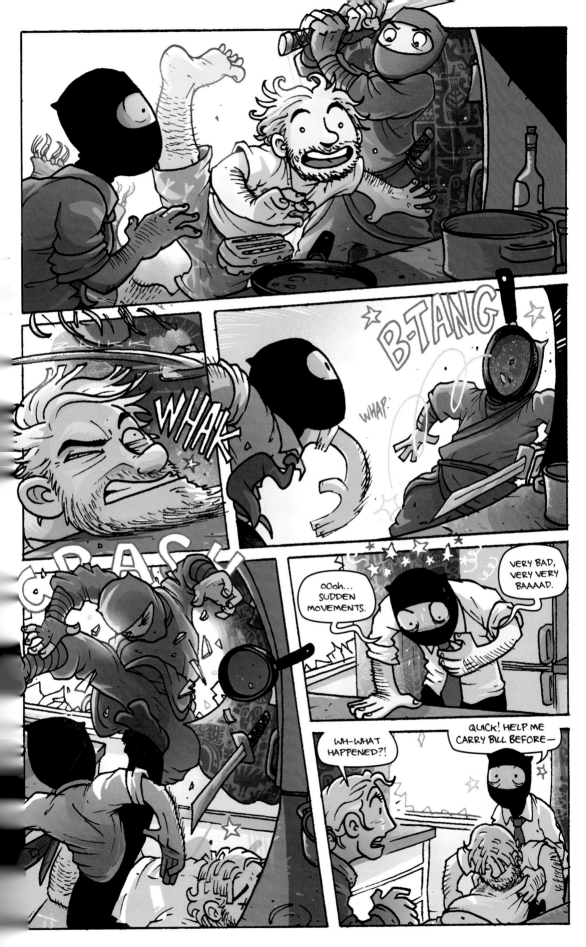

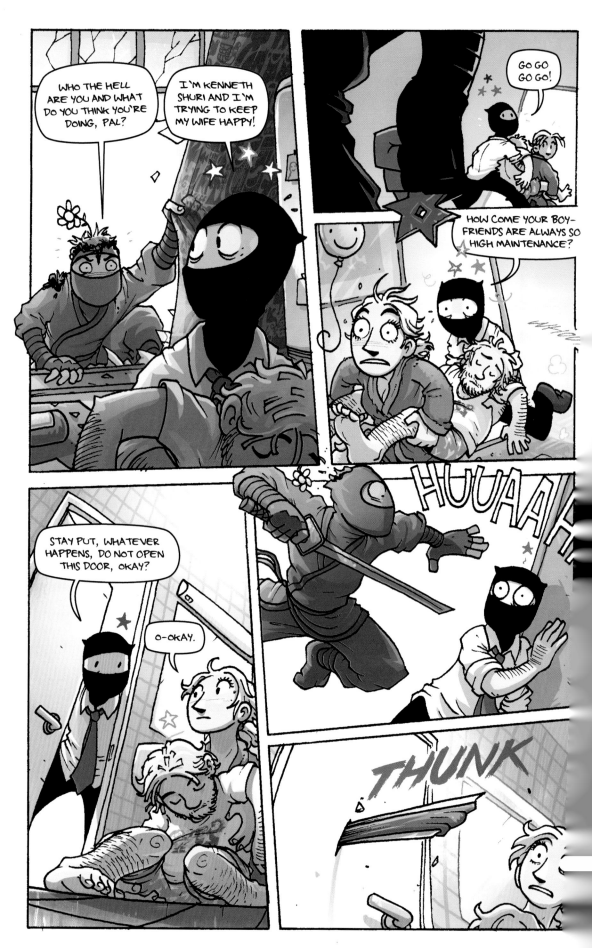

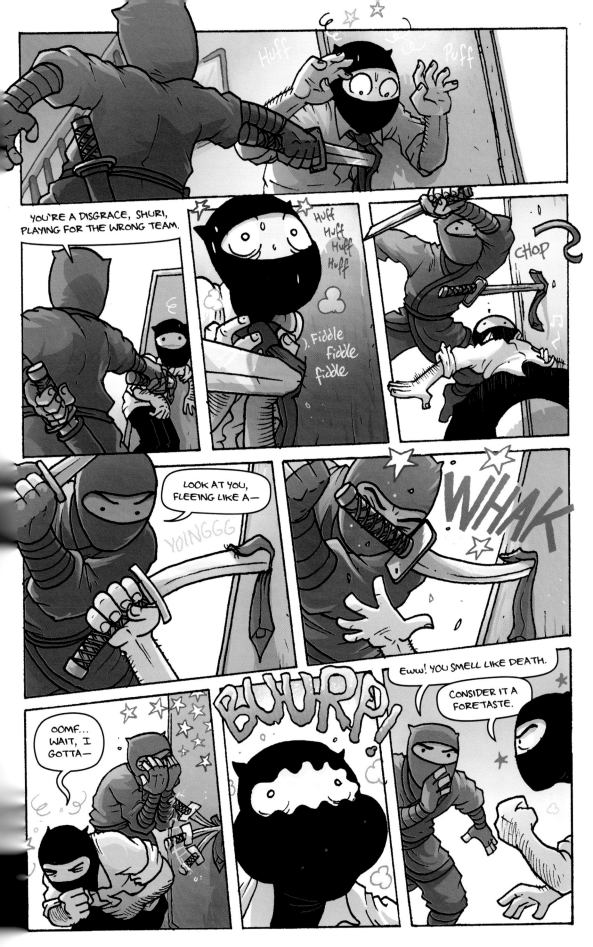

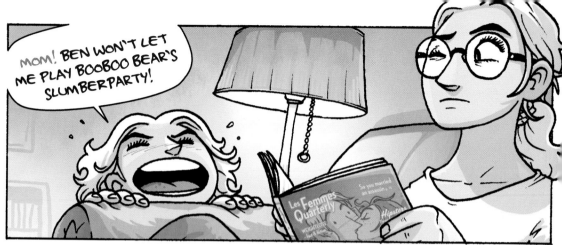

MOM! BEN WON'T LET ME PLAY BOOBOO BEAR'S SLUMBERPARTY!

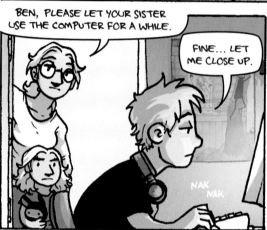

BEN, PLEASE LET YOUR SISTER USE THE COMPUTER FOR A WHILE.

FINE... LET ME CLOSE UP.

NAK NAK

SHEESH, DAD. WHY DO YOU ALWAYS LEAVE ALL YOUR STUFF OPEN? MAN, YOU ARE SUCH A NOOB.

YOU HAVE MAIL

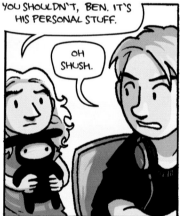

YOU SHOULDN'T, BEN. IT'S HIS PERSONAL STUFF.

OH SHUSH.

HE'S THE ONE BUTTING INTO MY LIFE ALL THE TIME.

YOU HAVE MAIL

CLICK CLICK

M	Re: re: re: re: re: re: Job inquiry	Tod
M	Re: re: re: re: re: Job inquiry	3.7
Bo Staff	Hey have you seen these?	3.7
M	Re: re: re: re: Job inquiry	3.7

Subject: Re: re: re: re: re: re: Job inquiry
Date: 4.7.2011 13.11.40

Hi Ken,
I just realized I had sent my you my son's picture by mistake
I'm sorry. Attached is the correct file, if you're still inetereste

- M

ps. I couldn't find your phone number. I'd suggest putting it

3.7.2011 18:01, Kenneth wrote:
Thank you for the advance, looking forward to fulfilling yo

umm...

MOM! WHAT WAS DAD DOING AT AUNT BRENDA' PLACE AGAIN?

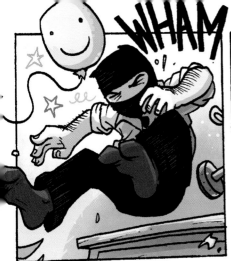
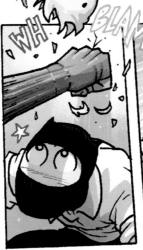
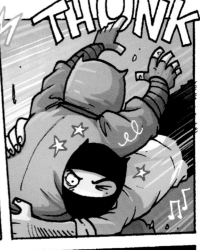
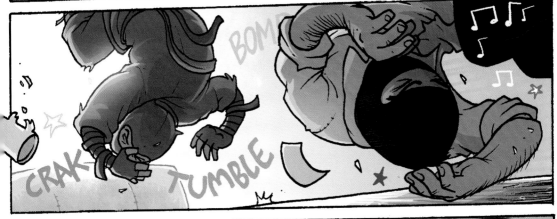
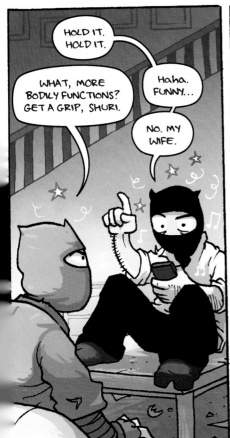
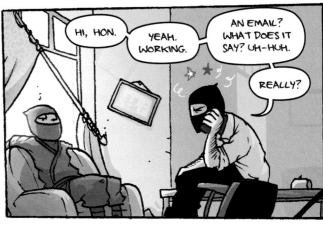
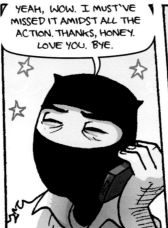
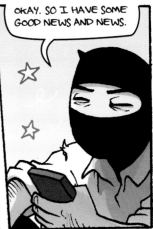

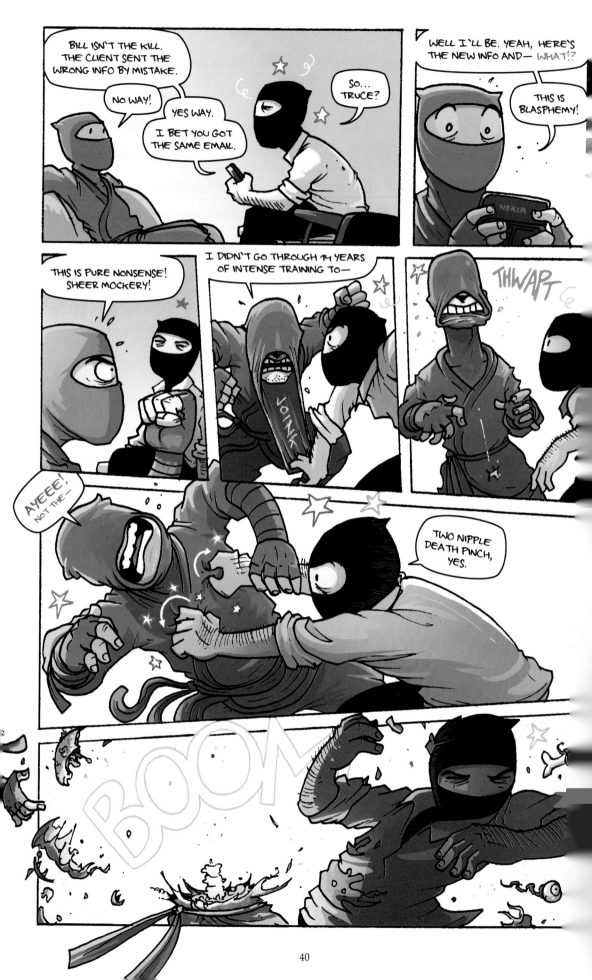

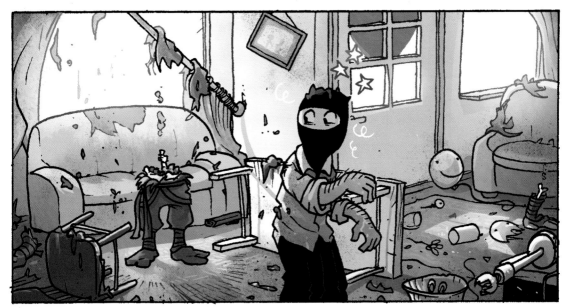

KLA-KLAK

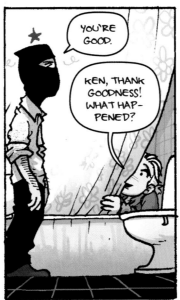

YOU'RE GOOD.

KEN, THANK GOODNESS! WHAT HAP-PENED?

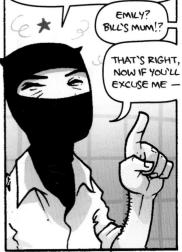

TURNED OUT THE CLIENT IS IN FACT YOUR MOTHER-IN-LAW. SHE SENT BILL'S INFO BY MISTAKE.

EMILY? BILL'S MUM!?

THAT'S RIGHT, NOW IF YOU'LL EXCUSE ME —

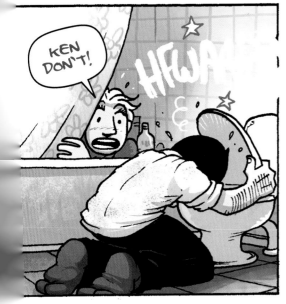

KEN DON'T!

HFWA

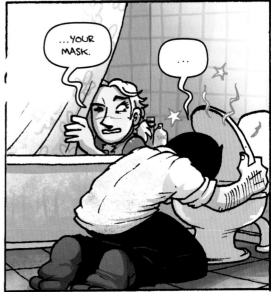

...YOUR MASK.

...

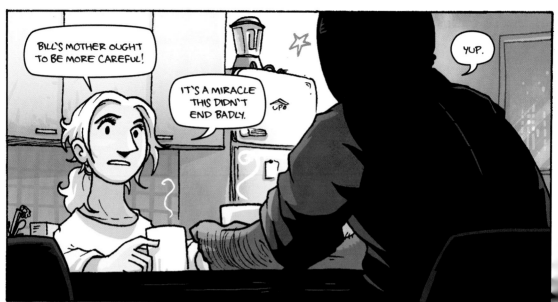

BILL'S MOTHER OUGHT TO BE MORE CAREFUL!

IT'S A MIRACLE THIS DIDN'T END BADLY.

YUP.

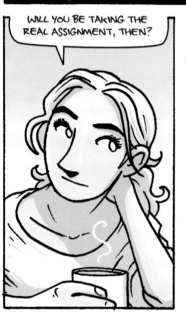

WILL YOU BE TAKING THE REAL ASSIGNMENT, THEN?

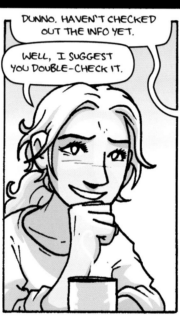

DUNNO. HAVEN'T CHECKED OUT THE INFO YET.

WELL, I SUGGEST YOU DOUBLE-CHECK IT.

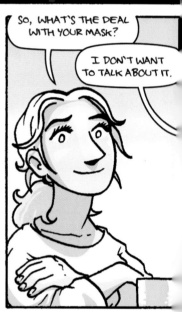

SO, WHAT'S THE DEAL WITH YOUR MASK?

I DON'T WANT TO TALK ABOUT IT.

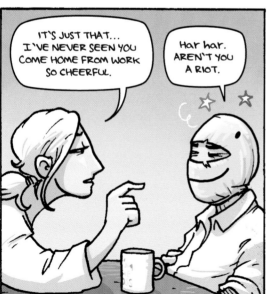

IT'S JUST THAT... I'VE NEVER SEEN YOU COME HOME FROM WORK SO CHEERFUL.

Har har. AREN'T YOU A RIOT.

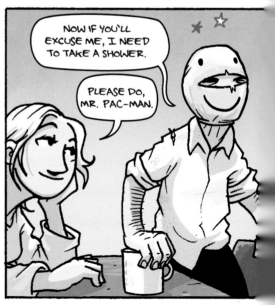

NOW IF YOU'LL EXCUSE ME, I NEED TO TAKE A SHOWER.

PLEASE DO, MR. PAC-MAN.

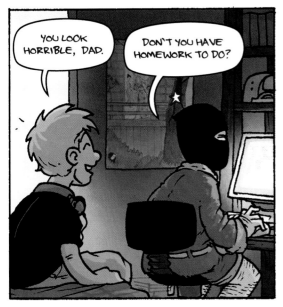

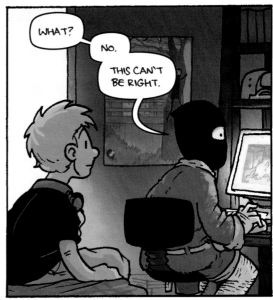

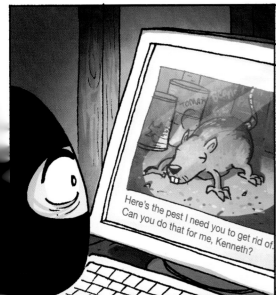

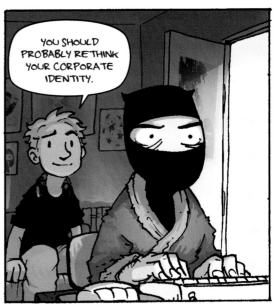

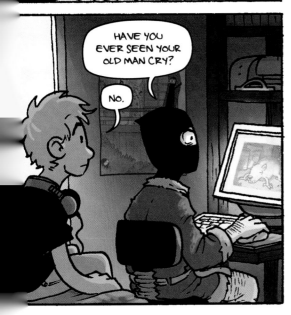

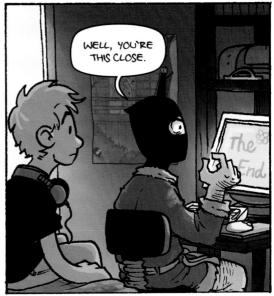

RIDDLE

KYLA VANDERKLUGT

IT HAD BEEN THREE DAYS SINCE WE ENTERED THE MAZE.

WE CAME TO HUNT THE MONSTER WITHIN, BUT ALL WE HAD FOUND WERE OUR OWN FOOTPRINTS.

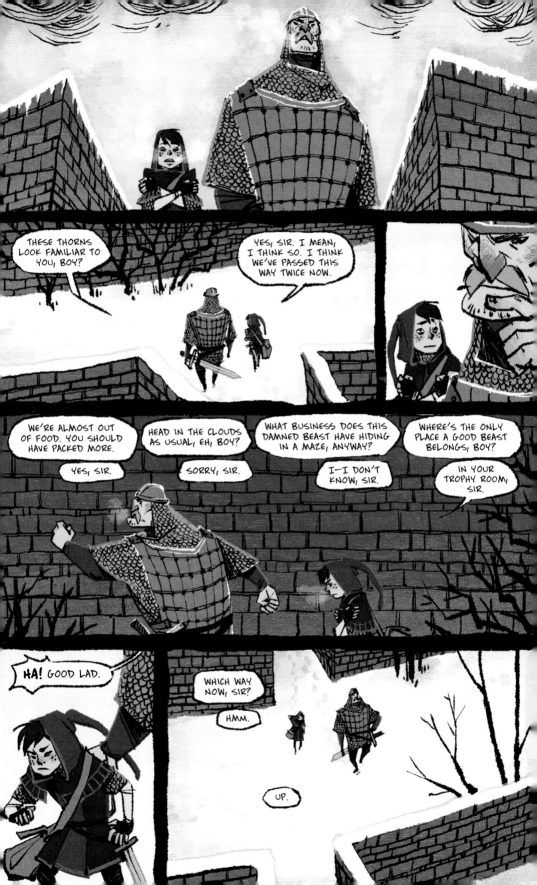

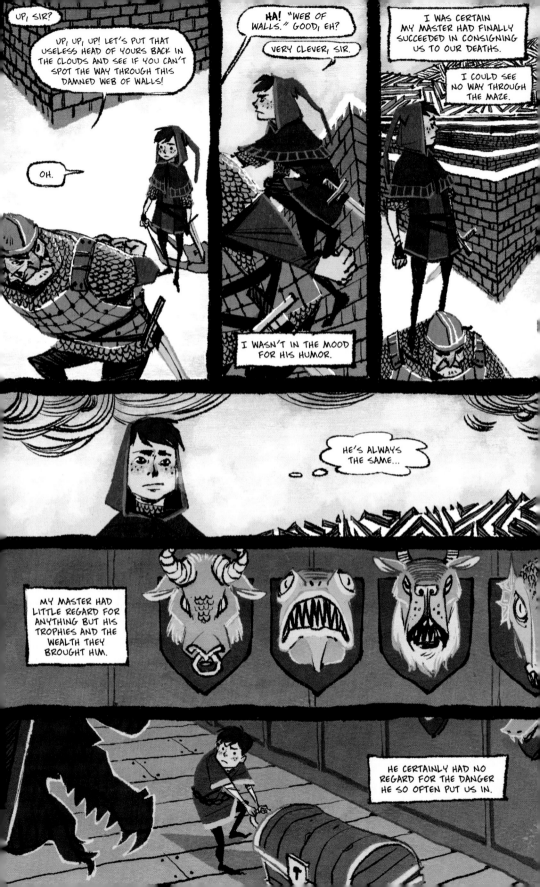

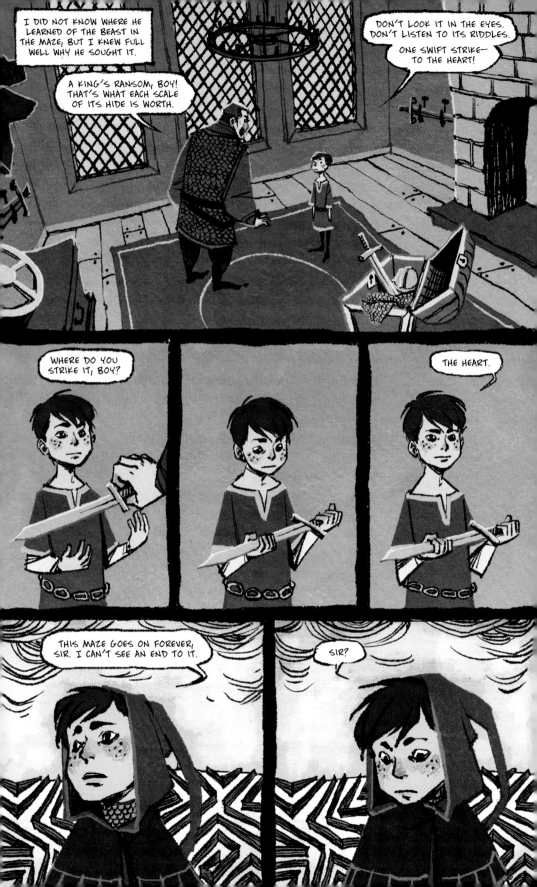

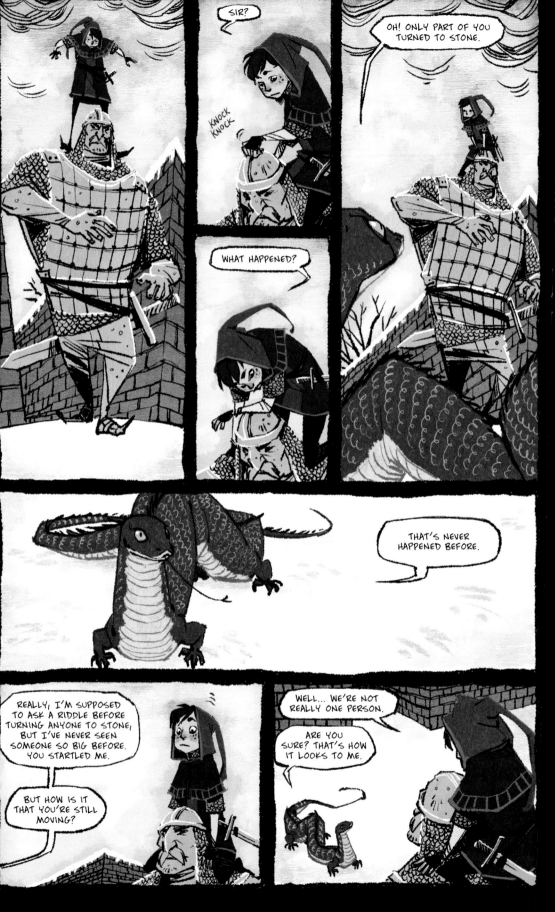

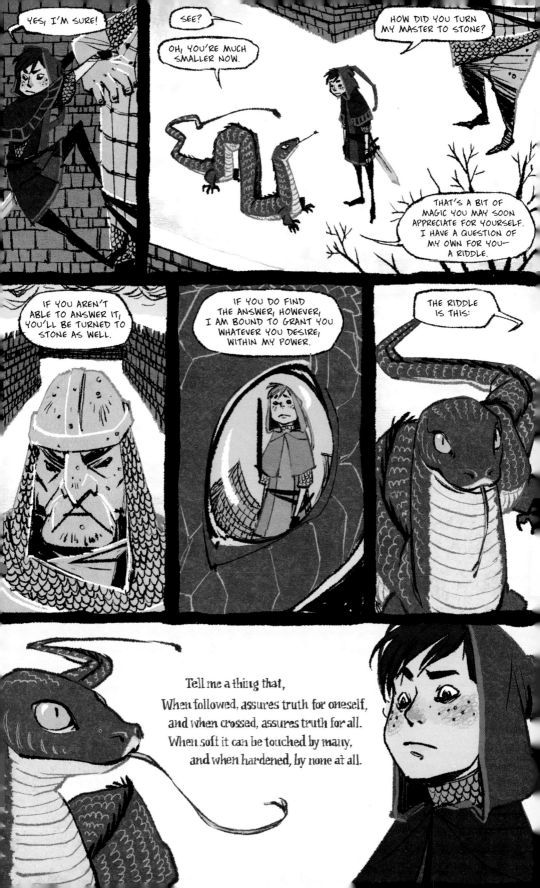

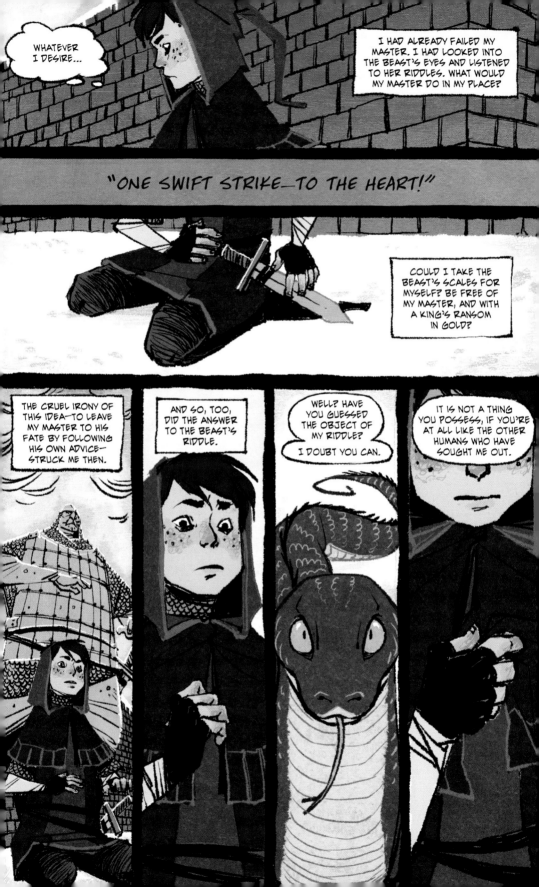

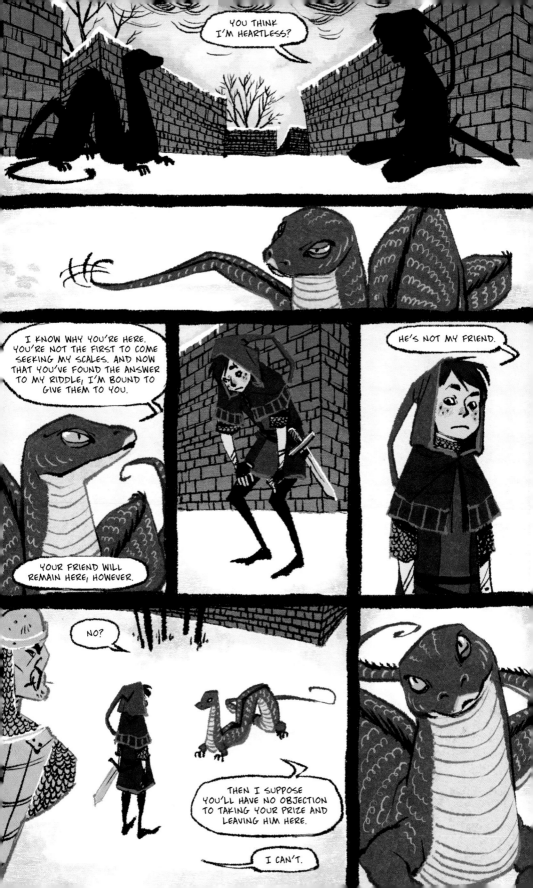

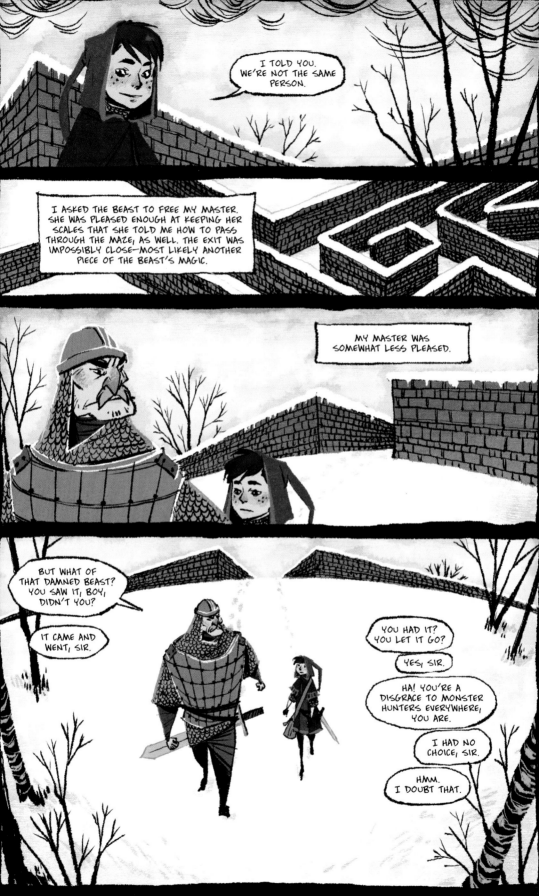

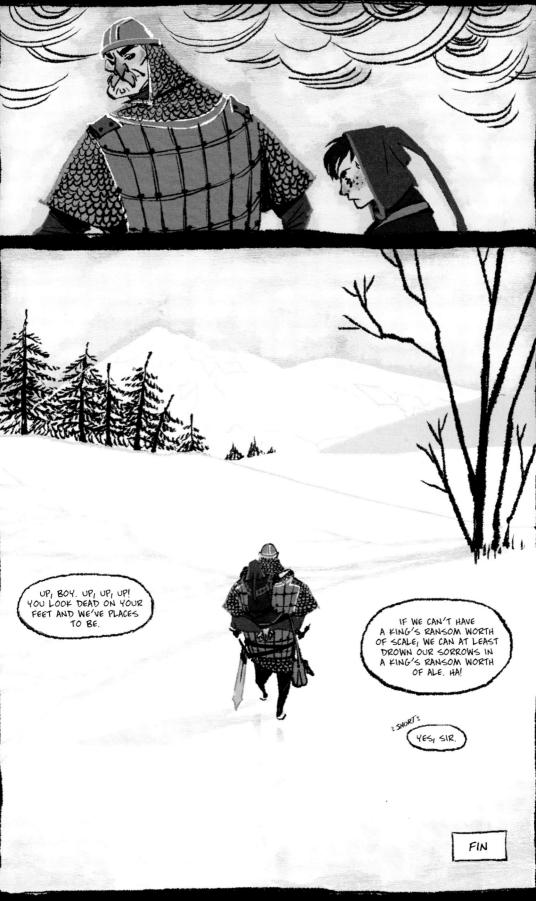

The Clockmaker's Daughter

by Cory Godbey

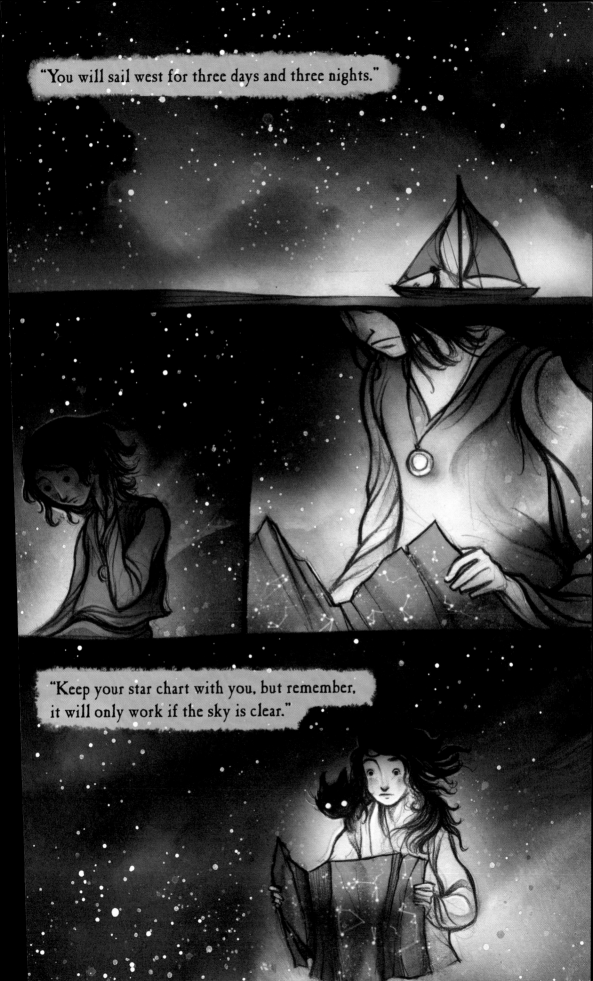

"You will sail west for three days and three nights."

"Keep your star chart with you, but remember,
it will only work if the sky is clear."

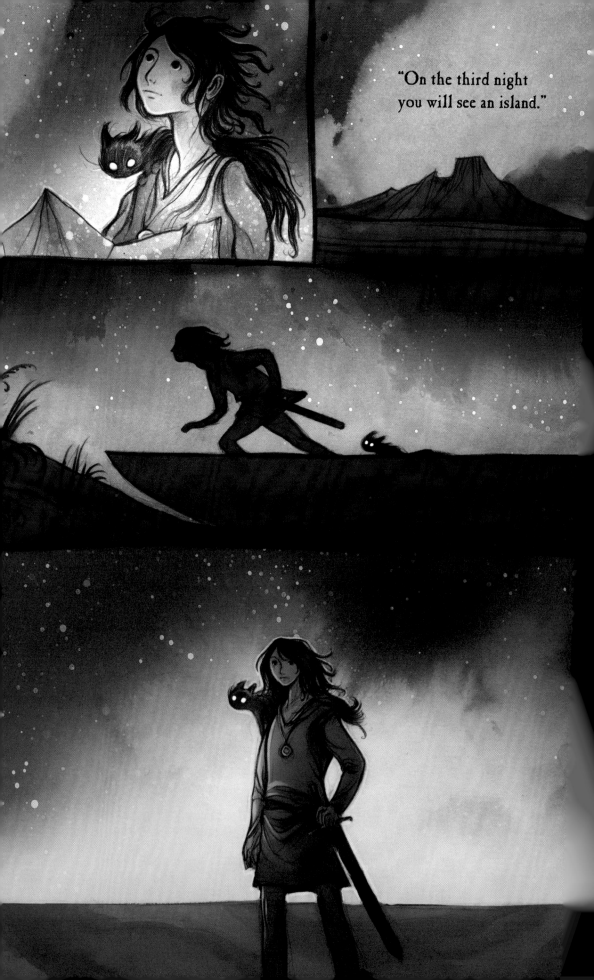

"On the third night
you will see an island."

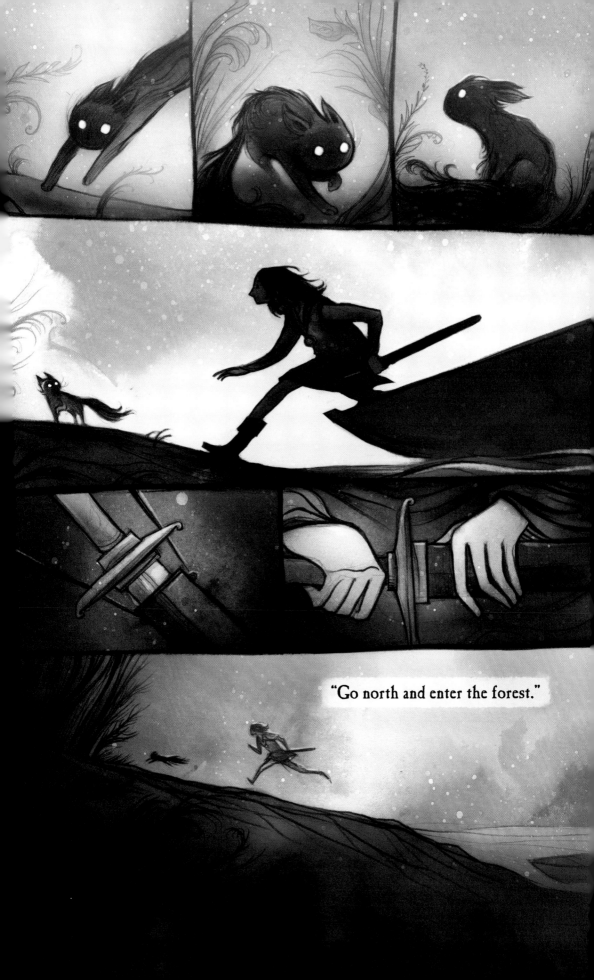

"Go north and enter the forest."

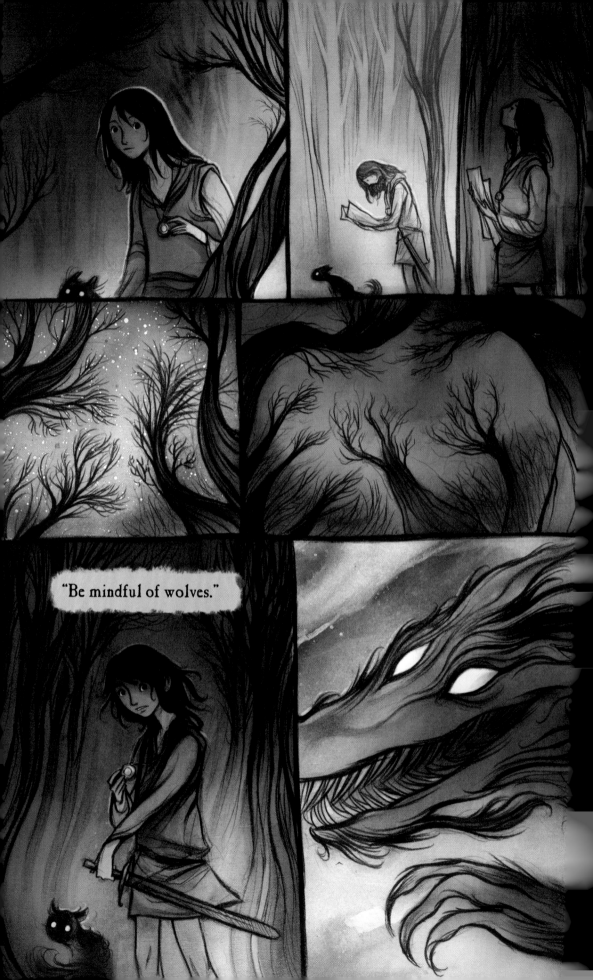

"Be mindful of wolves."

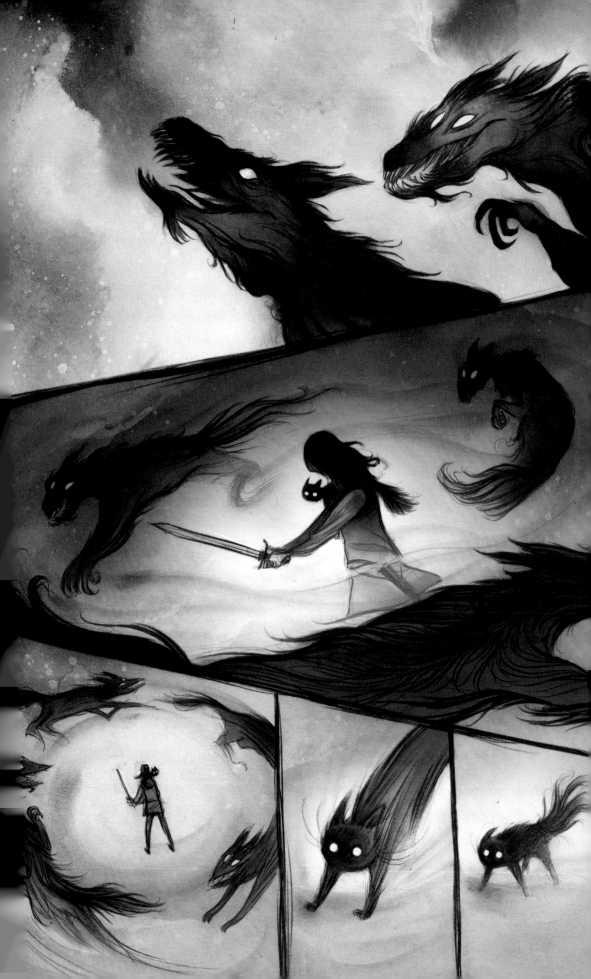

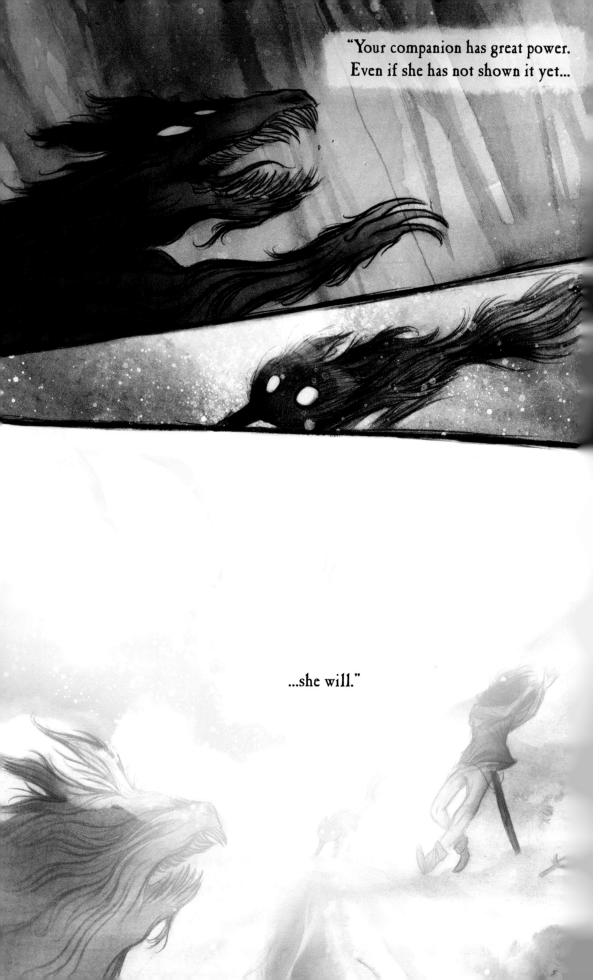

"Your companion has great power.
Even if she has not shown it yet...

...she will."

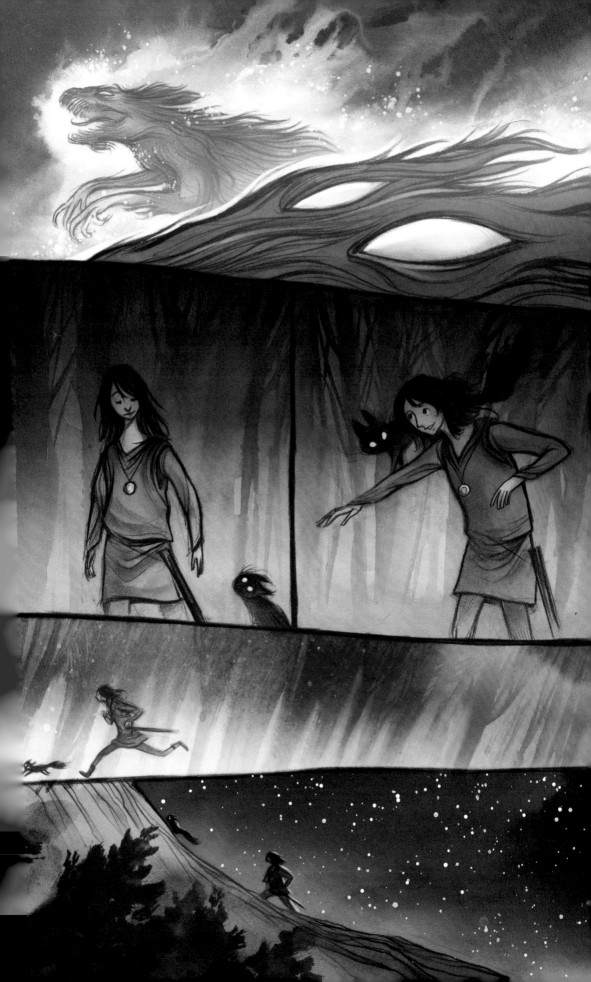

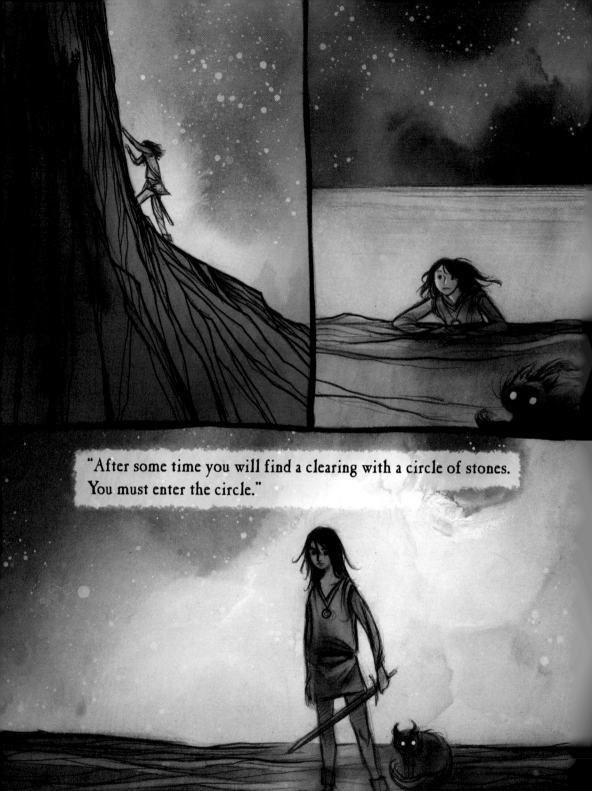

"After some time you will find a clearing with a circle of stones. You must enter the circle."

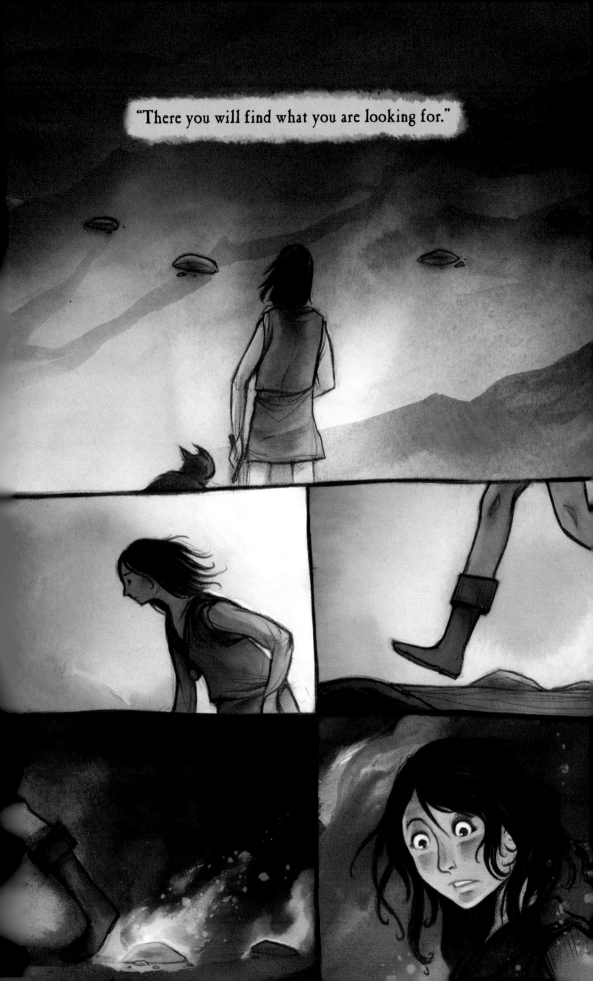

"There you will find what you are looking for."

"Do not be afraid of what happens next."

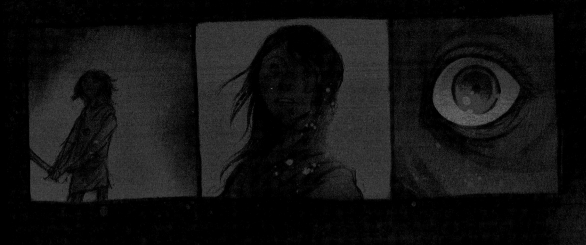

But what if I am afraid?

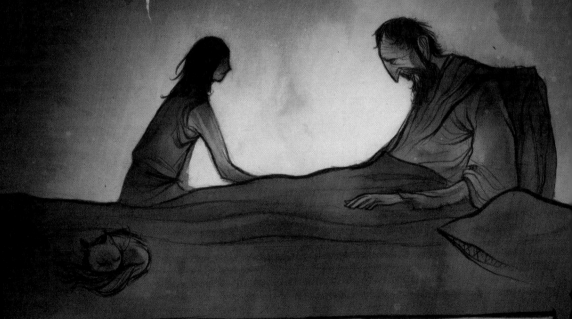

You will be, my dear.

Let me tell you a fairy tale.

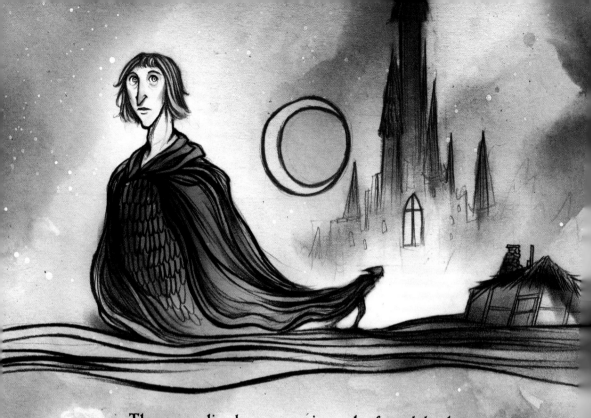

There once lived a young prince who feared death.

His father and mother, the king and queen, had fallen terribly ill
and no medicine could heal them.

After some time, they died.

In his grief, the young prince disguised himself and crept through the forest
to the home of a witch.

He asked if she could help him to cheat death. She agreed.

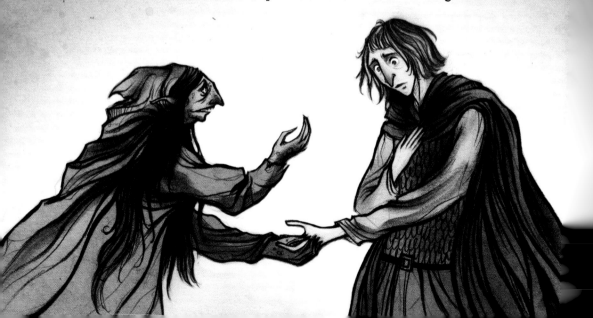

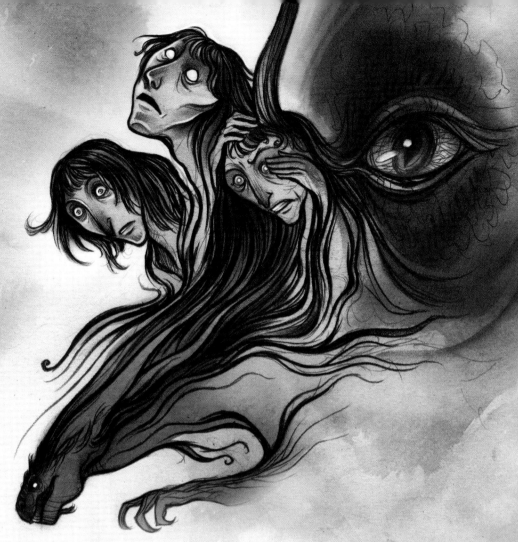

At once he started to change. His once blue eyes turned a deep red, his nimble hands turned to claws, and his smooth skin was covered in scales.

The prince realized a fear greater than death, trapped in the form of a monster that would never naturally die.

Ashamed of his choice, and his hideous new form, he crawled from the witch's home, laid himself down atop a hill, and wept.

But how is that a fairy tale? There's no happy ending.

The happy ending was not the prince's but it can be ours if we learn the lesson that he did not...

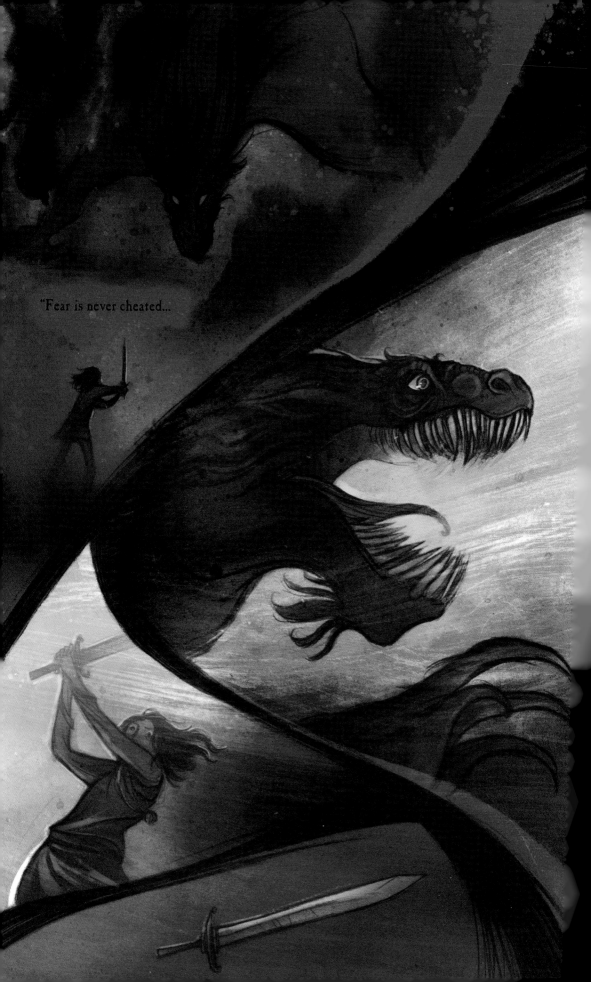

"Fear is never cheated...

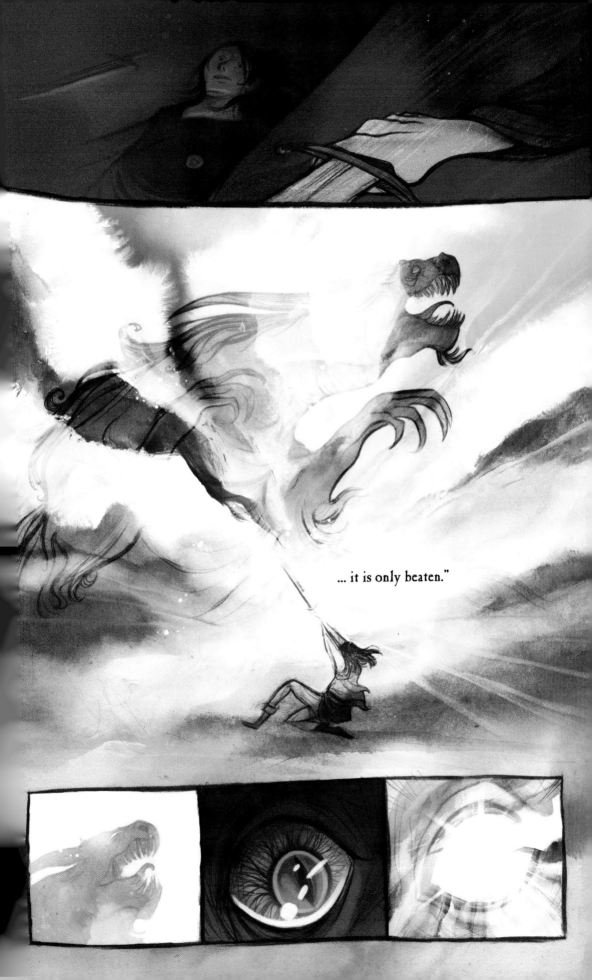

... it is only beaten."

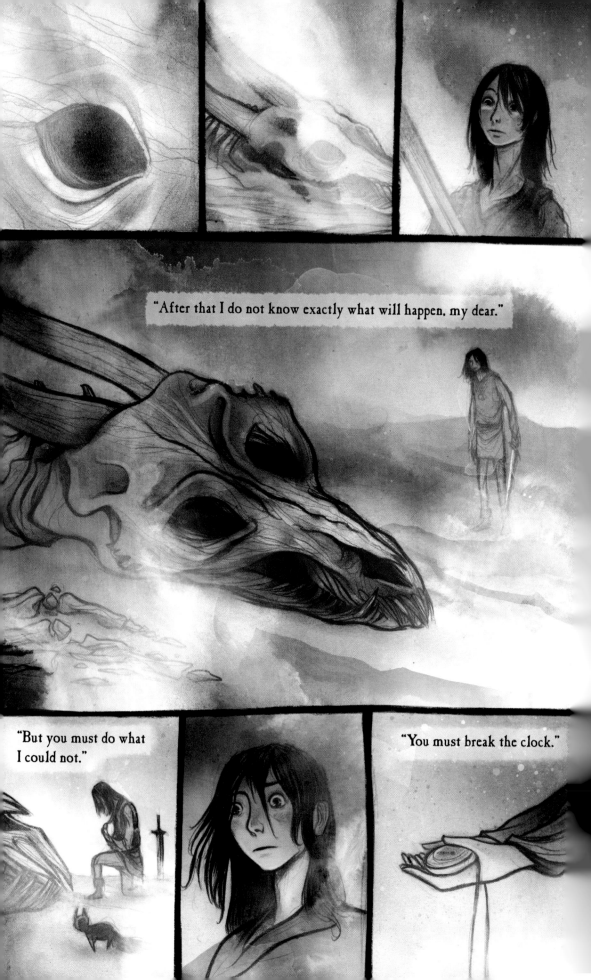

"After that I do not know exactly what will happen, my dear."

"But you must do what I could not."

"You must break the clock."

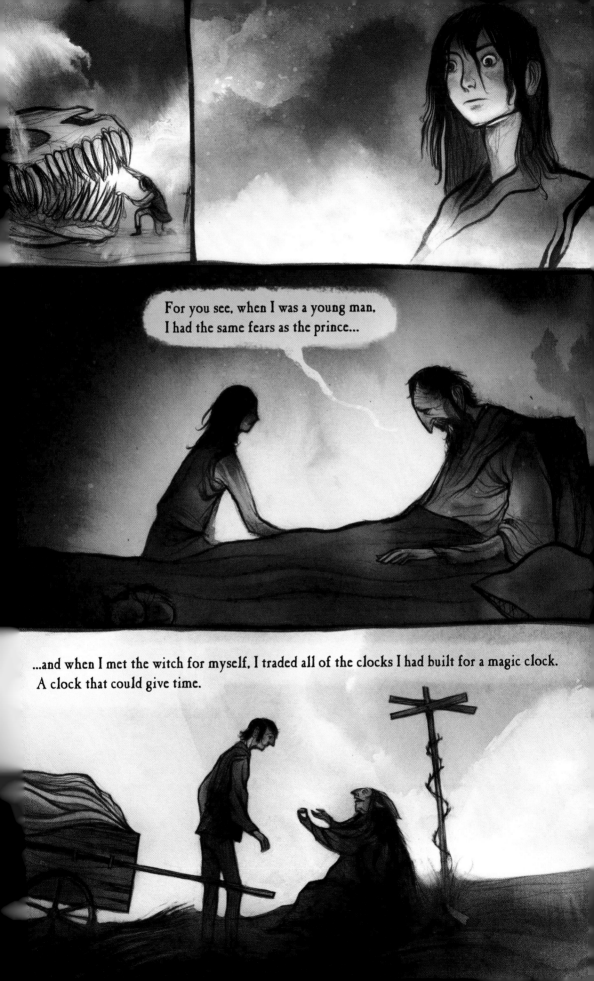

For you see, when I was a young man, I had the same fears as the prince...

...and when I met the witch for myself, I traded all of the clocks I had built for a magic clock. A clock that could give time.

Not in the sense that most clocks do, for it could actually bestow time on those who needed it most. Those whose time was short.

I traveled the world listening to last wishes and last words, offering the gift of time to those wh were not yet ready to meet death.

But just as the prince was cursed, so was the clock.

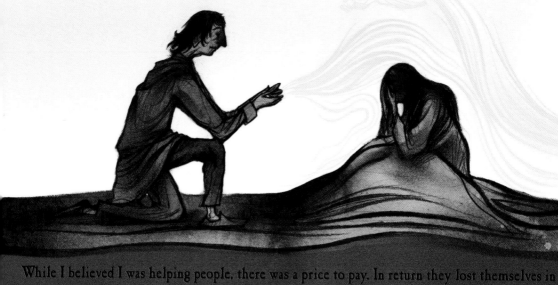

While I believed I was helping people, there was a price to pay. In return they lost themselves in their last moments, their memories swallowed by the clock and locked away.

So you see why it must be broken.
The memories must be returned, and this curse must be lifted.

I cannot break the clock, though I have tried.
Only the witch's own power can crack its evil casing.

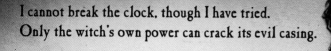
I have been guardian of the witch's treasure. It works its magic differently upon me,

but there are many ways to lose one's self.

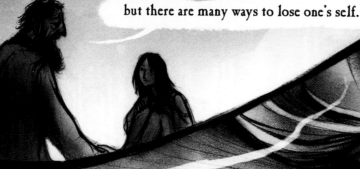

Even now the curse runs through my veins turning me into a monster.

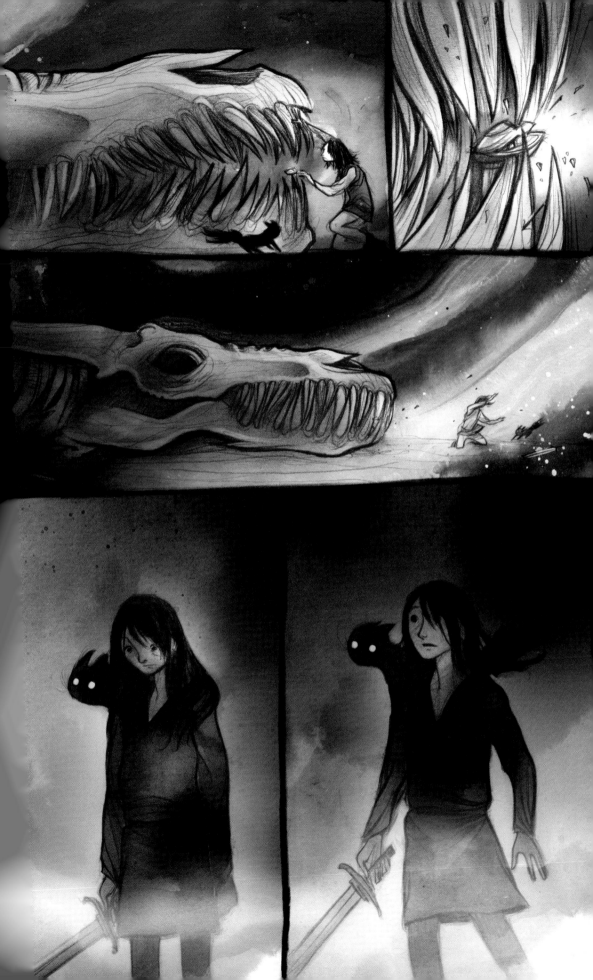

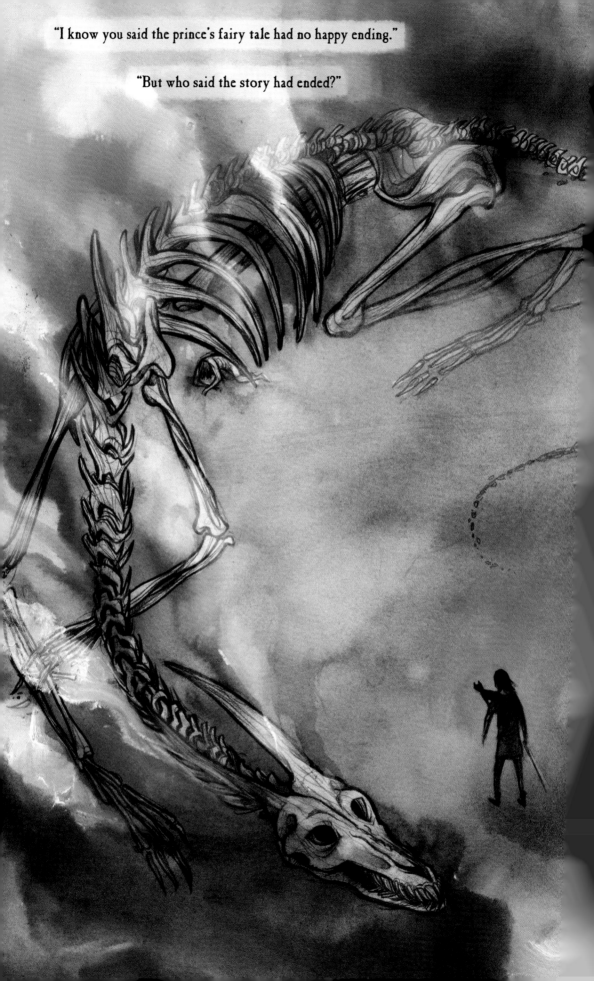

"I know you said the prince's fairy tale had no happy ending."

"But who said the story had ended?"

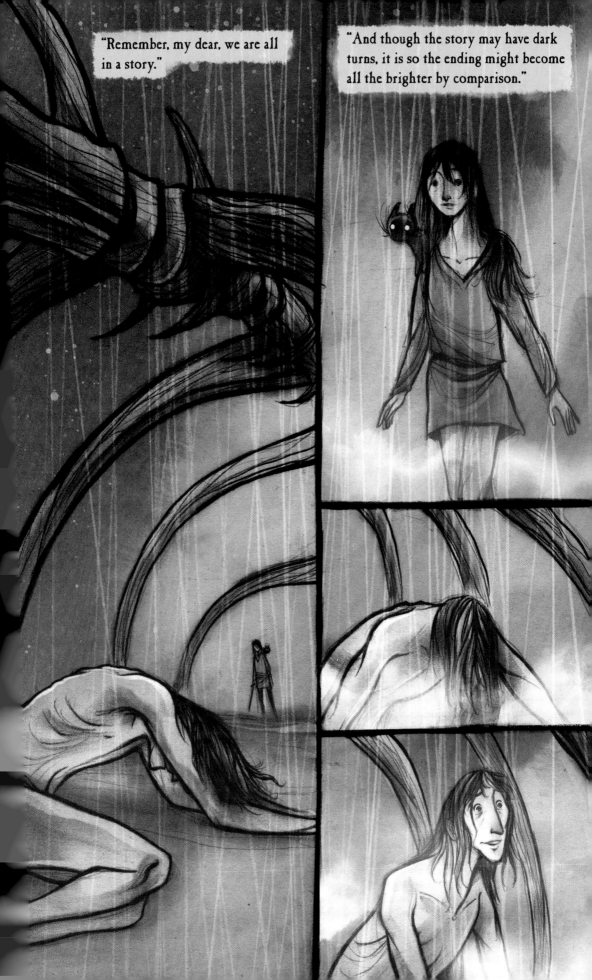

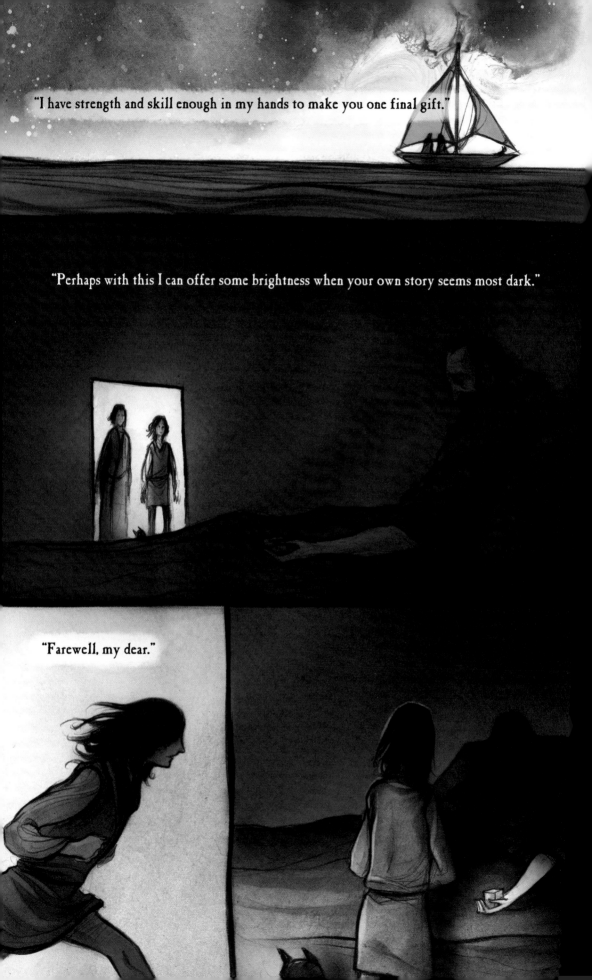

"I have strength and skill enough in my hands to make you one final gift."

"Perhaps with this I can offer some brightness when your own story seems most dark."

"Farewell, my dear."

end

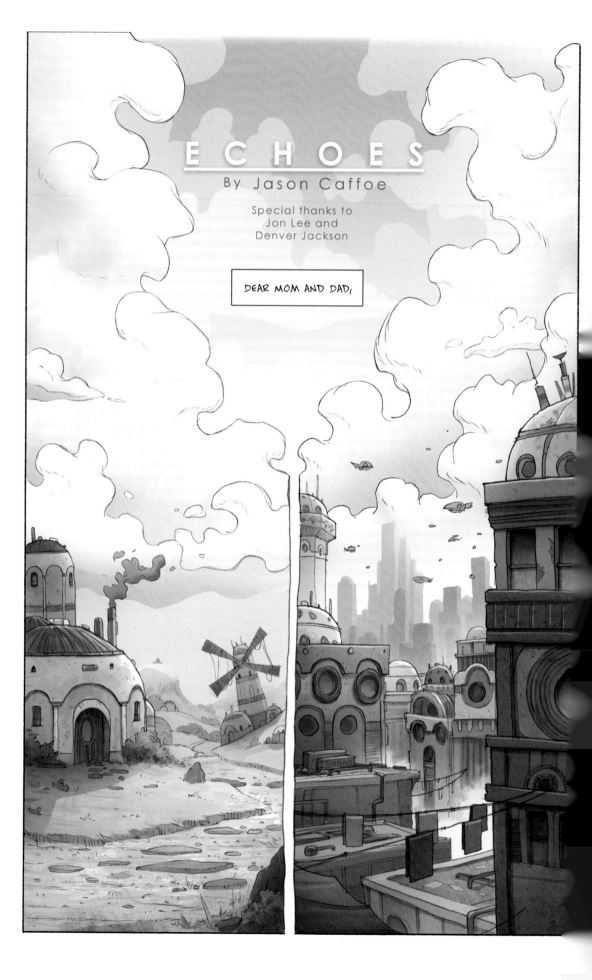

SORRY I WASN'T ABLE TO WRITE BACK RIGHT AWAY.

THINGS HAVE BEEN PRETTY BUSY.

I'VE BEEN DOING WELL, THOUGH! I HOPE YOU WEREN'T TOO WORRIED.

THE APARTMENT IS DEFINITELY A LITTLE CRAMPED, BUT I LIKE IT.

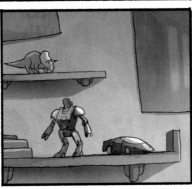

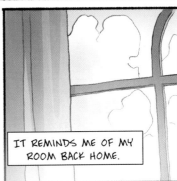

IT REMINDS ME OF MY ROOM BACK HOME.

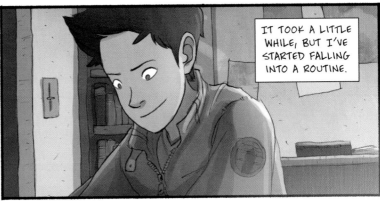

IT TOOK A LITTLE WHILE, BUT I'VE STARTED FALLING INTO A ROUTINE.

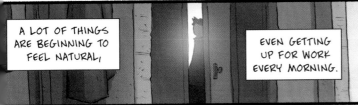

A LOT OF THINGS ARE BEGINNING TO FEEL NATURAL,

EVEN GETTING UP FOR WORK EVERY MORNING.

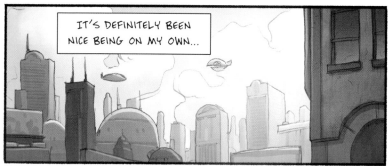

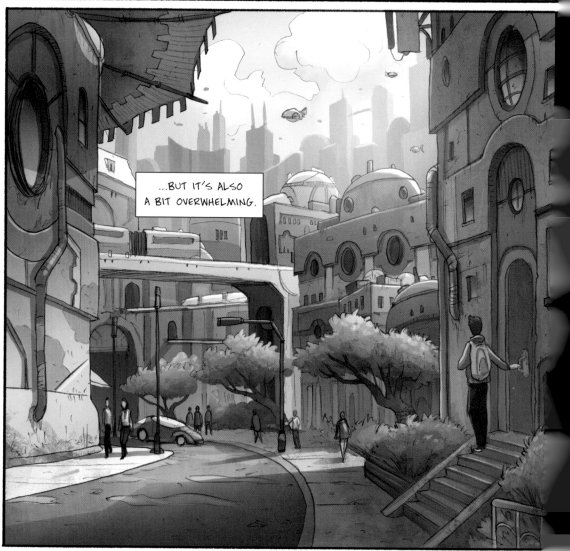

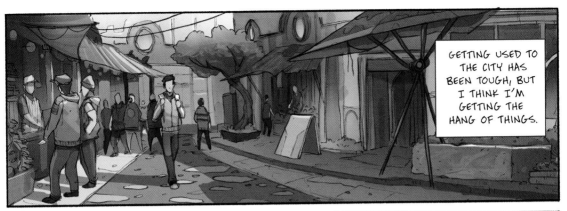

GETTING USED TO THE CITY HAS BEEN TOUGH, BUT I THINK I'M GETTING THE HANG OF THINGS.

IT'S CERTAINLY A CHANGE BEING AROUND SO MANY PEOPLE,

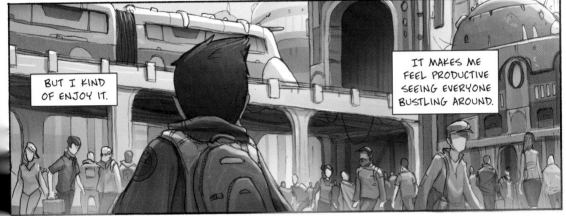

BUT I KIND OF ENJOY IT.

IT MAKES ME FEEL PRODUCTIVE SEEING EVERYONE BUSTLING AROUND.

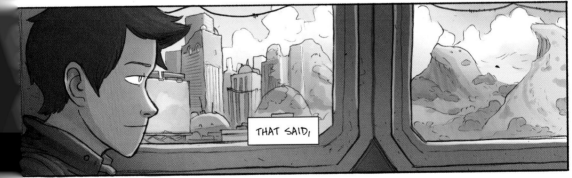

THAT SAID,

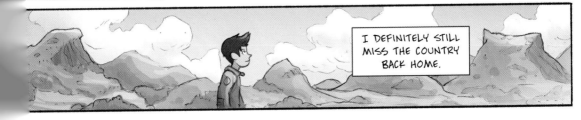

I DEFINITELY STILL MISS THE COUNTRY BACK HOME.

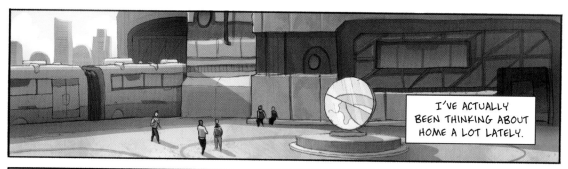

I'VE ACTUALLY BEEN THINKING ABOUT HOME A LOT LATELY.

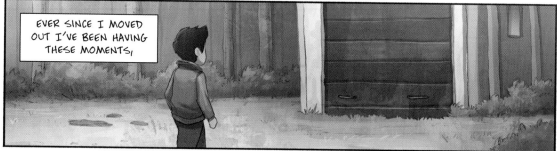

EVER SINCE I MOVED OUT I'VE BEEN HAVING THESE MOMENTS,

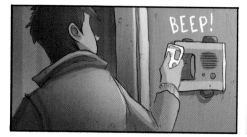

BEEP!

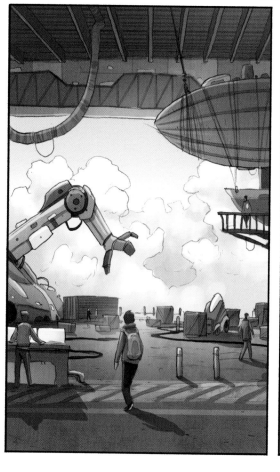

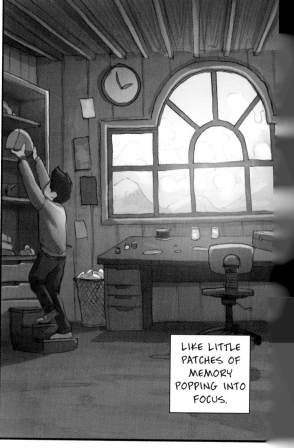

LIKE LITTLE PATCHES OF MEMORY POPPING INTO FOCUS.

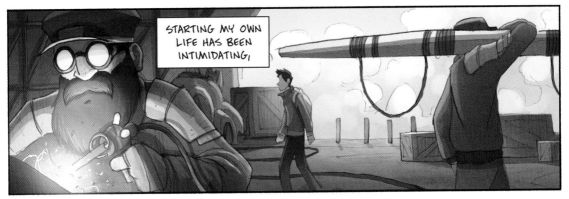

STARTING MY OWN LIFE HAS BEEN INTIMIDATING,

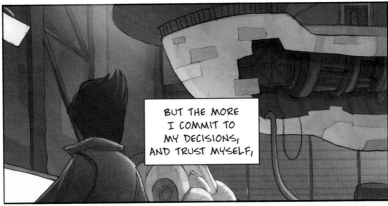

BUT THE MORE I COMMIT TO MY DECISIONS, AND TRUST MYSELF,

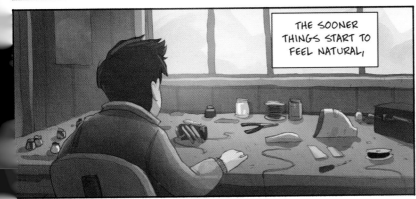

THE SOONER THINGS START TO FEEL NATURAL,

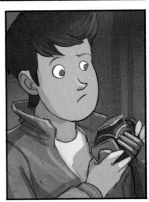

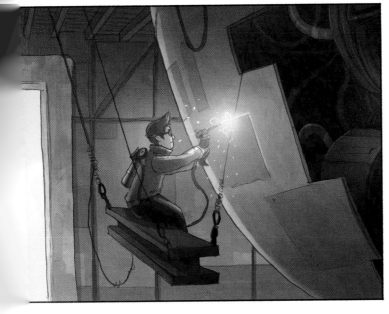

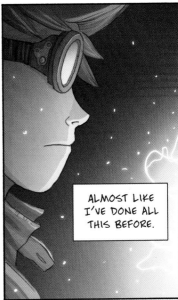

ALMOST LIKE I'VE DONE ALL THIS BEFORE.

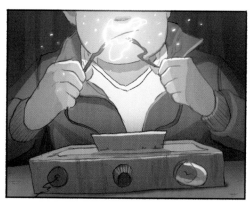

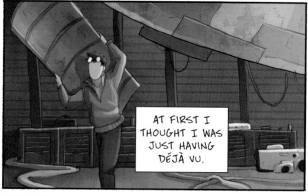

AT FIRST I THOUGHT I WAS JUST HAVING DÉJÀ VU.

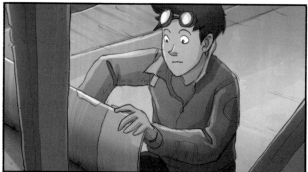

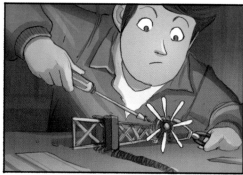

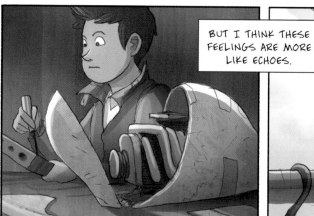

BUT I THINK THESE FEELINGS ARE MORE LIKE ECHOES.

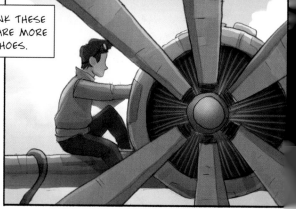

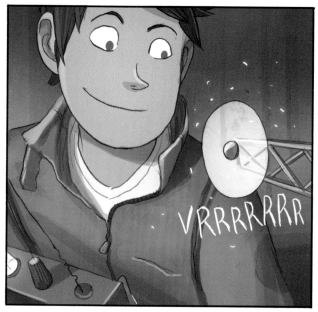

VRRRRRRR

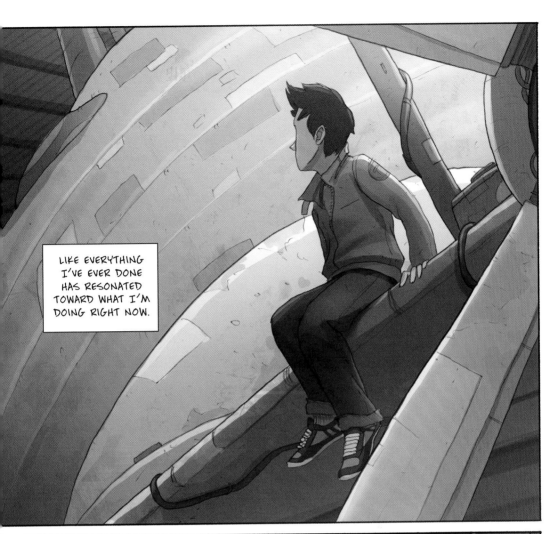

LIKE EVERYTHING I'VE EVER DONE HAS RESONATED TOWARD WHAT I'M DOING RIGHT NOW.

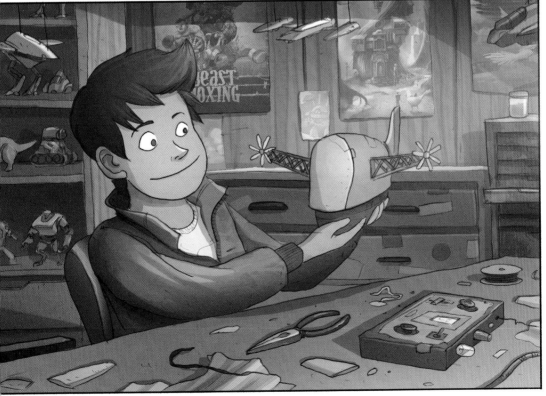

I DON'T REALLY BELIEVE IN FATE OR ANYTHING,

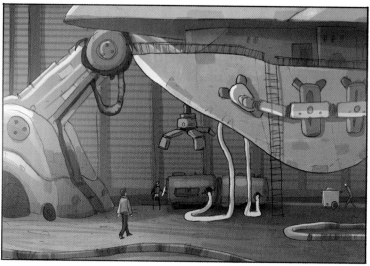

AND I NEVER EXPECTED TO END UP HERE.

I'M JUST DOING WHAT I LOVE.

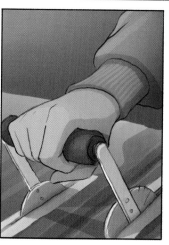

VRRRRRRR

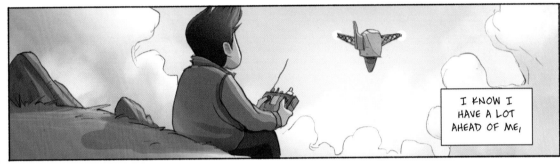

I KNOW I HAVE A LOT AHEAD OF ME,

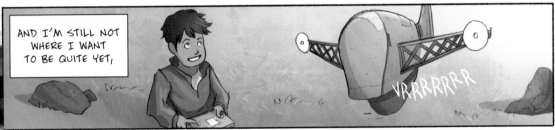

AND I'M STILL NOT WHERE I WANT TO BE QUITE YET,

VRRRRRRR

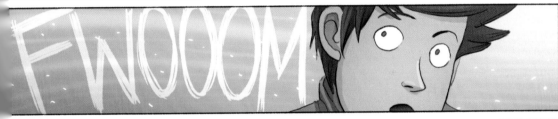

FWOOOM

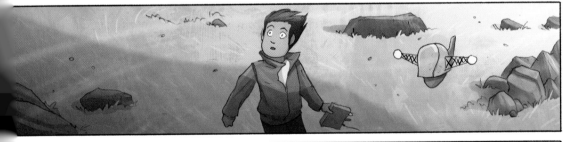

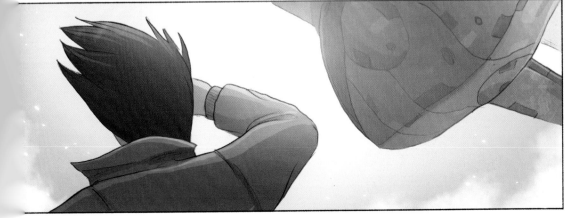

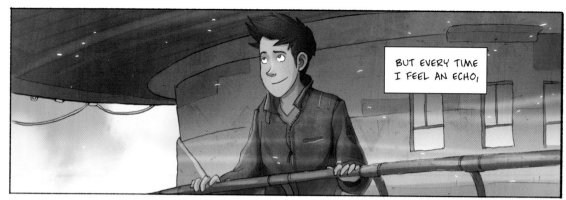

BUT EVERY TIME I FEEL AN ECHO,

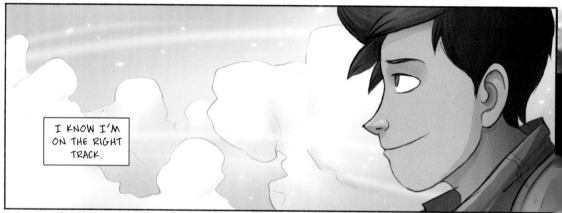

I KNOW I'M ON THE RIGHT TRACK.

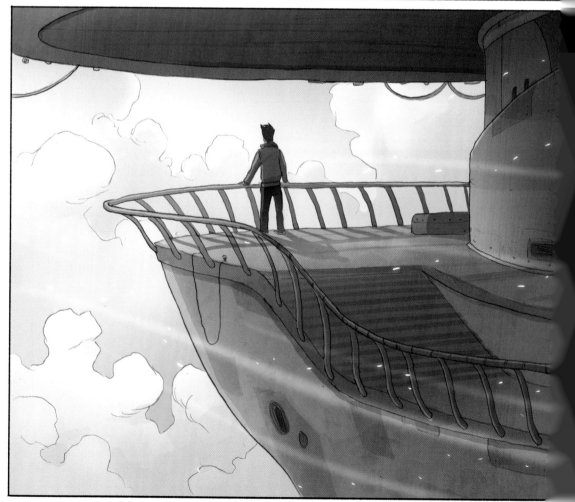

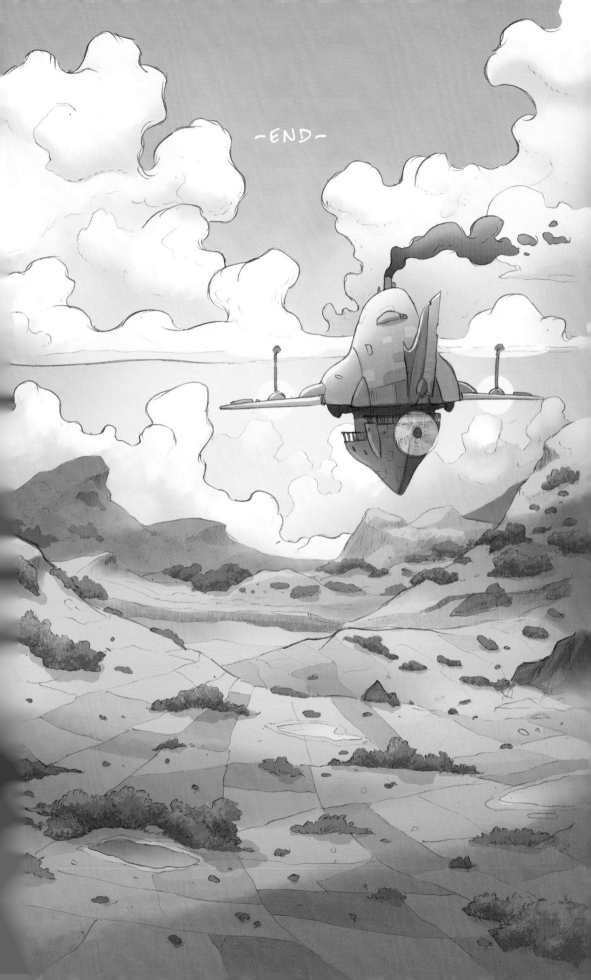

With thanks:

Abba, Most High
Mi Famiglia
Fabi
MJ
Shanth
Lia
Aaron
Beth
Peggy
Peter

Without all of you, none of this.

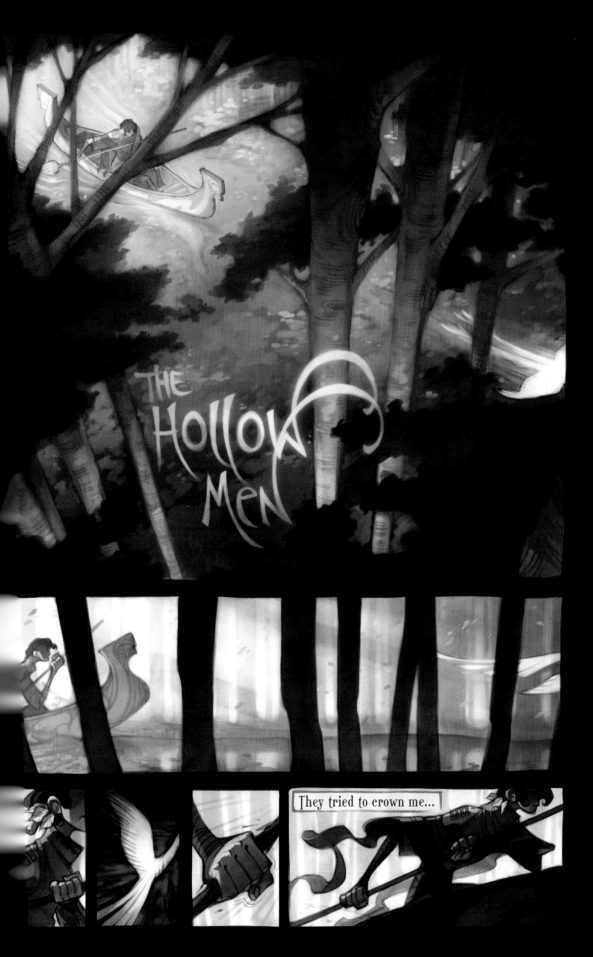

THE HOLLOW MEN

They tried to crown me...

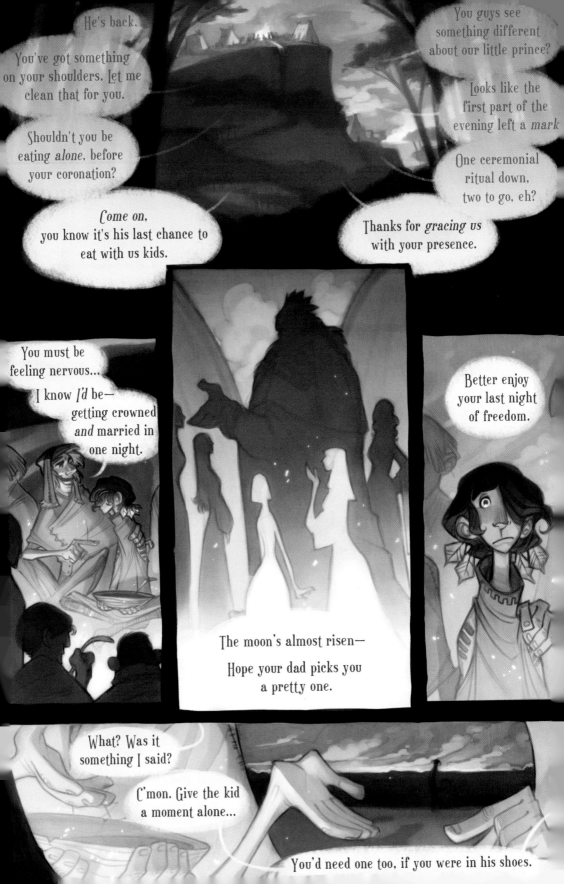

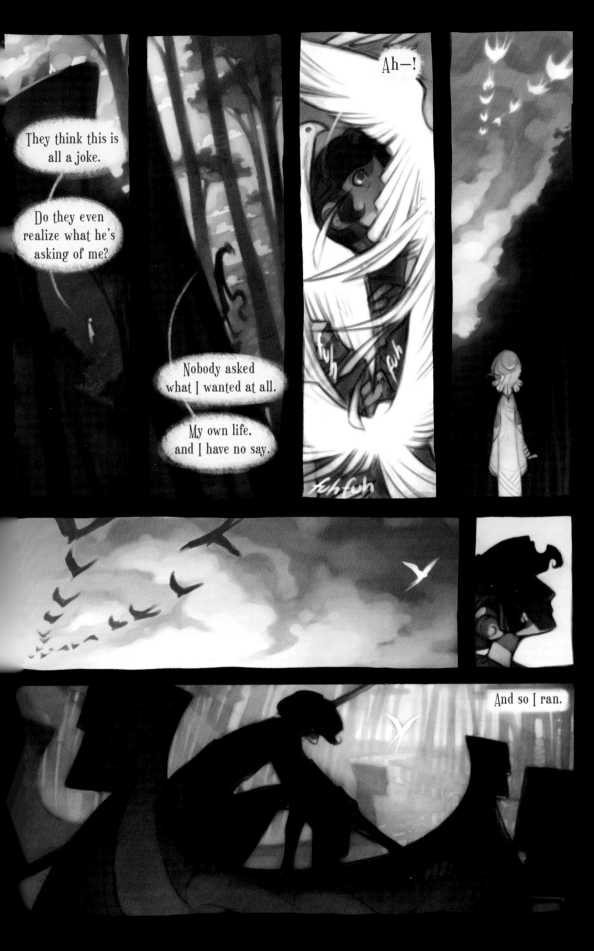

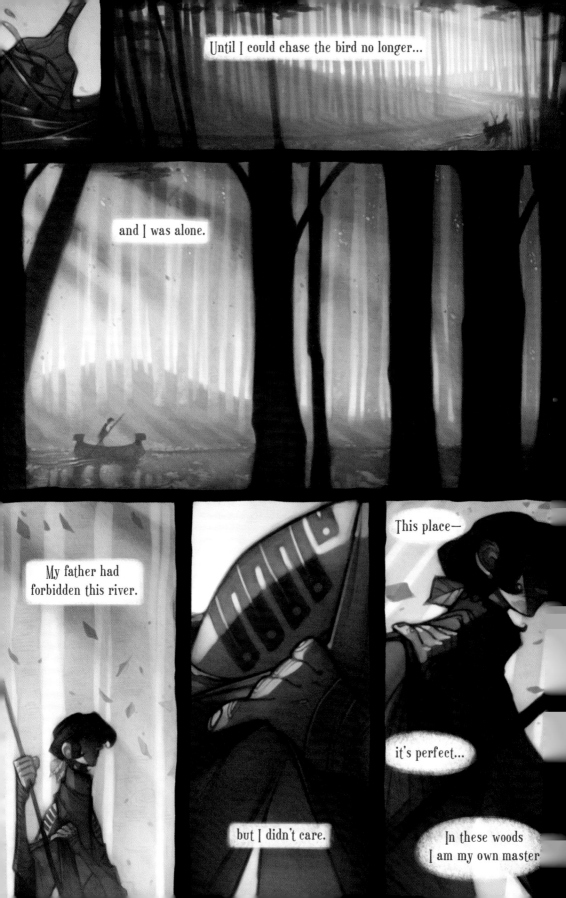

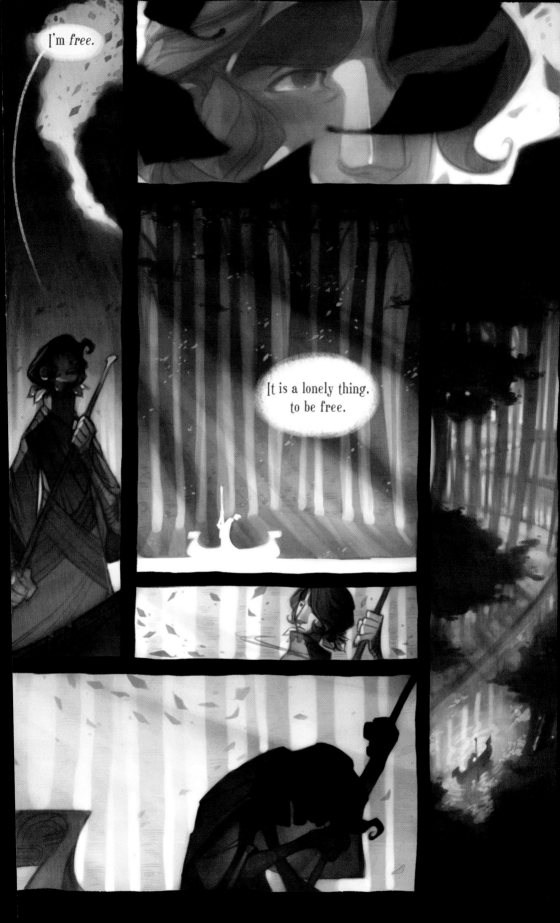

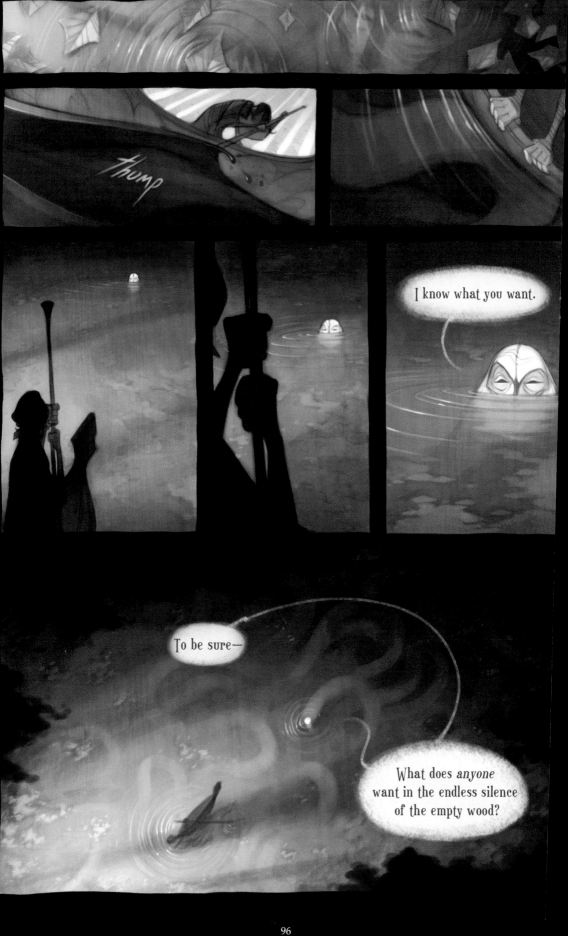

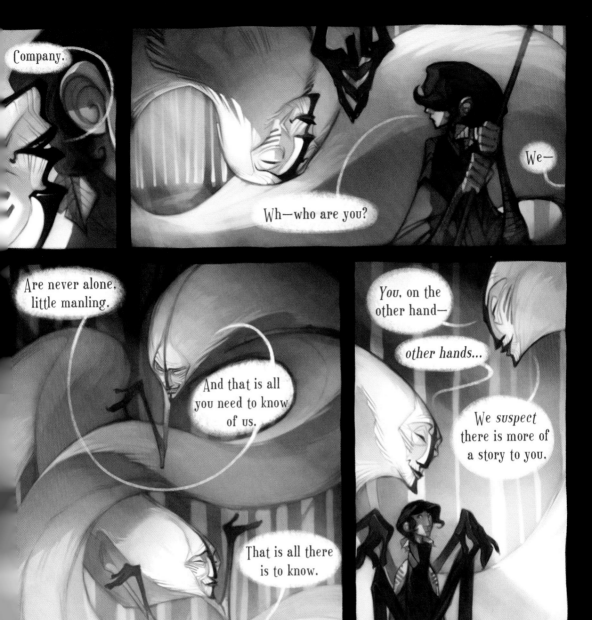

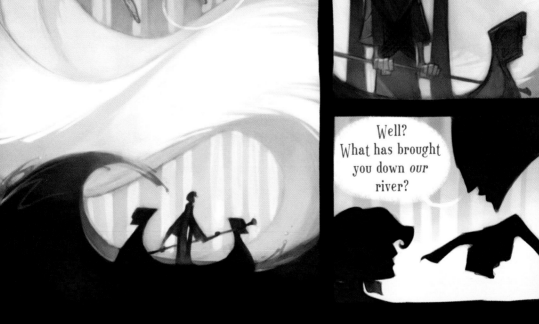

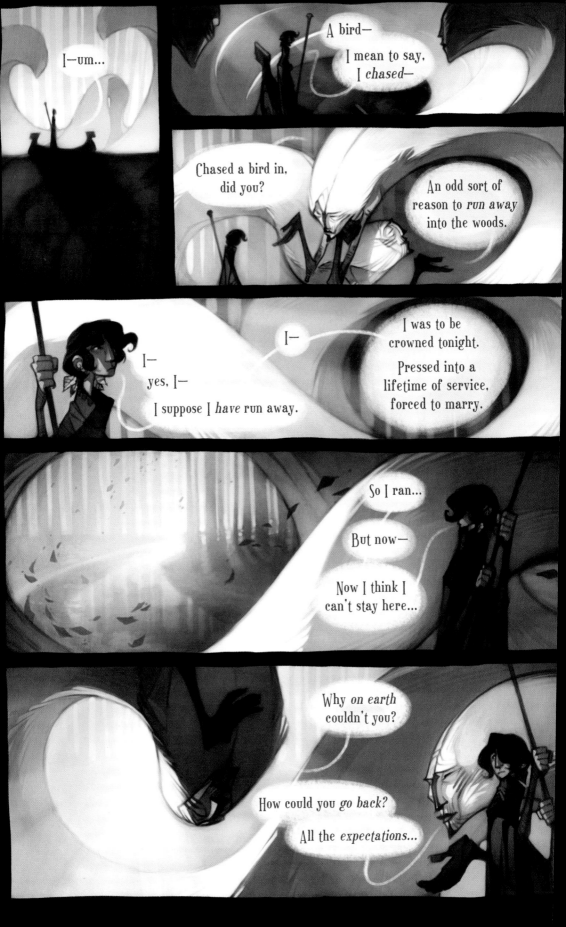

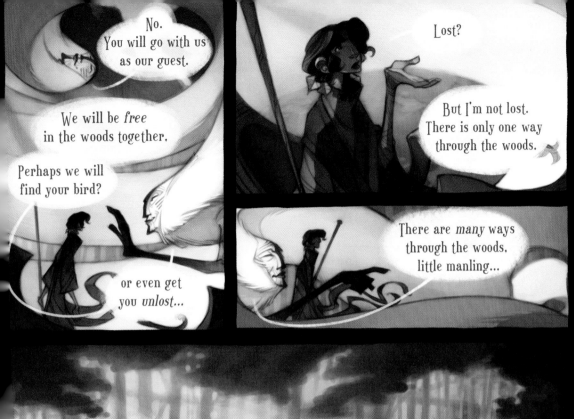

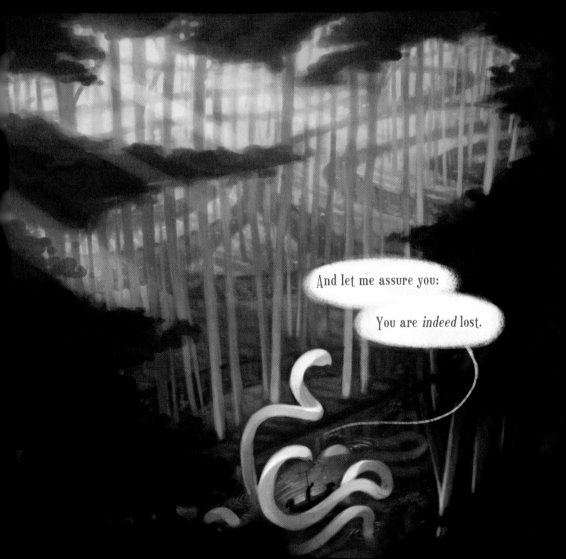

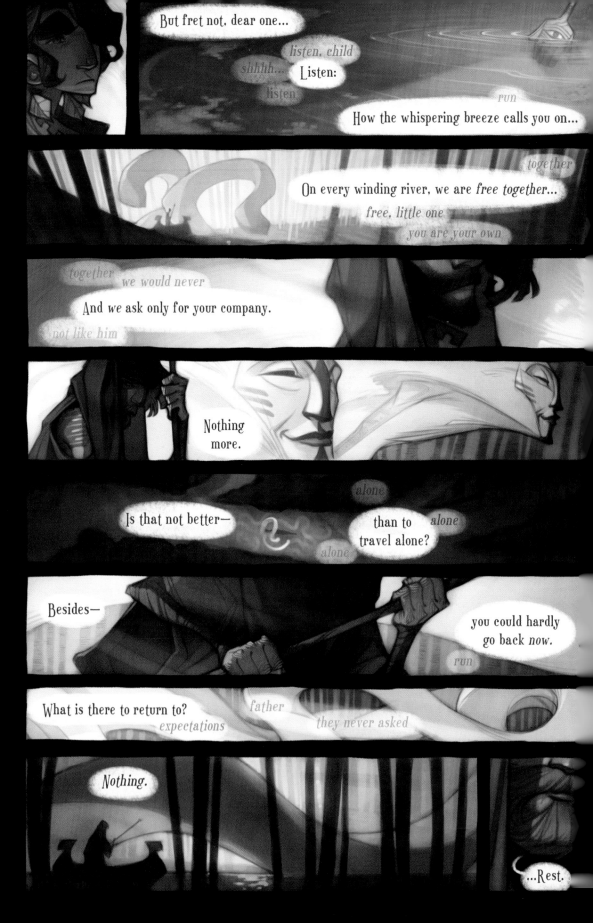

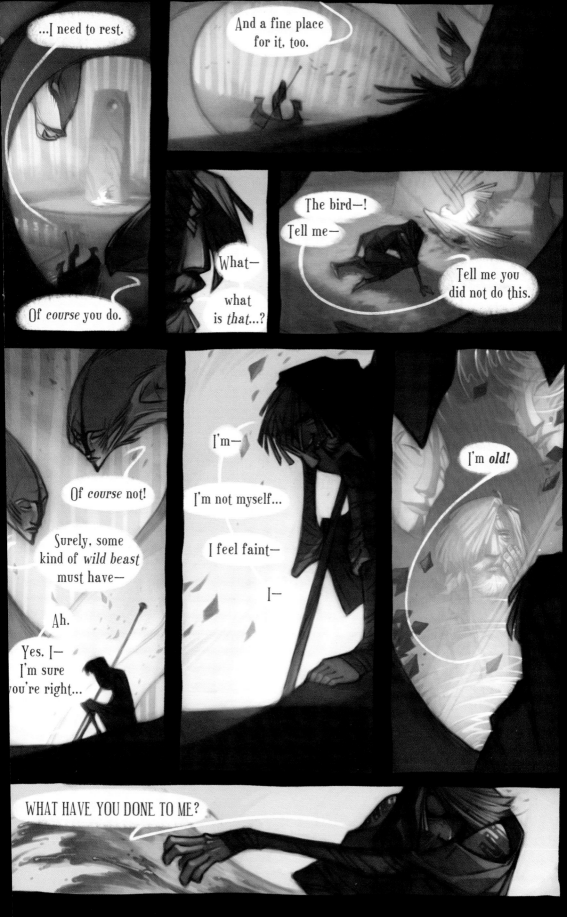

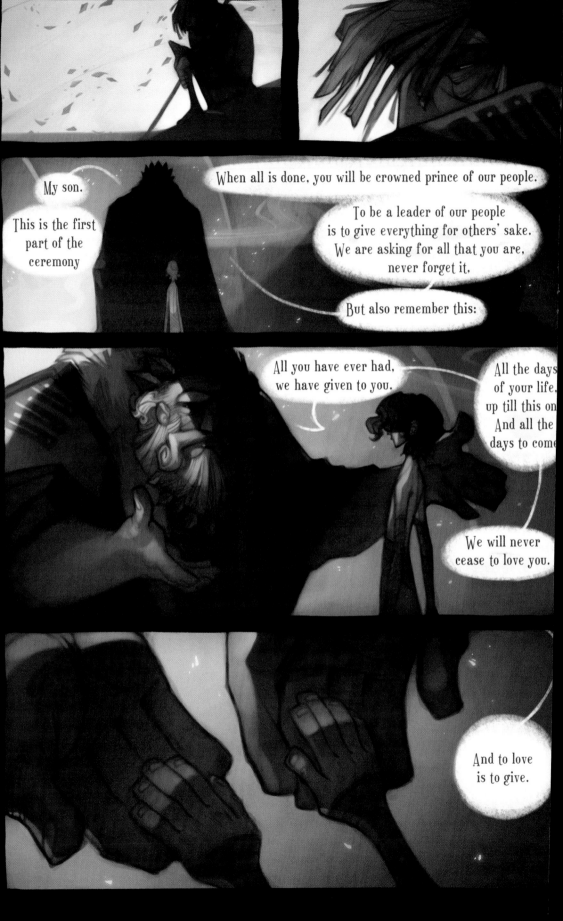

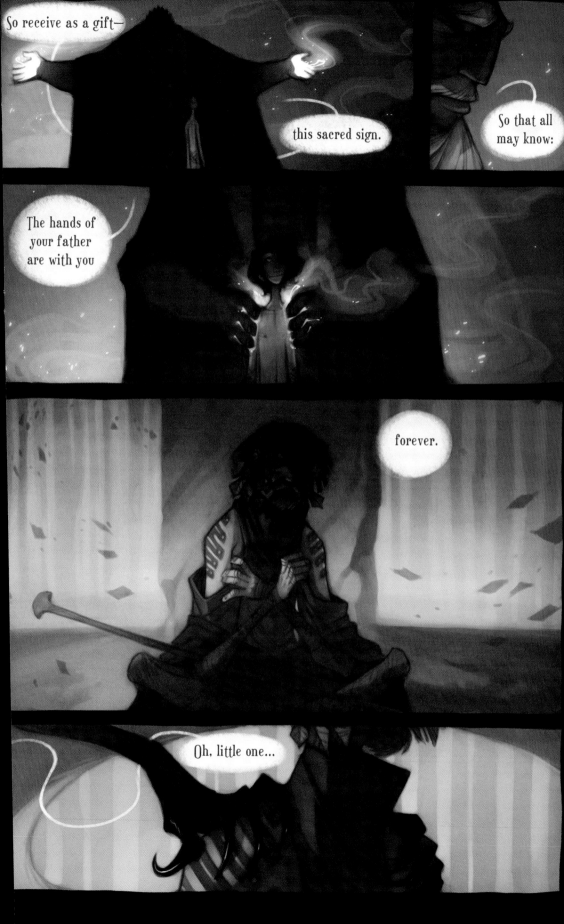

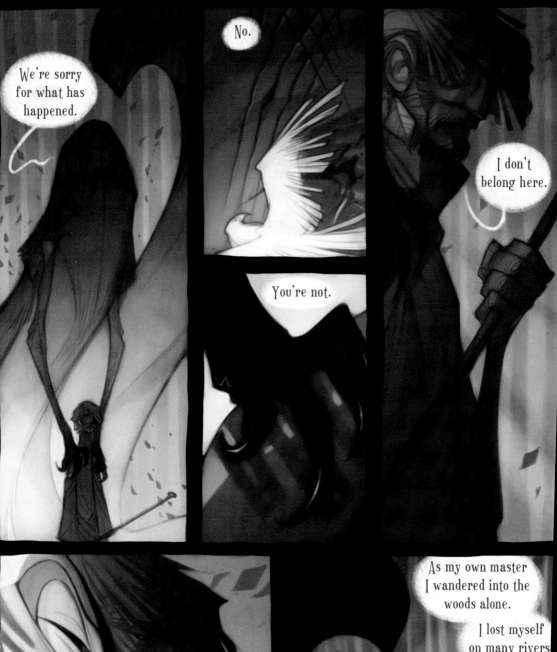

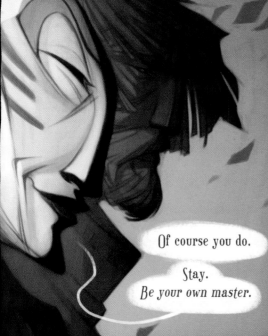

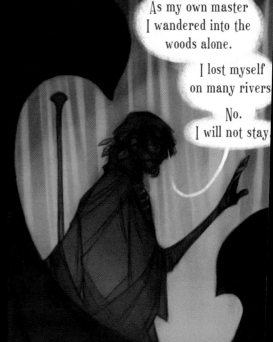

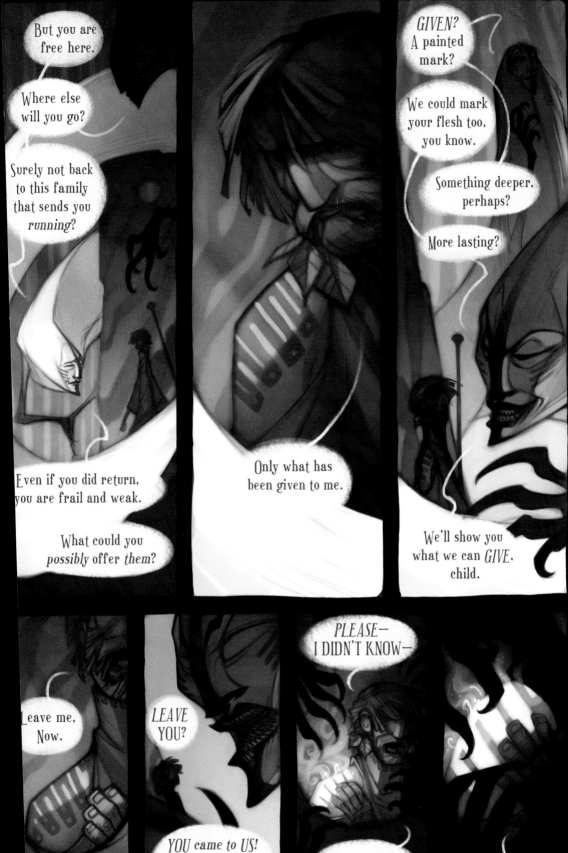

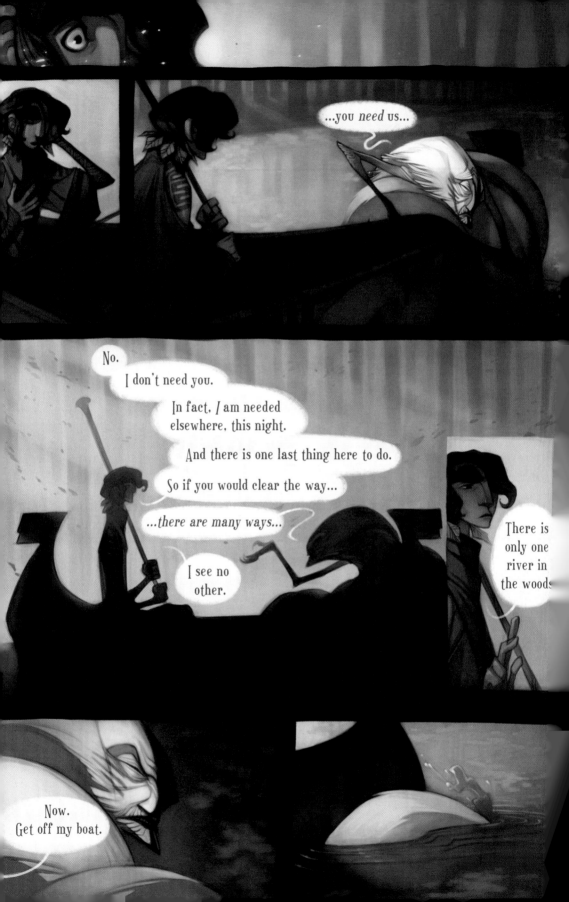

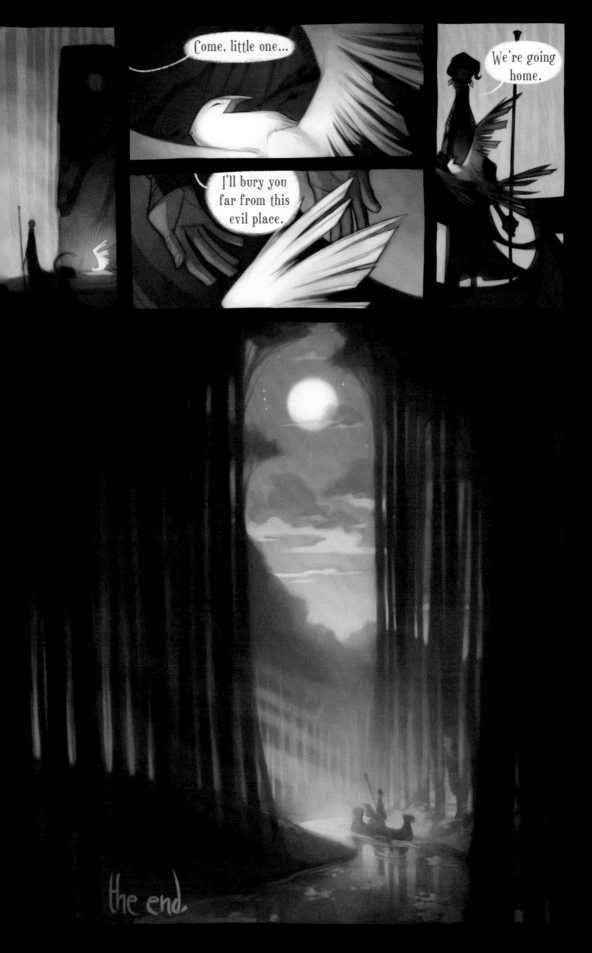

The Gift

By Kazu Kibuishi

Color & background assists:
Zane Yarbrough

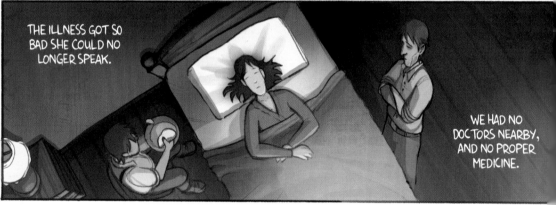

PA ALWAYS SAID THE SUMMERS ARE THE MOST TRYING SEASONS,

BUT THIS SUMMER WOULD TEST US LIKE NEVER BEFORE.

NOT ONLY DID WE SUFFER A BAD HARVEST, BUT MA BECAME TERRIBLY ILL.

THE ILLNESS GOT SO BAD SHE COULD NO LONGER SPEAK.

WE HAD NO DOCTORS NEARBY, AND NO PROPER MEDICINE.

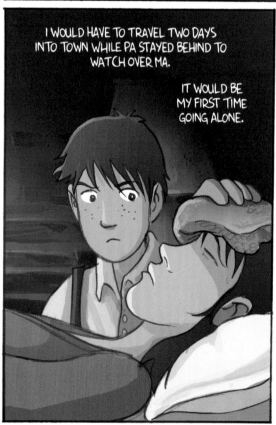

I WOULD HAVE TO TRAVEL TWO DAYS INTO TOWN WHILE PA STAYED BEHIND TO WATCH OVER MA.

IT WOULD BE MY FIRST TIME GOING ALONE.

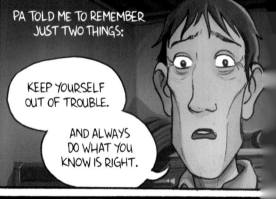

PA TOLD ME TO REMEMBER JUST TWO THINGS:

KEEP YOURSELF OUT OF TROUBLE.

AND ALWAYS DO WHAT YOU KNOW IS RIGHT.

YES, SIR.

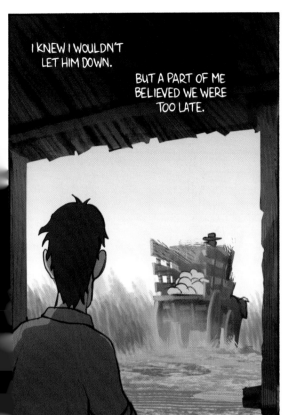

I KNEW I WOULDN'T LET HIM DOWN.

BUT A PART OF ME BELIEVED WE WERE TOO LATE.

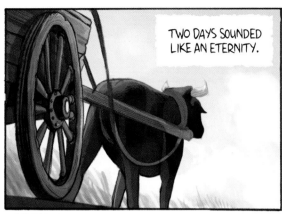

TWO DAYS SOUNDED LIKE AN ETERNITY.

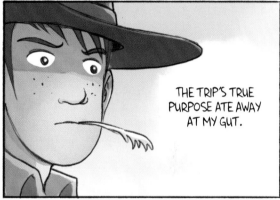

THE TRIP'S TRUE PURPOSE ATE AWAY AT MY GUT.

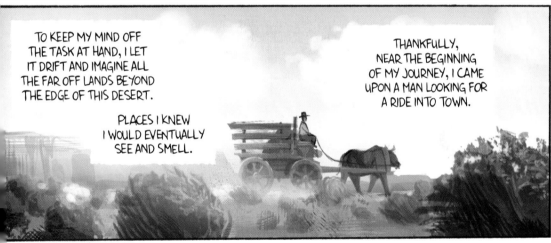

TO KEEP MY MIND OFF THE TASK AT HAND, I LET IT DRIFT AND IMAGINE ALL THE FAR OFF LANDS BEYOND THE EDGE OF THIS DESERT.

PLACES I KNEW I WOULD EVENTUALLY SEE AND SMELL.

THANKFULLY, NEAR THE BEGINNING OF MY JOURNEY, I CAME UPON A MAN LOOKING FOR A RIDE INTO TOWN.

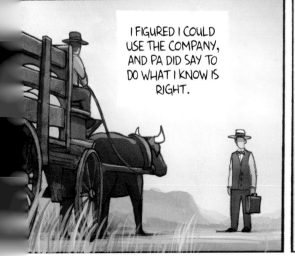

I FIGURED I COULD USE THE COMPANY, AND PA DID SAY TO DO WHAT I KNOW IS RIGHT.

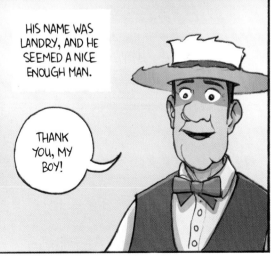

HIS NAME WAS LANDRY, AND HE SEEMED A NICE ENOUGH MAN.

THANK YOU, MY BOY!

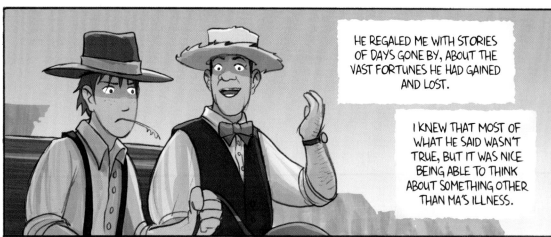

HE REGALED ME WITH STORIES OF DAYS GONE BY, ABOUT THE VAST FORTUNES HE HAD GAINED AND LOST.

I KNEW THAT MOST OF WHAT HE SAID WASN'T TRUE, BUT IT WAS NICE BEING ABLE TO THINK ABOUT SOMETHING OTHER THAN MA'S ILLNESS.

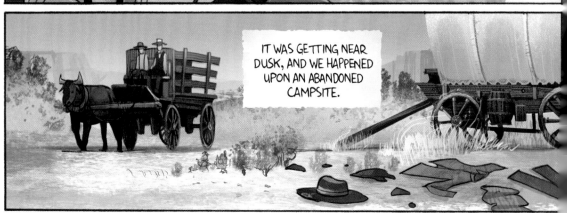

IT WAS GETTING NEAR DUSK, AND WE HAPPENED UPON AN ABANDONED CAMPSITE.

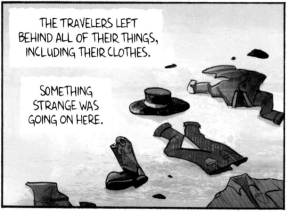

THE TRAVELERS LEFT BEHIND ALL OF THEIR THINGS, INCLUDING THEIR CLOTHES.

SOMETHING STRANGE WAS GOING ON HERE.

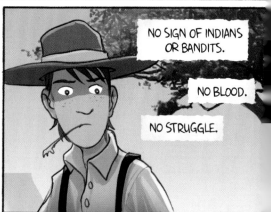

NO SIGN OF INDIANS OR BANDITS.

NO BLOOD.

NO STRUGGLE.

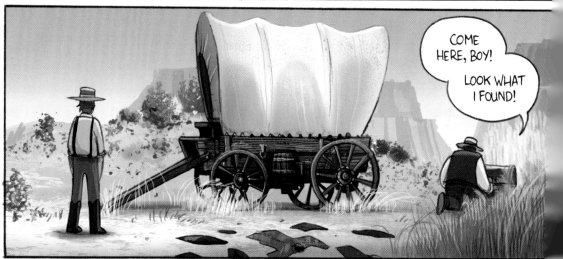

COME HERE, BOY! LOOK WHAT I FOUND!

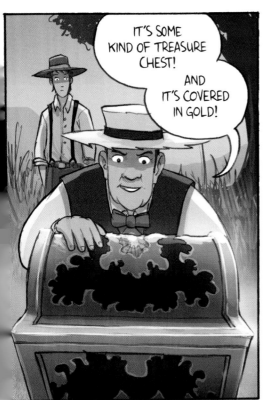

IT'S SOME KIND OF TREASURE CHEST!

AND IT'S COVERED IN GOLD!

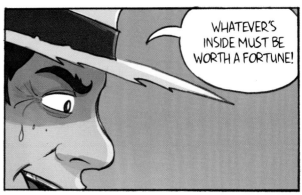

WHATEVER'S INSIDE MUST BE WORTH A FORTUNE!

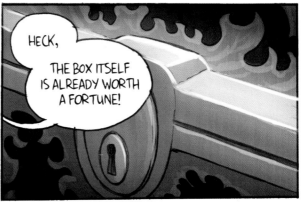

HECK,

THE BOX ITSELF IS ALREADY WORTH A FORTUNE!

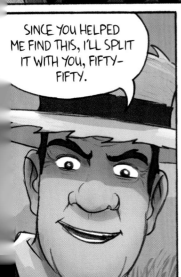

SINCE YOU HELPED ME FIND THIS, I'LL SPLIT IT WITH YOU, FIFTY-FIFTY.

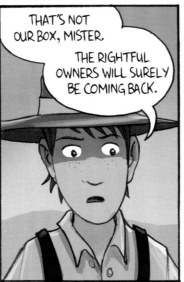

THAT'S NOT OUR BOX, MISTER.

THE RIGHTFUL OWNERS WILL SURELY BE COMING BACK.

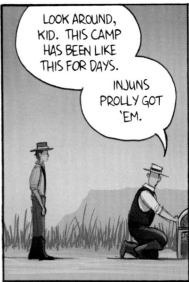

LOOK AROUND, KID. THIS CAMP HAS BEEN LIKE THIS FOR DAYS.

INJUNS PROLLY GOT 'EM.

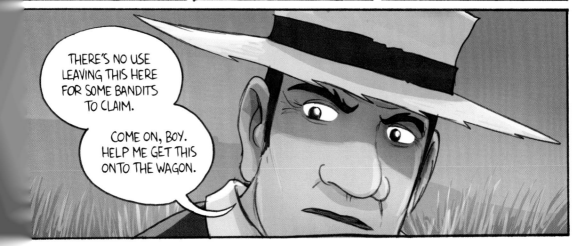

THERE'S NO USE LEAVING THIS HERE FOR SOME BANDITS TO CLAIM.

COME ON, BOY. HELP ME GET THIS ONTO THE WAGON.

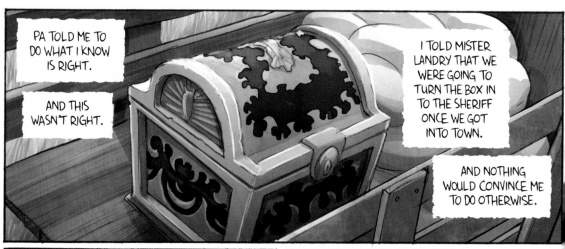

PA TOLD ME TO DO WHAT I KNOW IS RIGHT.

AND THIS WASN'T RIGHT.

I TOLD MISTER LANDRY THAT WE WERE GOING TO TURN THE BOX IN TO THE SHERIFF ONCE WE GOT INTO TOWN.

AND NOTHING WOULD CONVINCE ME TO DO OTHERWISE.

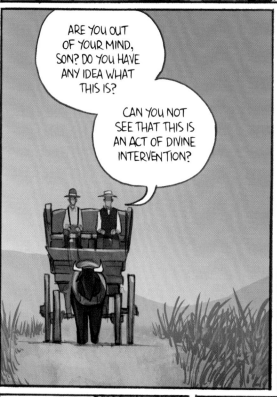

ARE YOU OUT OF YOUR MIND, SON? DO YOU HAVE ANY IDEA WHAT THIS IS?

CAN YOU NOT SEE THAT THIS IS AN ACT OF DIVINE INTERVENTION?

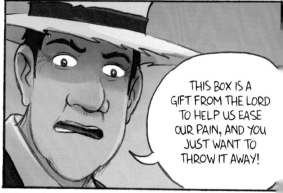

THIS BOX IS A GIFT FROM THE LORD TO HELP US EASE OUR PAIN, AND YOU JUST WANT TO THROW IT AWAY!

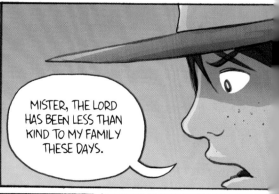

MISTER, THE LORD HAS BEEN LESS THAN KIND TO MY FAMILY THESE DAYS.

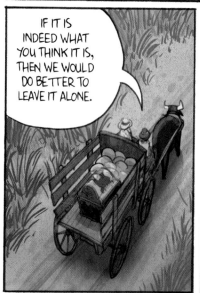

IF IT IS INDEED WHAT YOU THINK IT IS, THEN WE WOULD DO BETTER TO LEAVE IT ALONE.

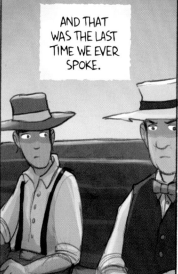

AND THAT WAS THE LAST TIME WE EVER SPOKE.

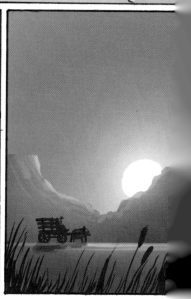

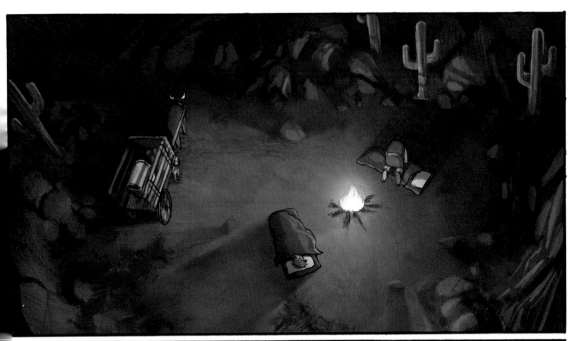

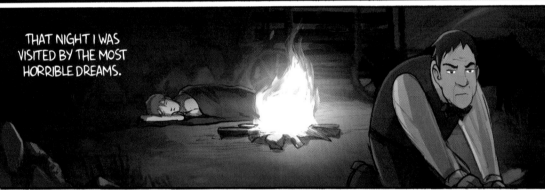

THAT NIGHT I WAS VISITED BY THE MOST HORRIBLE DREAMS.

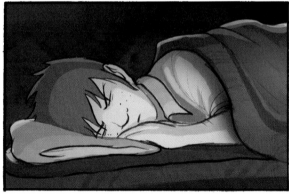

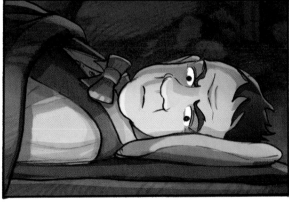

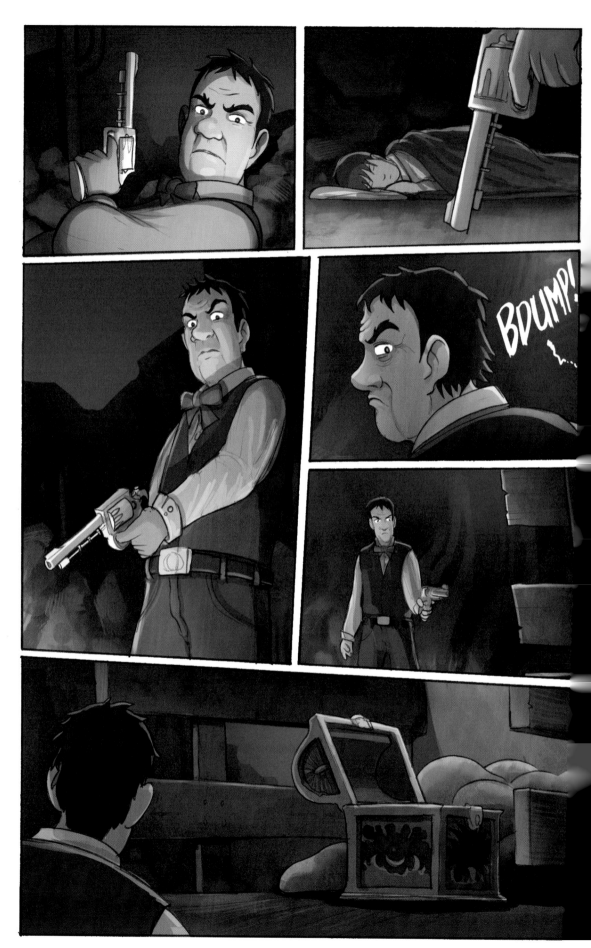

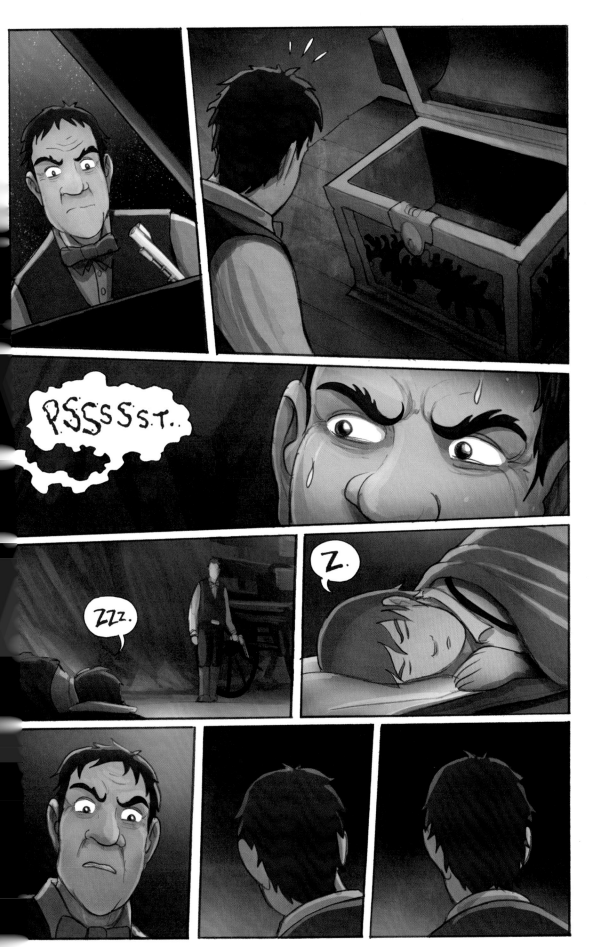

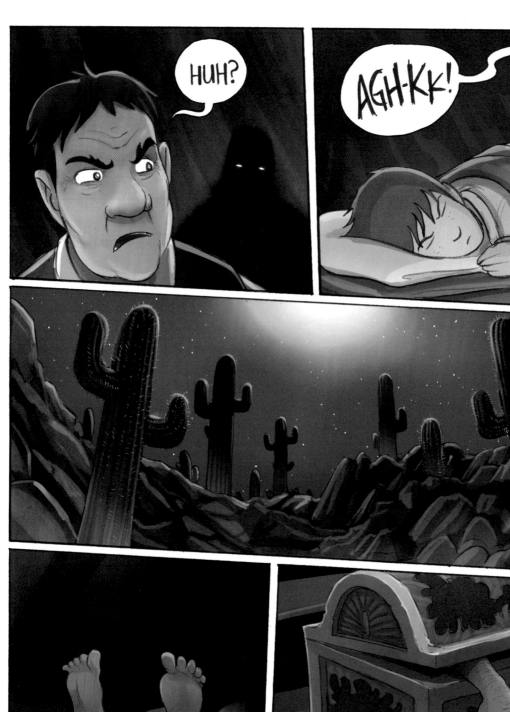

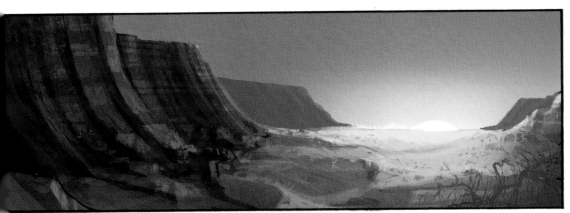

THE NEXT MORNING, MISTER LANDRY WAS NOWHERE TO BE FOUND.

HE LEFT BEHIND HIS PISTOL AND A FEW ARTICLES OF CLOTHING.

COULD HE HAVE BEEN KIDNAPPED LIKE THE OTHERS?

AND IF SO, WHY DIDN'T THEY TAKE ME?

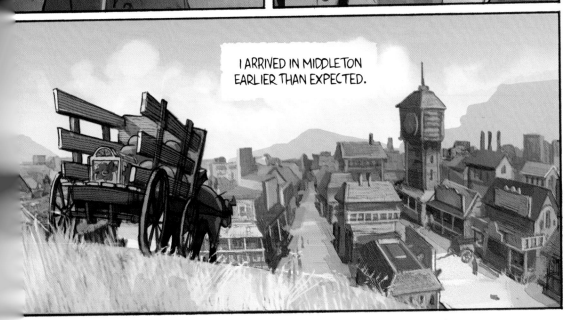

I ARRIVED IN MIDDLETON EARLIER THAN EXPECTED.

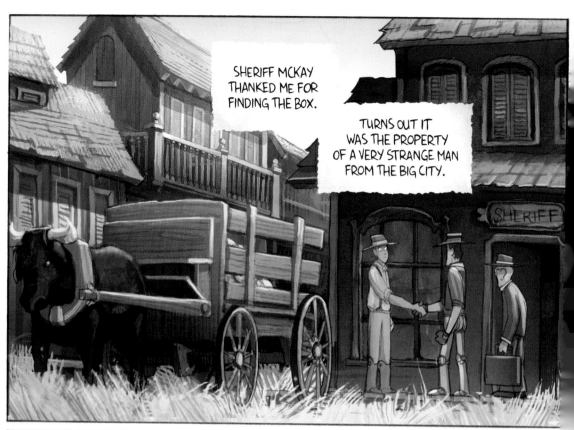

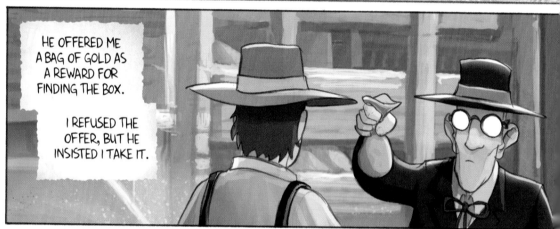

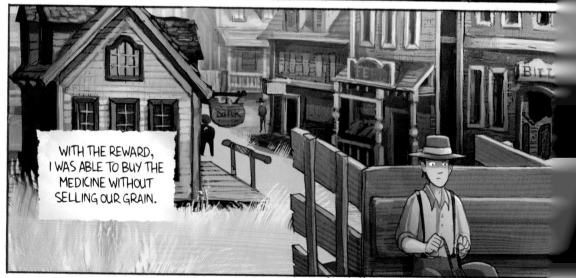

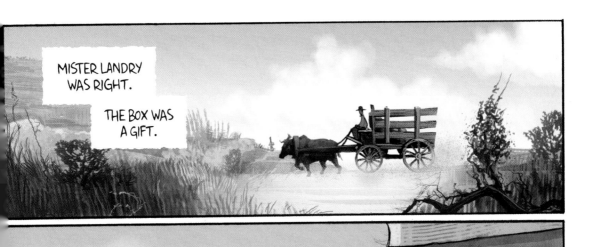

MISTER LANDRY WAS RIGHT.

THE BOX WAS A GIFT.

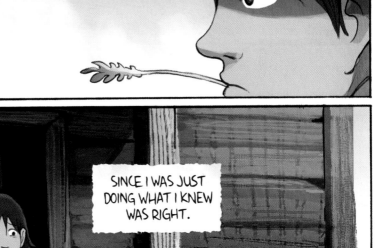

BUT I LIKE TO THINK I WAS REWARDED FOR LISTENING TO PA.

SINCE I WAS JUST DOING WHAT I KNEW WAS RIGHT.

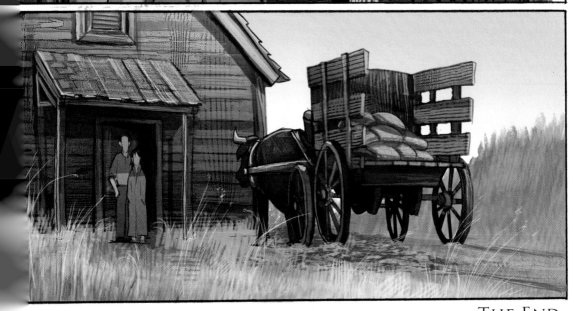

THE END

THE BLACK FOUNTAIN

by Tony Cliff

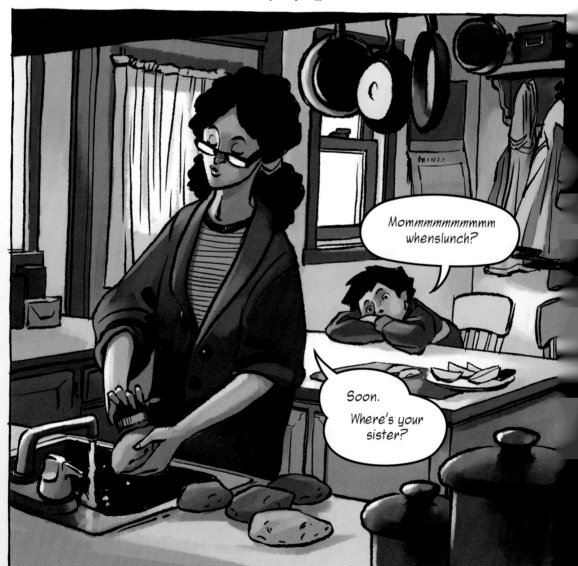

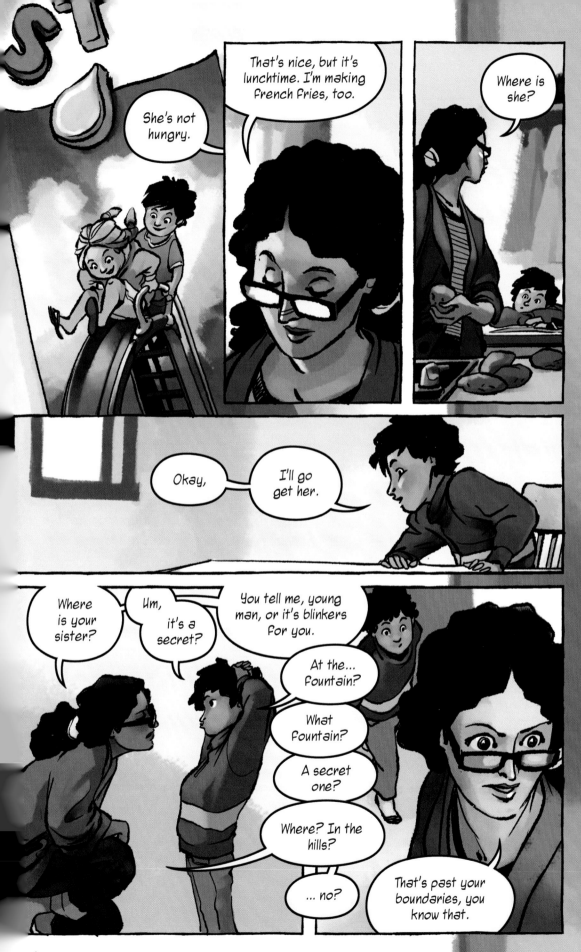

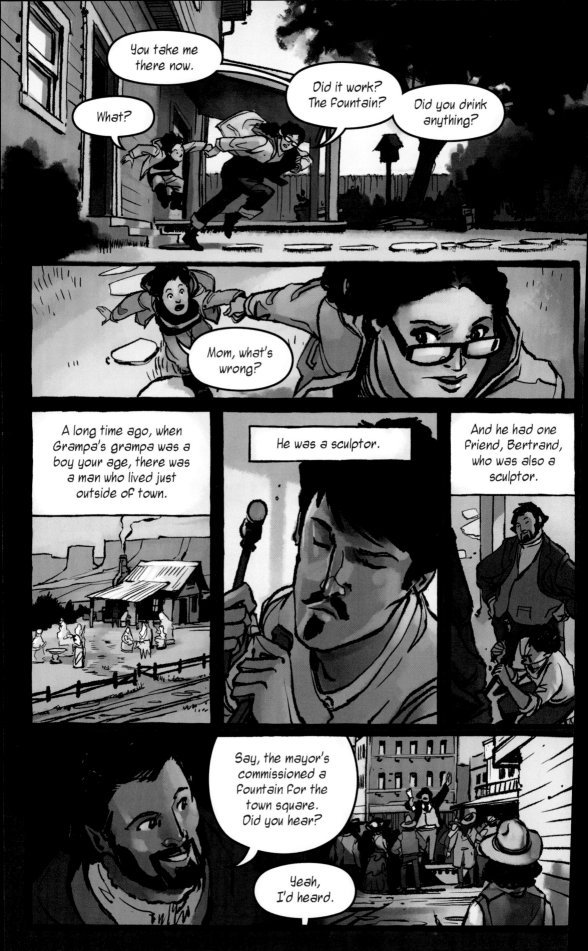

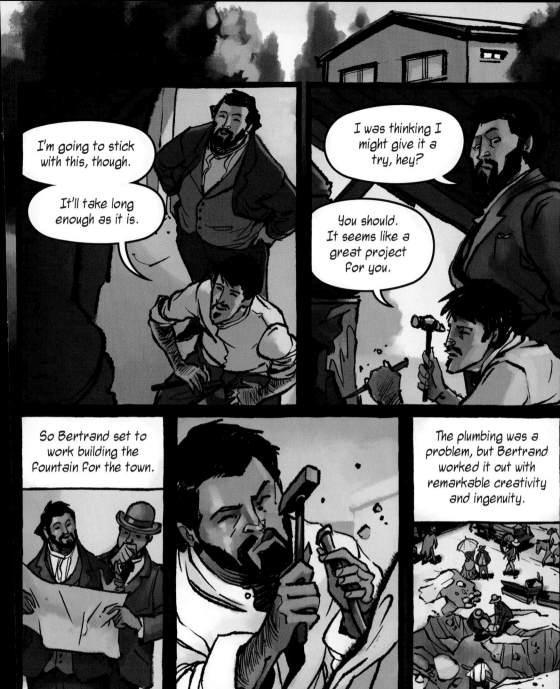

I'm going to stick with this, though.

It'll take long enough as it is.

I was thinking I might give it a try, hey?

You should. It seems like a great project for you.

So Bertrand set to work building the fountain for the town.

The plumbing was a problem, but Bertrand worked it out with remarkable creativity and ingenuity.

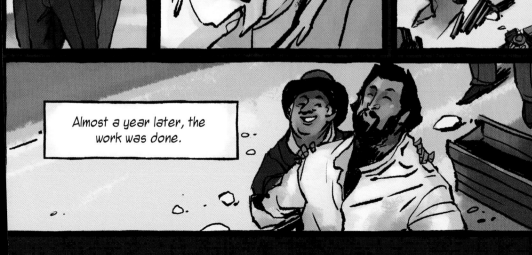

Almost a year later, the work was done.

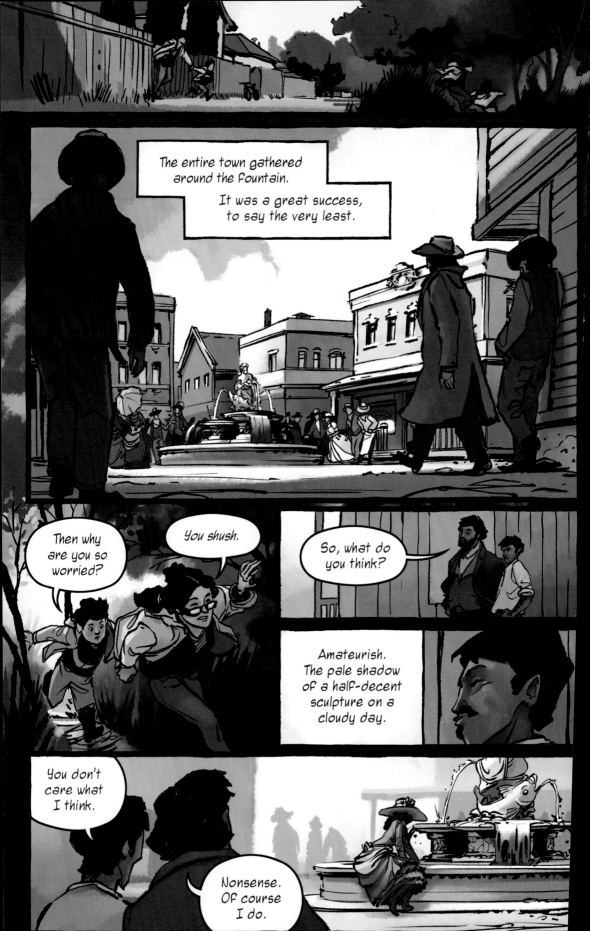

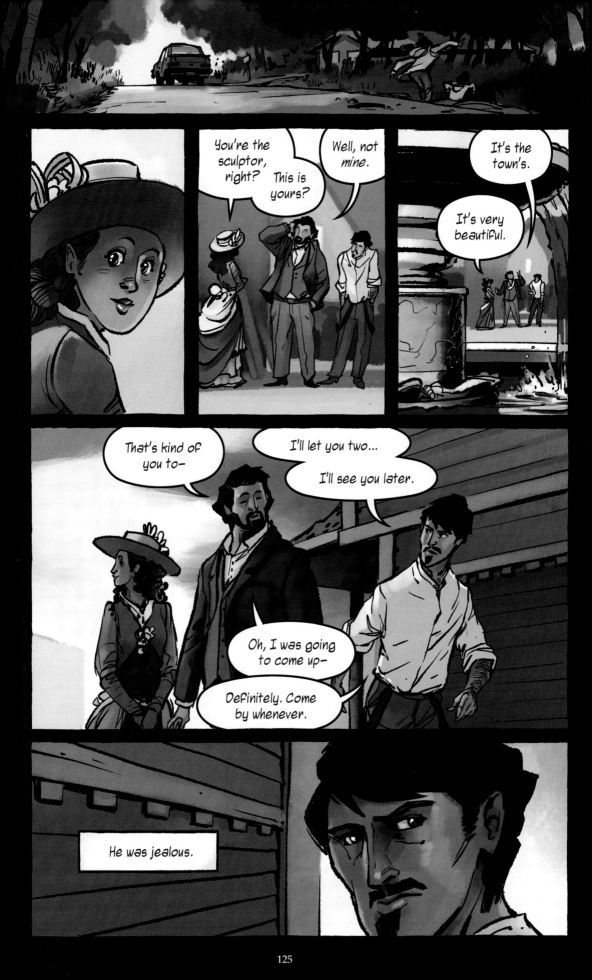

You're the sculptor, right? This is yours?

Well, not mine.

It's the town's.

It's very beautiful.

That's kind of you to–

I'll let you two... I'll see you later.

Oh, I was going to come up–

Definitely. Come by whenever.

He was jealous.

In the time since the fountain was started, the sculptor had recieved no attention for *his* work.

But then, he hadn't finished a single sculpture. He made excuses to abandon each one, to move on to something new.

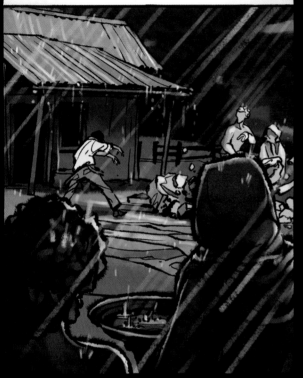

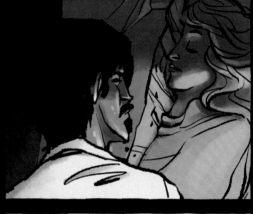

His skills *were* superior. Bertrand's cloth handling was shoddy; his decorative elements lacked definition.

Yet the fountain's appeal was undeniable. All the nearby counties hired him to make one for them, too.

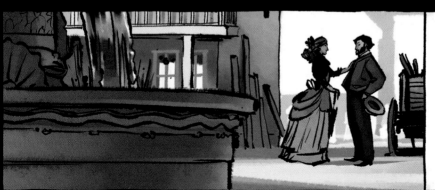

If Bertrand could do so well with such modest skill, it seemed impossible that the sculptor could not improve on that success.

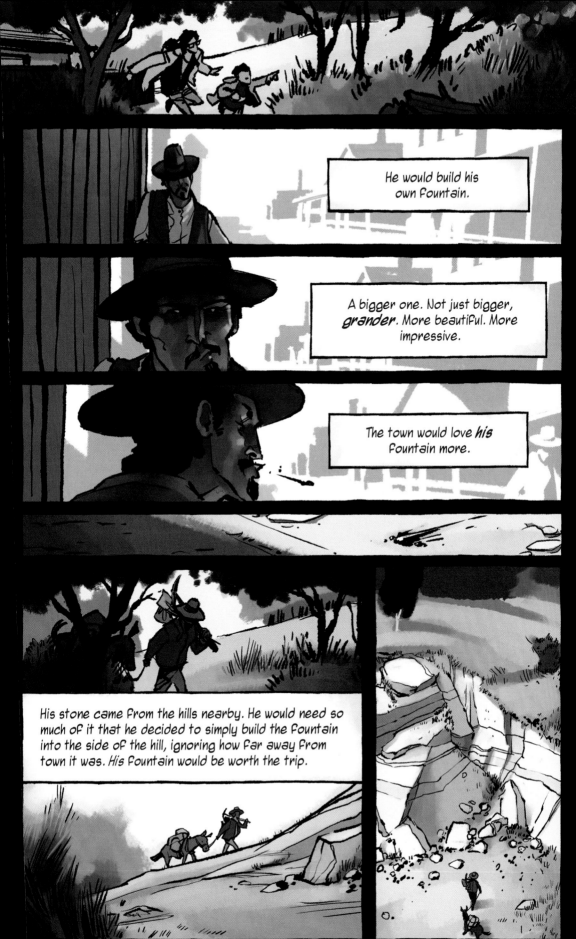

He would build his own fountain.

A bigger one. Not just bigger, *grander*. More beautiful. More impressive.

The town would love *his* fountain more.

His stone came from the hills nearby. He would need so much of it that he decided to simply build the fountain into the side of the hill, ignoring how far away from town it was. *His* fountain would be worth the trip.

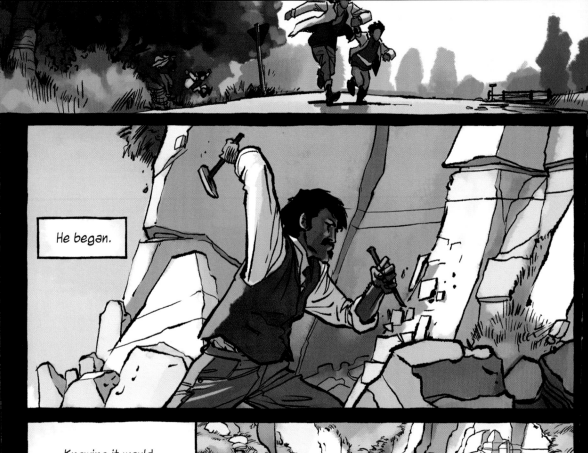

He began.

Knowing it would take a long time, he locked up his old house and set up shelter beside the rock face.

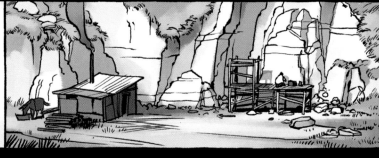

He worked until fatigue or hunger threatened to slow him down, indulging his needs only enough to keep going.

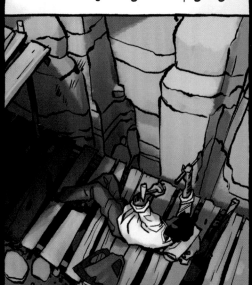

Bertrand visited whenever he was in town. He worried about the sculptor's odd behaviour, and said as much. This angered the sculptor.

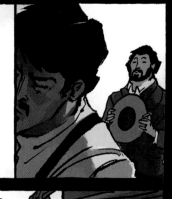

So he worked.

He needed Bertrand, though, to help with the plumbing mechanics. The sculptor knew nothing of the topic. Bertrand was relieved to be able to engage his friend's attention again.

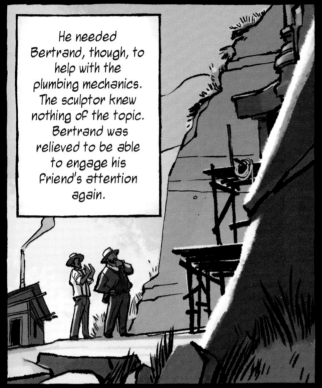

They would plumb the fountain from an aquifer below the hill.

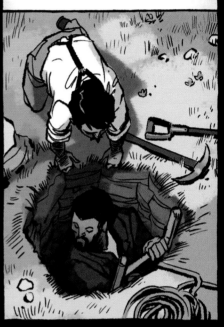

The sculptor was presented with a horrible opportunity.

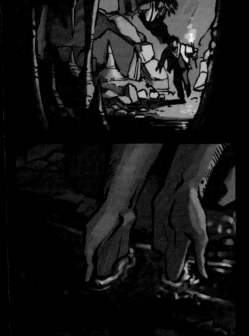

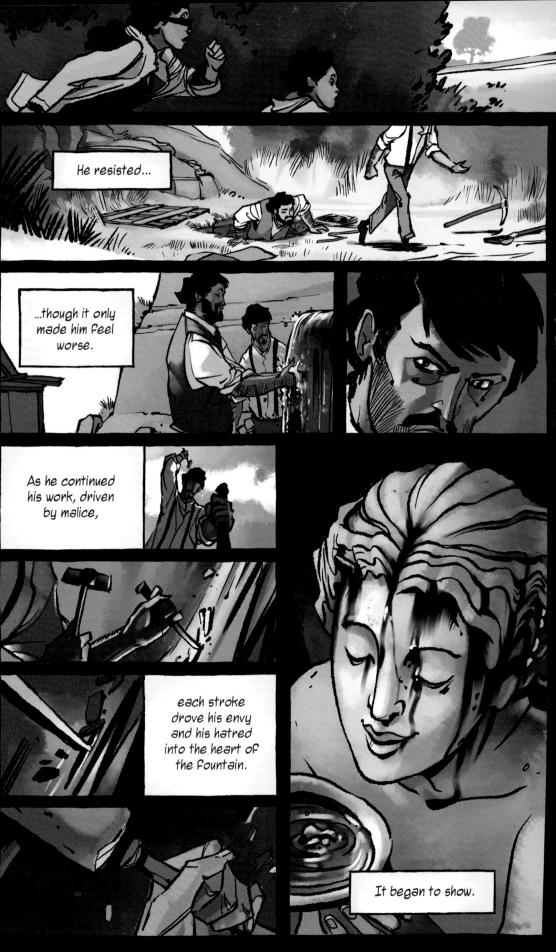

He resisted...

...though it only made him feel worse.

As he continued his work, driven by malice,

each stroke drove his envy and his hatred into the heart of the fountain.

It began to show.

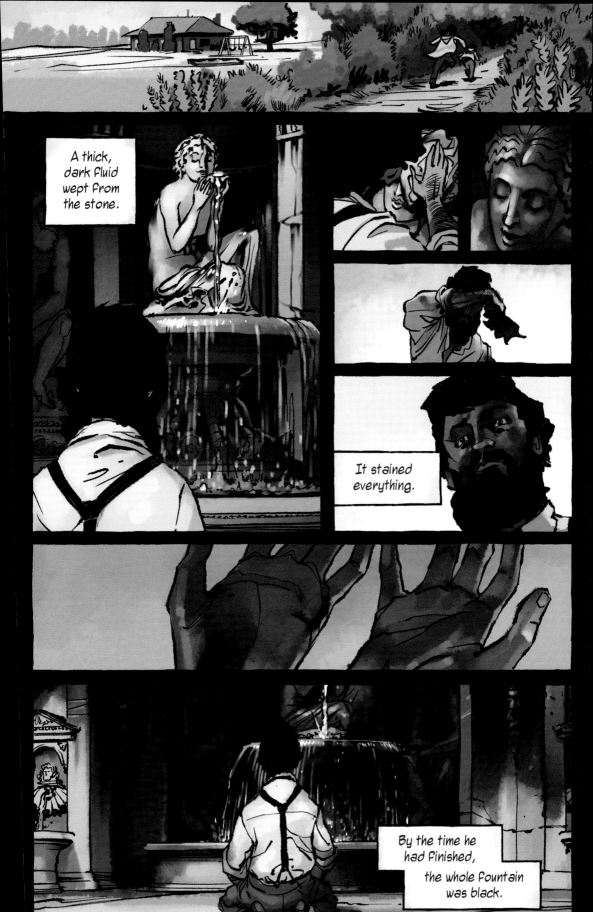

But finished it was. He returned to town.

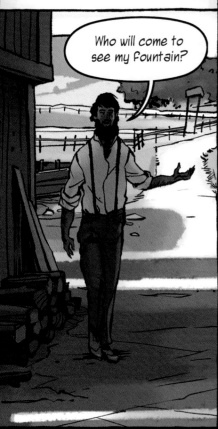

Who will come to see my fountain?

Will you?

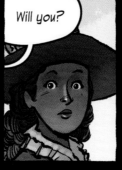

You've finished?

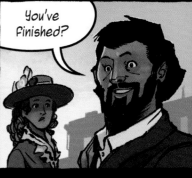

Who will come see the new fountain that my friend has made for the town?

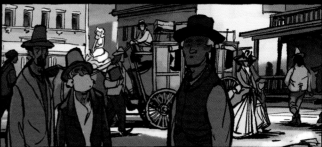

I will come to see it.

The rest of them will follow once they hear of it, I'm sure.

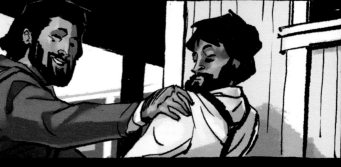

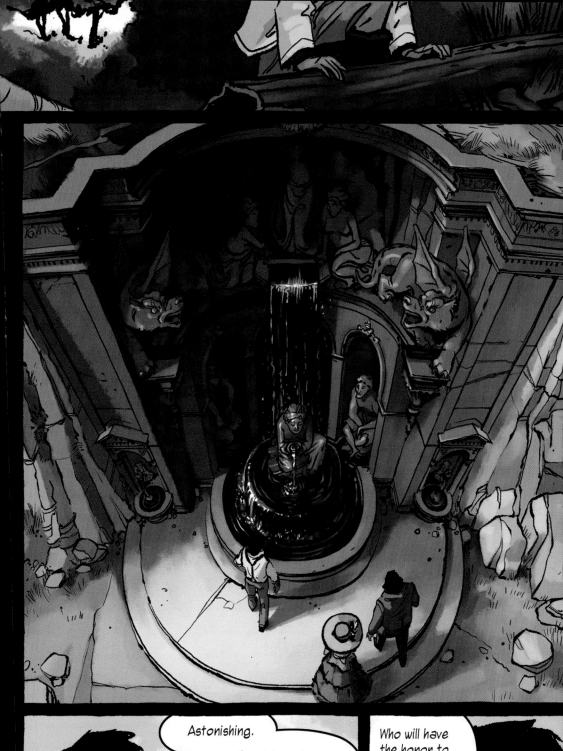

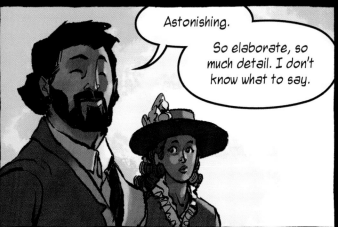

Astonishing. So elaborate, so much detail. I don't know what to say.

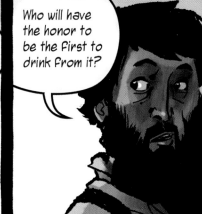

Who will have the honor to be the first to drink from it?

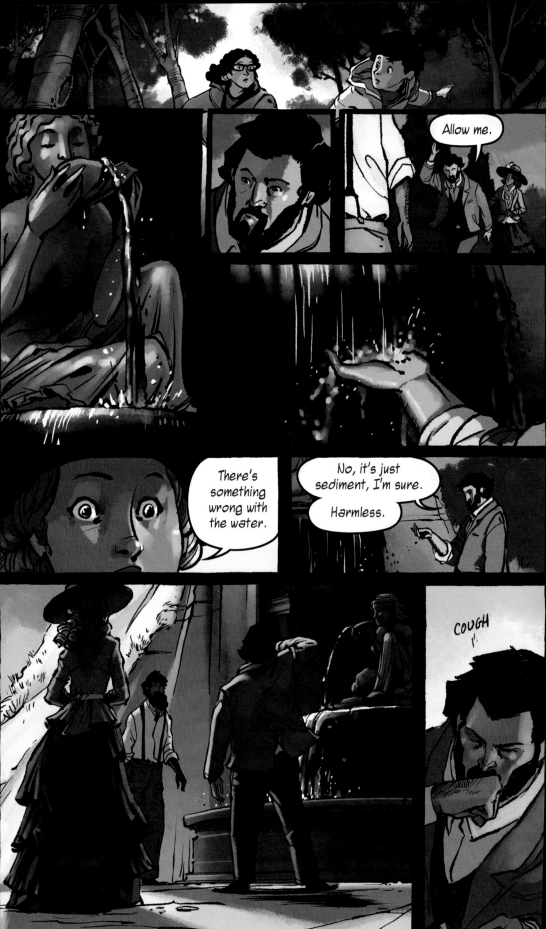

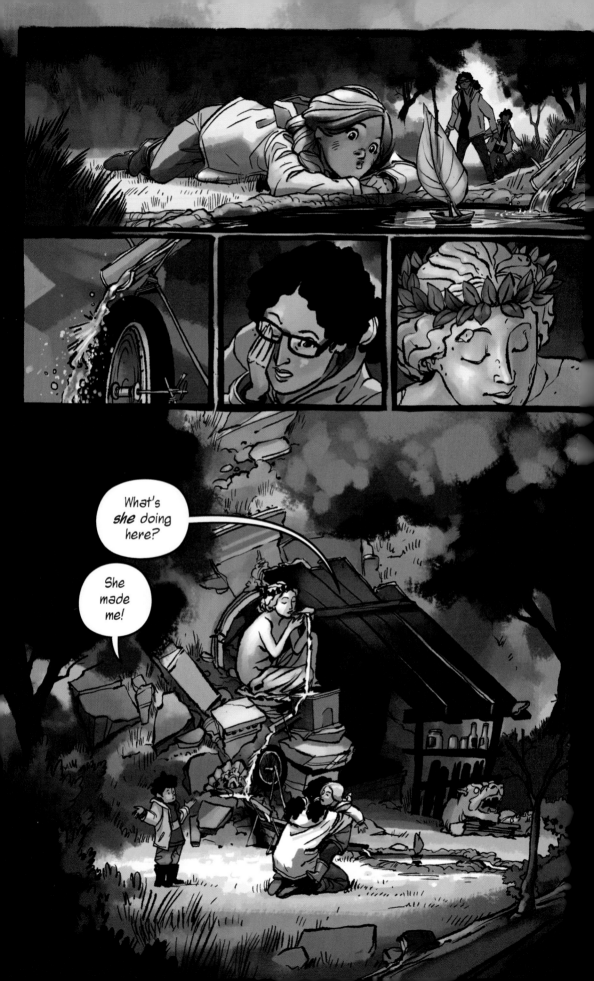

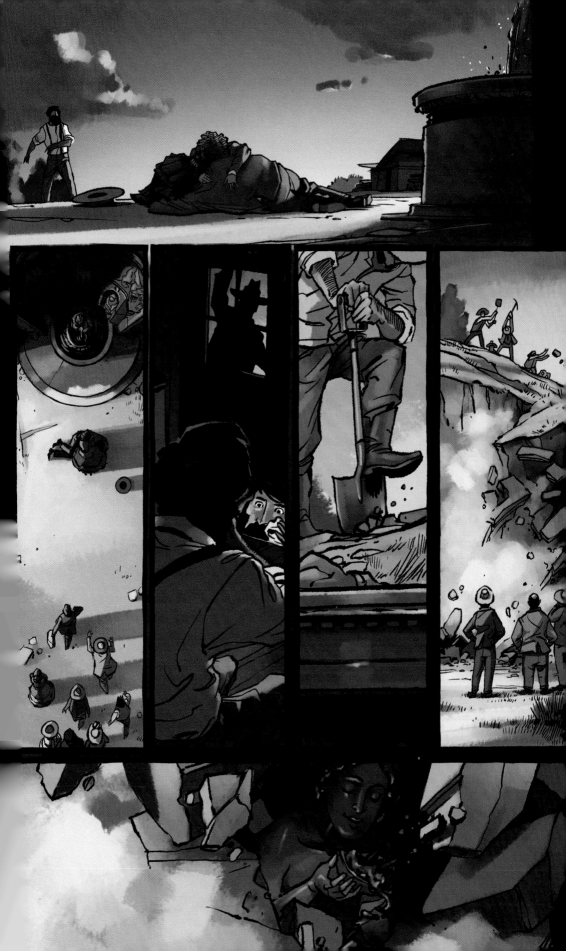

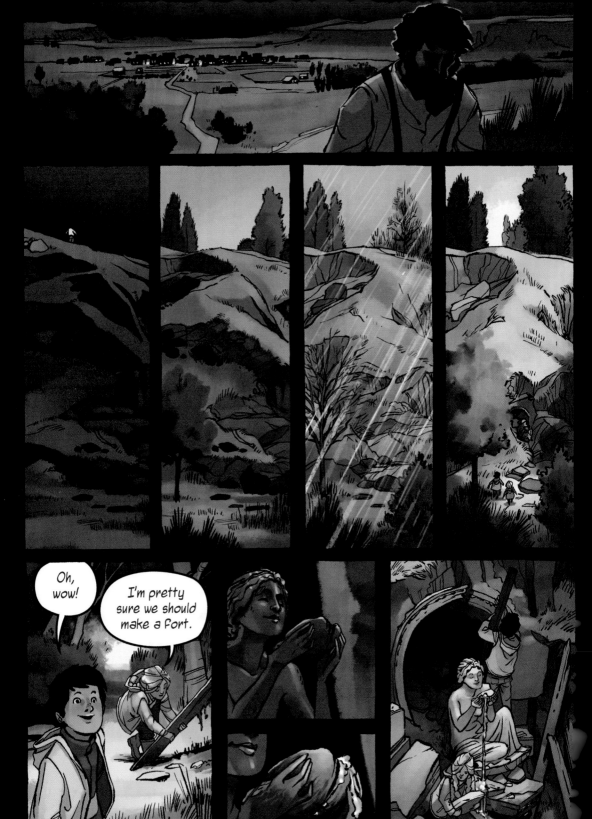

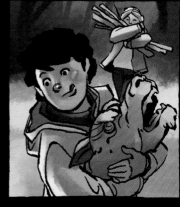
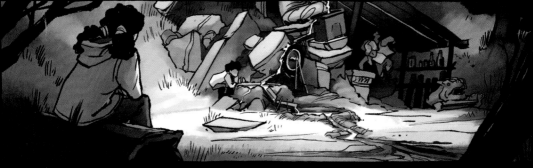

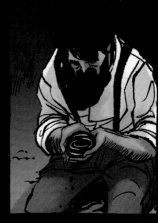

THE
END

THE COLLECTOR

Leland Myrick

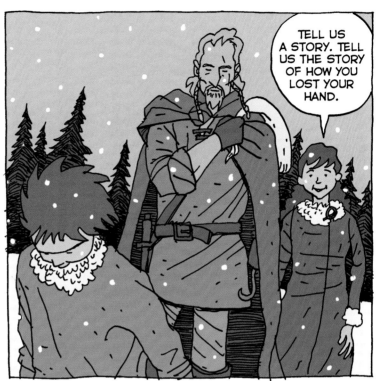

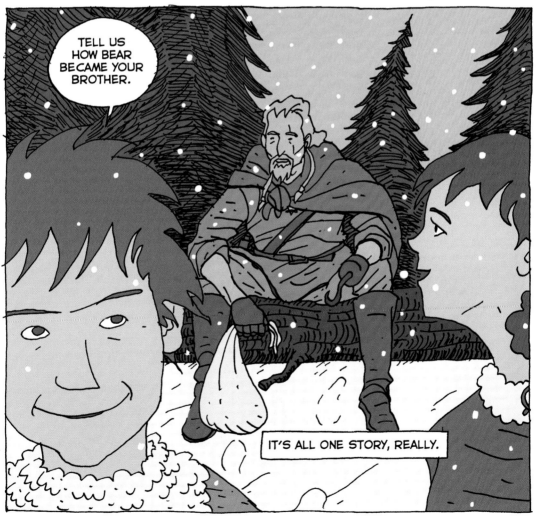

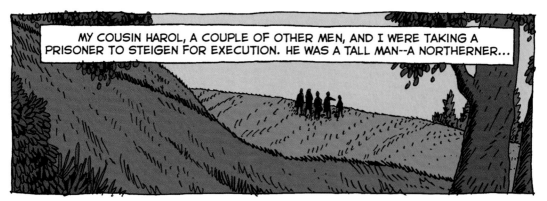

MY COUSIN HAROL, A COUPLE OF OTHER MEN, AND I WERE TAKING A PRISONER TO STEIGEN FOR EXECUTION. HE WAS A TALL MAN--A NORTHERNER...

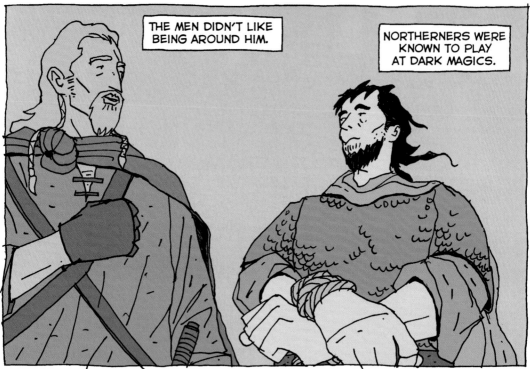

THE MEN DIDN'T LIKE BEING AROUND HIM.

NORTHERNERS WERE KNOWN TO PLAY AT DARK MAGICS.

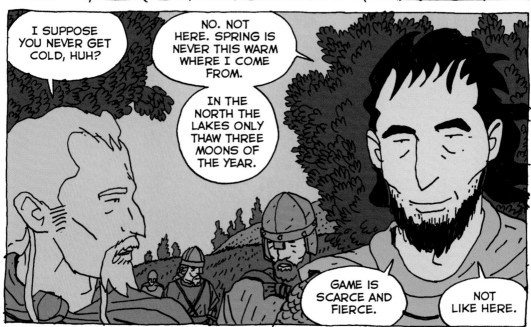

I SUPPOSE YOU NEVER GET COLD, HUH?

NO. NOT HERE. SPRING IS NEVER THIS WARM WHERE I COME FROM.

IN THE NORTH THE LAKES ONLY THAW THREE MOONS OF THE YEAR.

GAME IS SCARCE AND FIERCE.

NOT LIKE HERE.

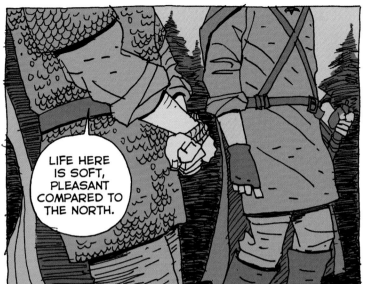

LIFE HERE IS SOFT, PLEASANT COMPARED TO THE NORTH.

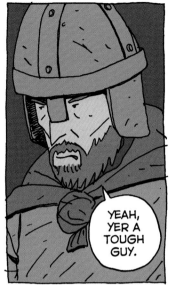

YEAH, YER A TOUGH GUY.

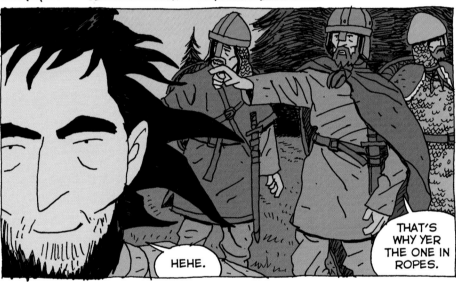

SNAP

HEHE.

THAT'S WHY YER THE ONE IN ROPES.

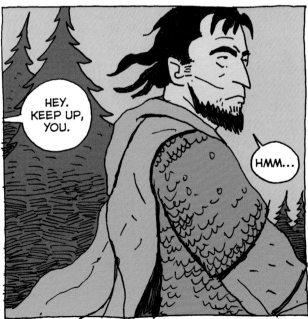

HEY. KEEP UP, YOU.

HMM...

COME ON!

143

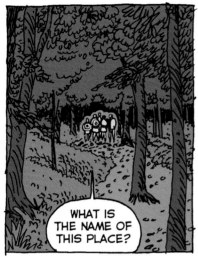

WHAT IS THE NAME OF THIS PLACE?

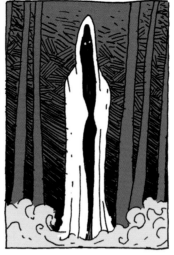

THIS FOREST? IT HAS NO NAME.

EVERY PLACE HAS A NAME, WHETHER WE KNOW IT OR NOT.

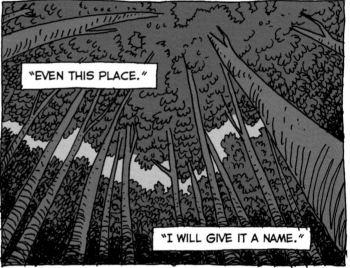

"EVEN THIS PLACE."

"I WILL GIVE IT A NAME."

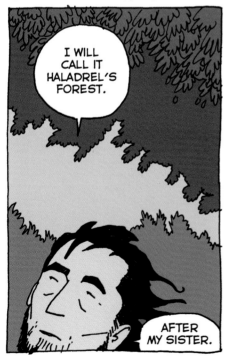

I WILL CALL IT HALADREL'S FOREST.

AFTER MY SISTER.

FOOL! YOU CAN'T GO NAMING PLACES ANY-THING YOU WANT!

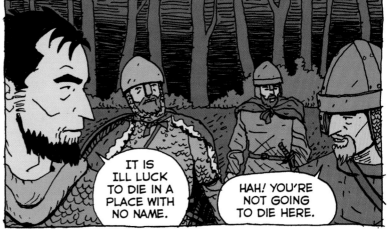

IT IS ILL LUCK TO DIE IN A PLACE WITH NO NAME.

HAH! YOU'RE NOT GOING TO DIE HERE.

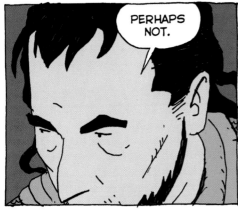

PERHAPS NOT.

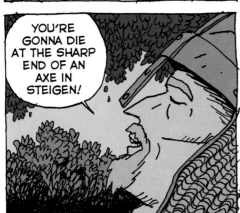

YOU'RE GONNA DIE AT THE SHARP END OF AN AXE IN STEIGEN!

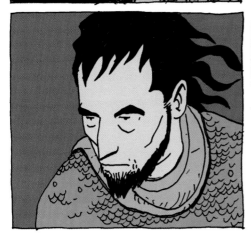

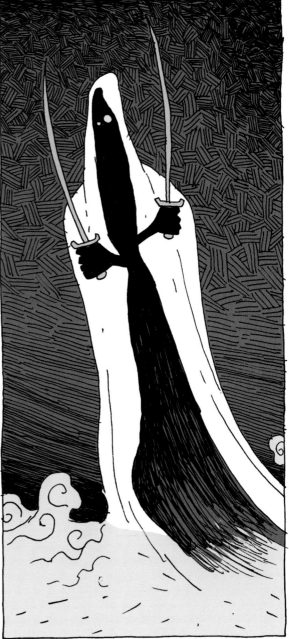

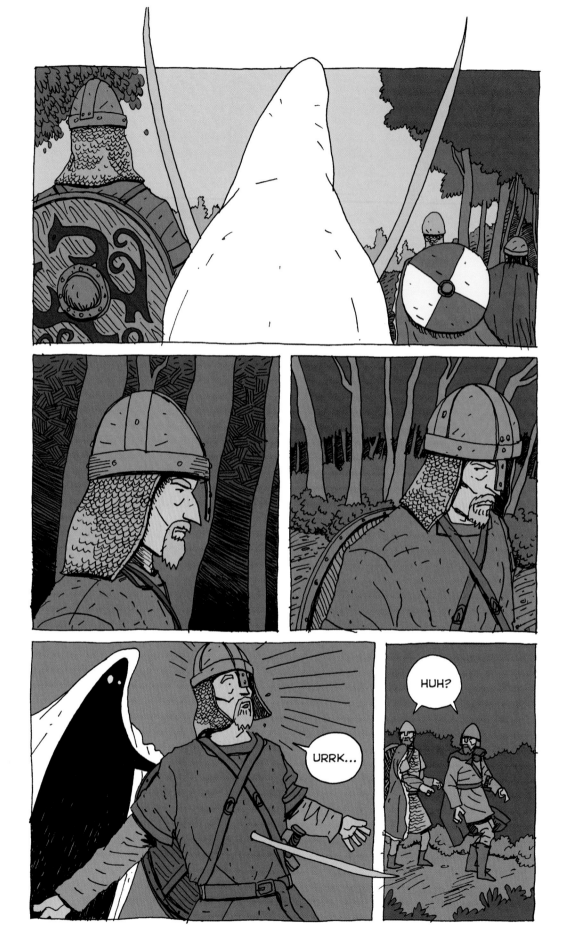

HAROL!

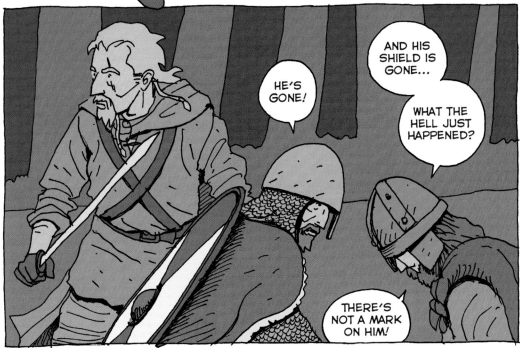

HE'S GONE!

AND HIS SHIELD IS GONE...

WHAT THE HELL JUST HAPPENED?

THERE'S NOT A MARK ON HIM!

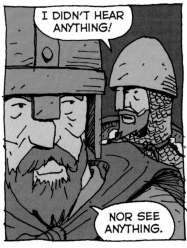

I DIDN'T HEAR ANYTHING!

NOR SEE ANYTHING.

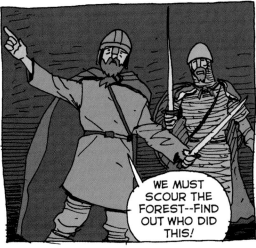

WE MUST SCOUR THE FOREST--FIND OUT WHO DID THIS!

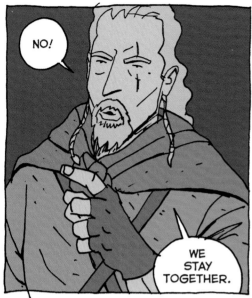

NO!

WE STAY TOGETHER.

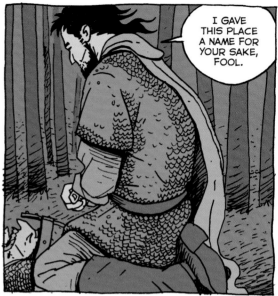

I GAVE THIS PLACE A NAME FOR YOUR SAKE, FOOL.

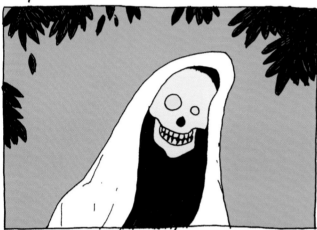

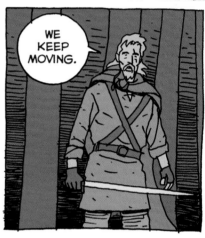

WE KEEP MOVING.

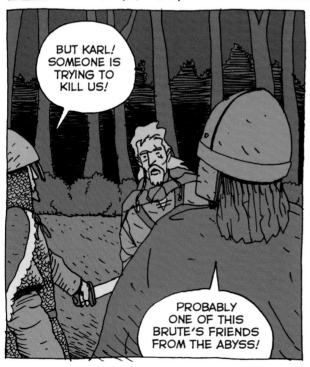

BUT KARL! SOMEONE IS TRYING TO KILL US!

PROBABLY ONE OF THIS BRUTE'S FRIENDS FROM THE ABYSS!

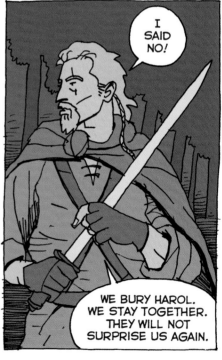

I SAID NO!

WE BURY HAROL. WE STAY TOGETHER. THEY WILL NOT SURPRISE US AGAIN.

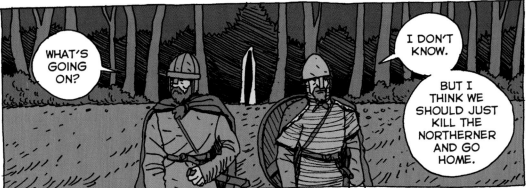

WHAT'S GOING ON?

I DON'T KNOW.

BUT I THINK WE SHOULD JUST KILL THE NORTHERNER AND GO HOME.

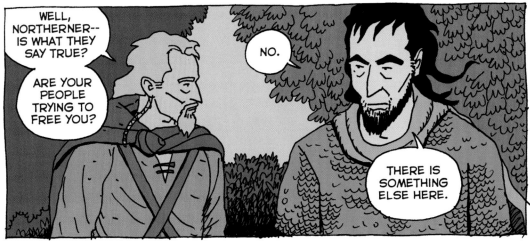

WELL, NORTHERNER-- IS WHAT THEY SAY TRUE?

ARE YOUR PEOPLE TRYING TO FREE YOU?

NO.

THERE IS SOMETHING ELSE HERE.

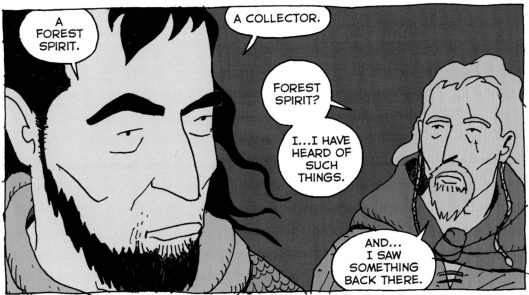

A FOREST SPIRIT.

A COLLECTOR.

FOREST SPIRIT?

I...I HAVE HEARD OF SUCH THINGS.

AND... I SAW SOMETHING BACK THERE.

FEW THAT SEE ONE LIVE TO TELL ABOUT IT.

AND I BELIEVE THIS ONE WISHES US ALL DEAD.

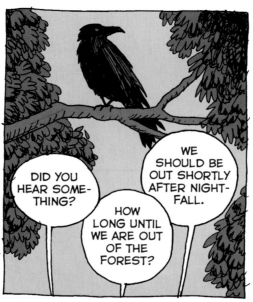

DID YOU HEAR SOMETHING?

HOW LONG UNTIL WE ARE OUT OF THE FOREST?

WE SHOULD BE OUT SHORTLY AFTER NIGHTFALL.

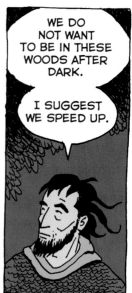

WE DO NOT WANT TO BE IN THESE WOODS AFTER DARK.

I SUGGEST WE SPEED UP.

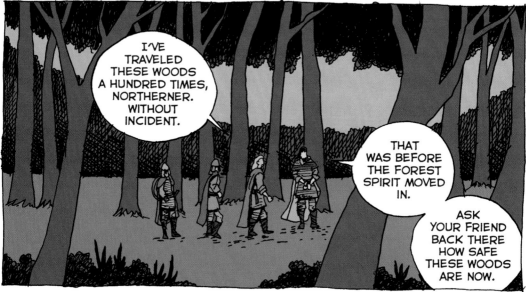

I'VE TRAVELED THESE WOODS A HUNDRED TIMES, NORTHERNER. WITHOUT INCIDENT.

THAT WAS BEFORE THE FOREST SPIRIT MOVED IN.

ASK YOUR FRIEND BACK THERE HOW SAFE THESE WOODS ARE NOW.

ALL RIGHT! PICK UP THE PACE!

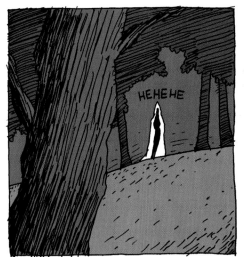

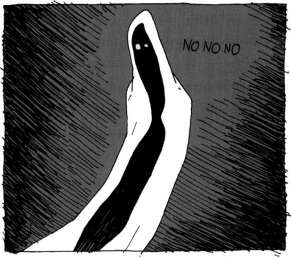

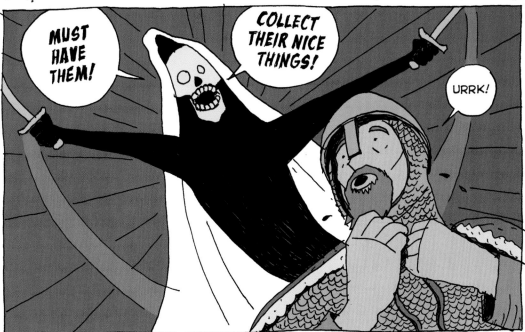

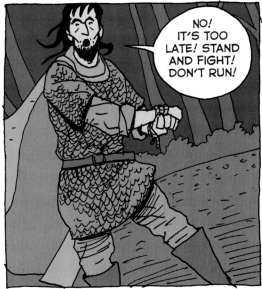

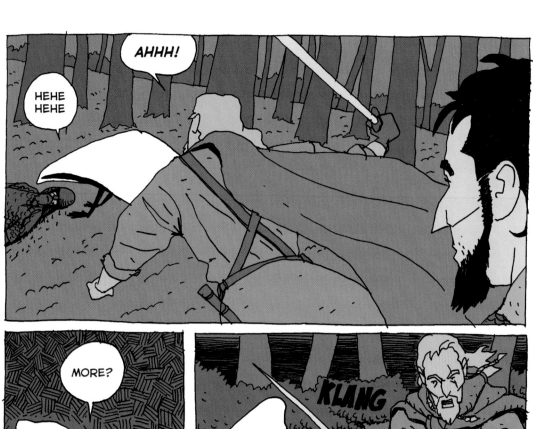

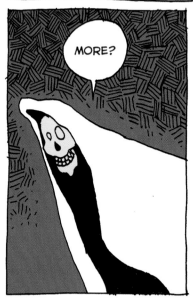

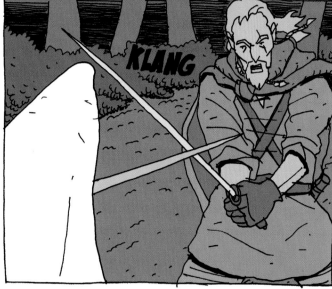

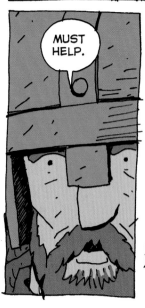

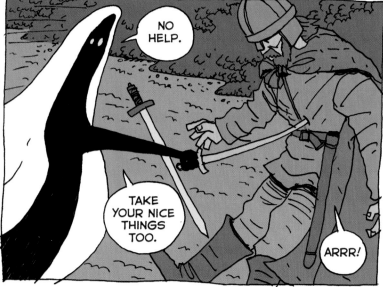

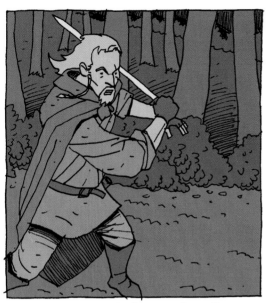

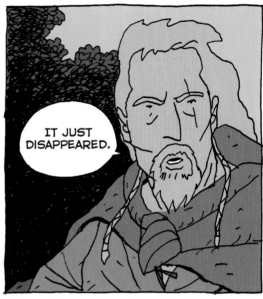

IT JUST DISAPPEARED.

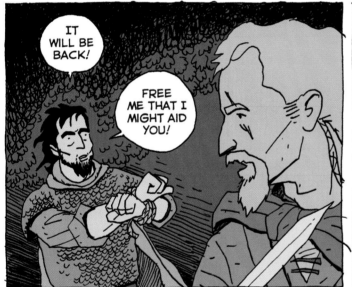

IT WILL BE BACK!

FREE ME THAT I MIGHT AID YOU!

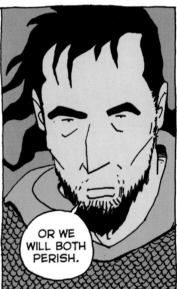

OR WE WILL BOTH PERISH.

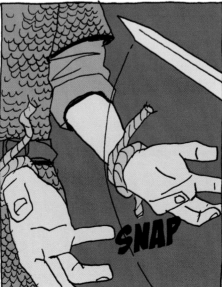

SNAP

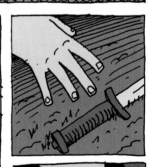

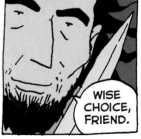

WISE CHOICE, FRIEND.

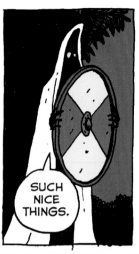

SUCH NICE THINGS.

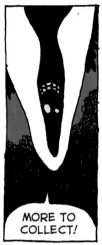

MORE TO COLLECT!

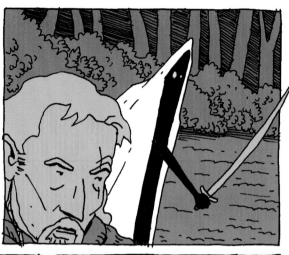

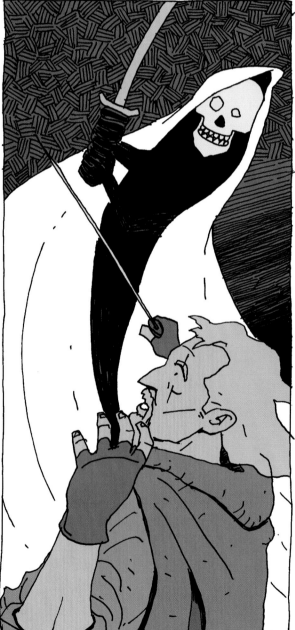

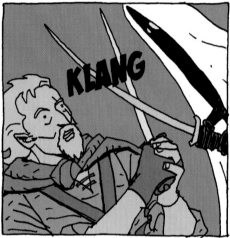

KLANG

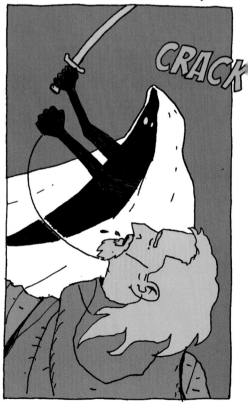

CRACK

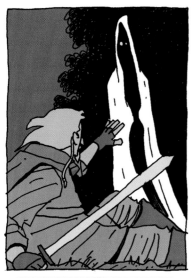
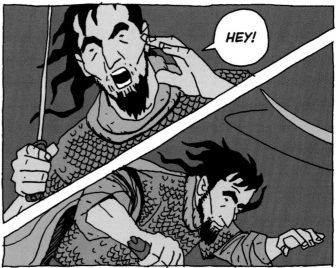
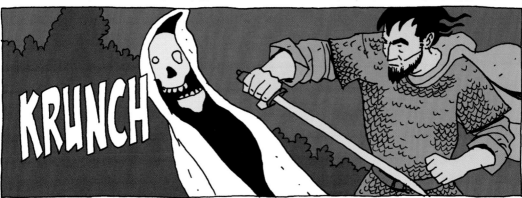
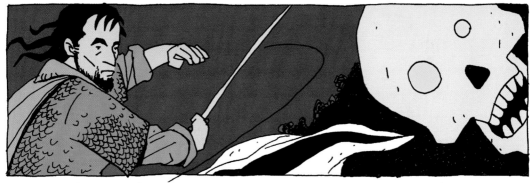

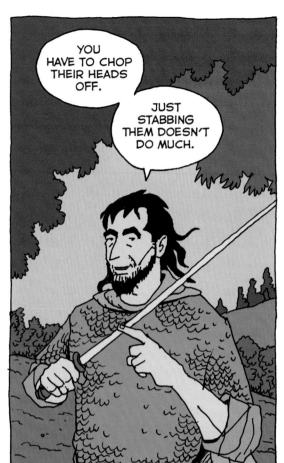

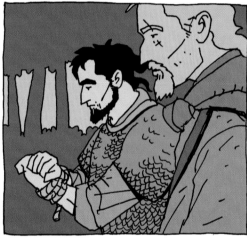

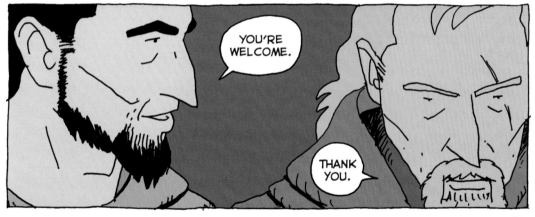

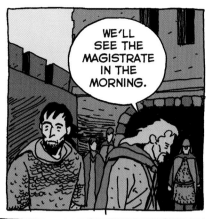

WE'LL SEE THE MAGISTRATE IN THE MORNING.

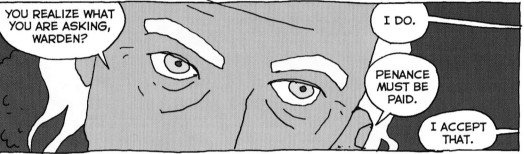

YOU REALIZE WHAT YOU ARE ASKING, WARDEN?

I DO.

PENANCE MUST BE PAID.

I ACCEPT THAT.

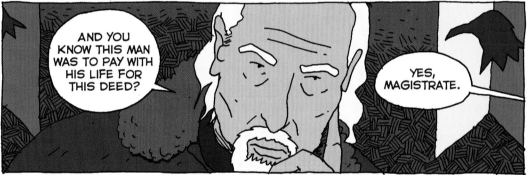

AND YOU KNOW THIS MAN WAS TO PAY WITH HIS LIFE FOR THIS DEED?

YES, MAGISTRATE.

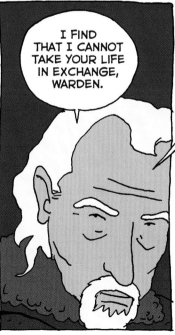

I FIND THAT I CANNOT TAKE YOUR LIFE IN EXCHANGE, WARDEN.

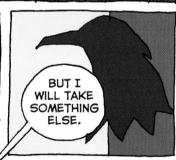

BUT I WILL TAKE SOMETHING ELSE.

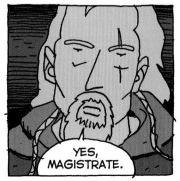

YES, MAGISTRATE.

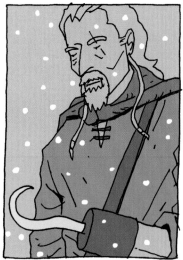

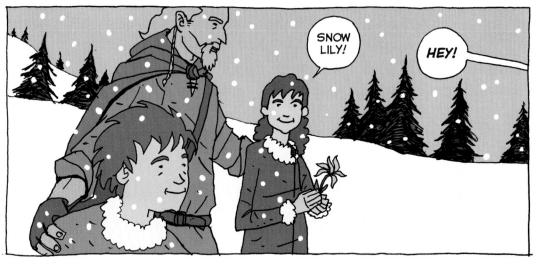

SNOW LILY!

HEY!

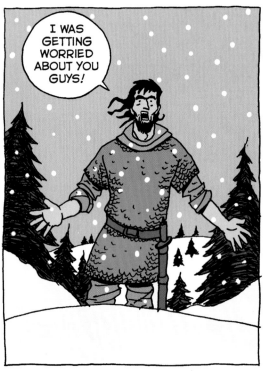

I WAS GETTING WORRIED ABOUT YOU GUYS!

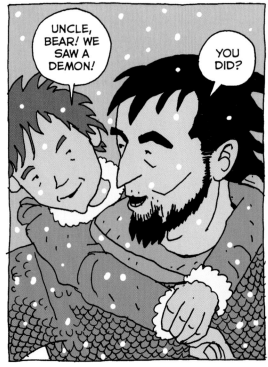

UNCLE, BEAR! WE SAW A DEMON!

YOU DID?

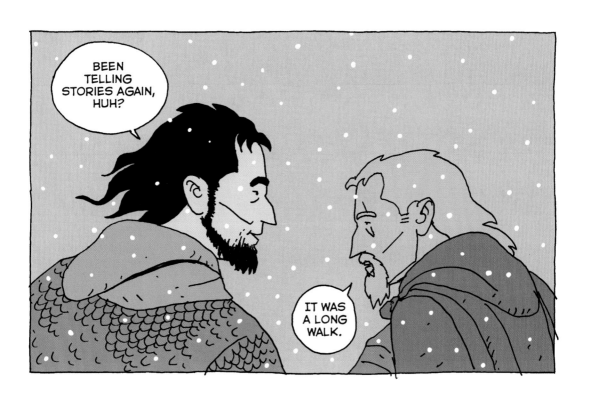

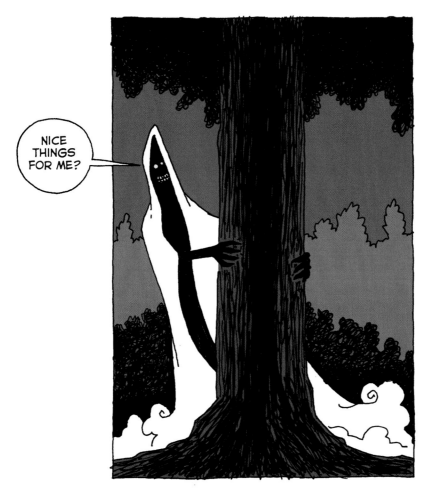

NEW YEAR'S DAY
a MALINKY ROBOT
story

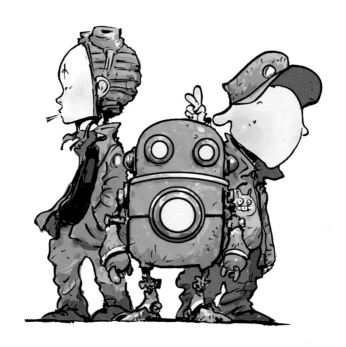

by sonny liew

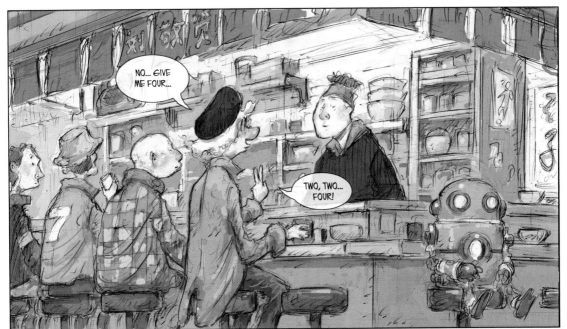

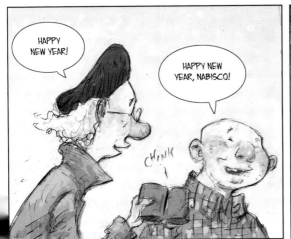

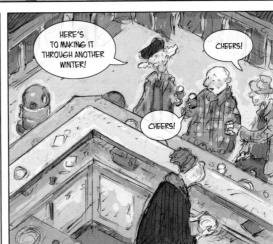

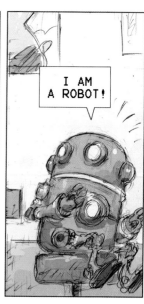

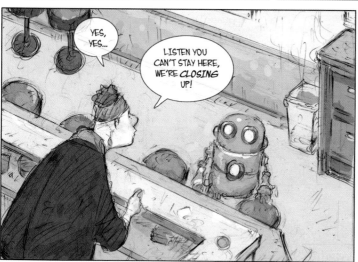

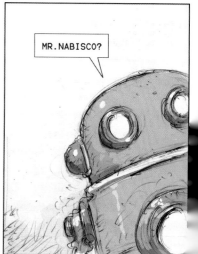

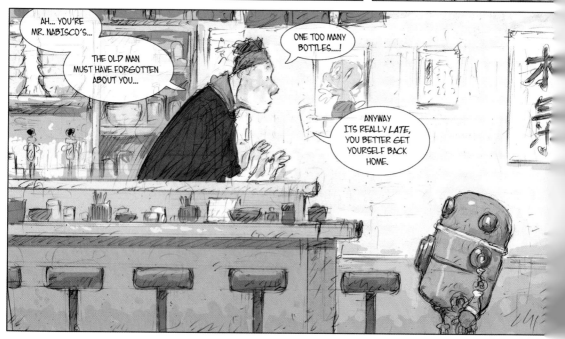

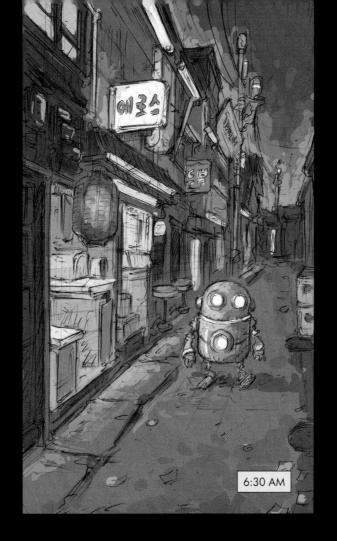

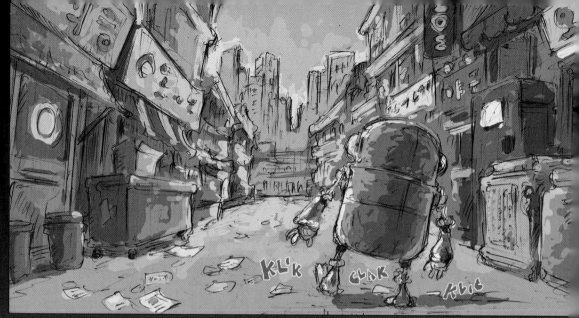

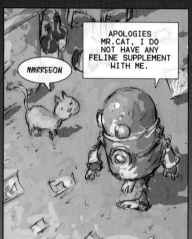

APOLOGIES MR. CAT, I DO NOT HAVE ANY FELINE SUPPLEMENT WITH ME.

MMRREEOW

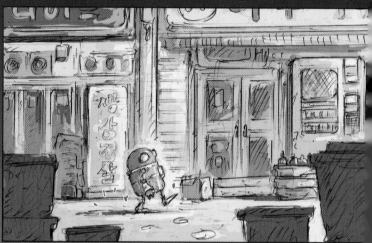

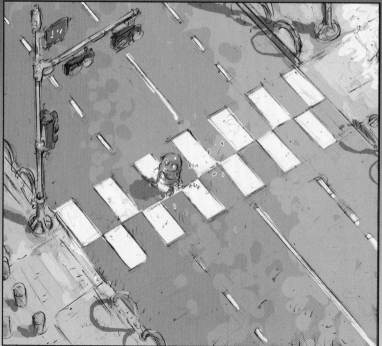

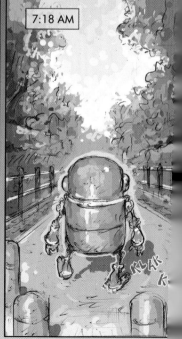

7:18 AM

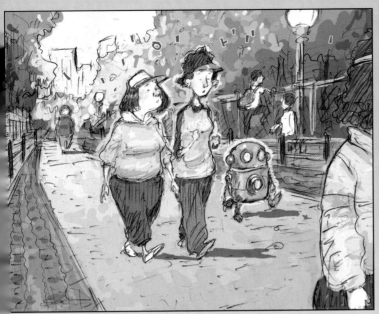
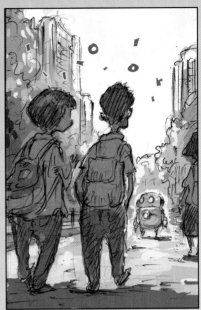
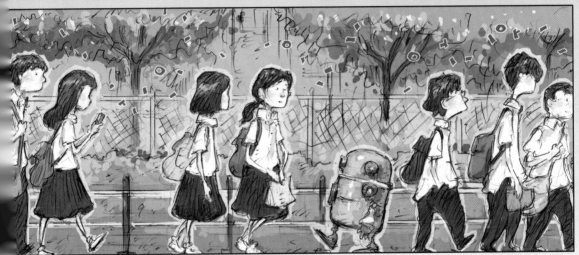
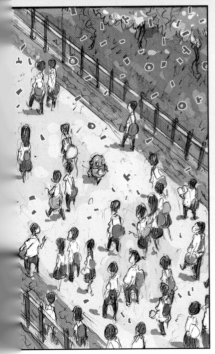
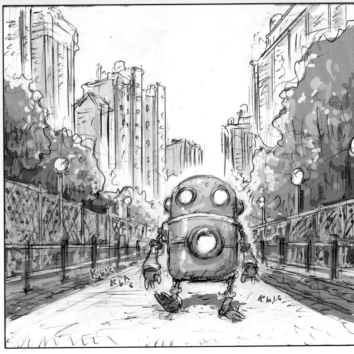

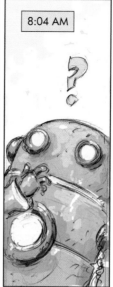

8:04 AM

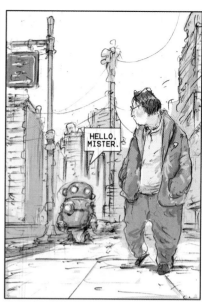

HELLO, MISTER.

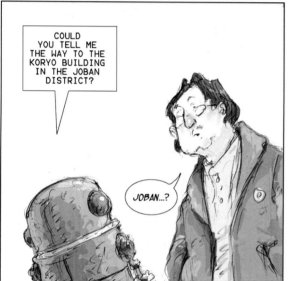

COULD YOU TELL ME THE WAY TO THE KORYO BUILDING IN THE JOBAN DISTRICT?

JOBAN...?

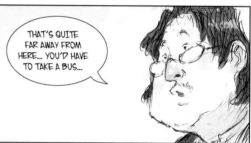

THAT'S QUITE FAR AWAY FROM HERE... YOU'D HAVE TO TAKE A BUS...

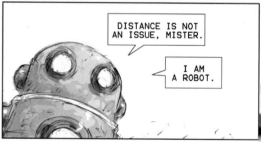

DISTANCE IS NOT AN ISSUE, MISTER.

I AM A ROBOT.

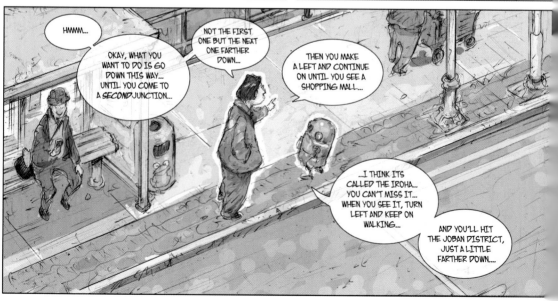

HMMM...

OKAY, WHAT YOU WANT TO DO IS GO DOWN THIS WAY... UNTIL YOU COME TO A SECOND JUNCTION...

NOT THE FIRST ONE BUT THE NEXT ONE FARTHER DOWN...

THEN YOU MAKE A LEFT AND CONTINUE ON UNTIL YOU SEE A SHOPPING MALL...

...I THINK ITS CALLED THE IROHA... YOU CAN'T MISS IT... WHEN YOU SEE IT, TURN LEFT AND KEEP ON WALKING...

AND YOU'LL HIT THE JOBAN DISTRICT, JUST A LITTLE FARTHER DOWN...

166

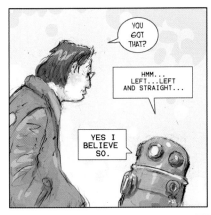

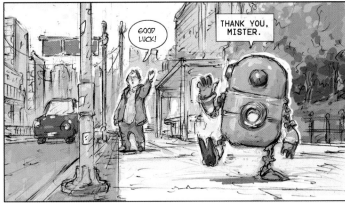

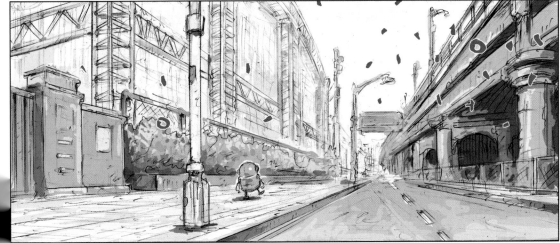

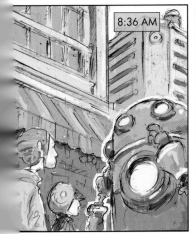 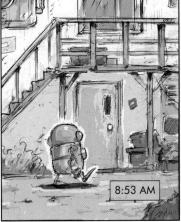 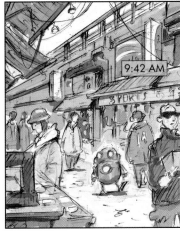

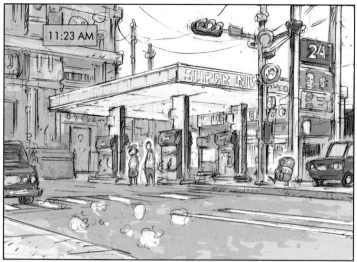

11:23 AM

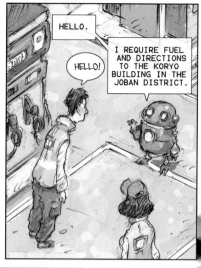

HELLO.

I REQUIRE FUEL AND DIRECTIONS TO THE KORYO BUILDING IN THE JOBAN DISTRICT.

HELLO!

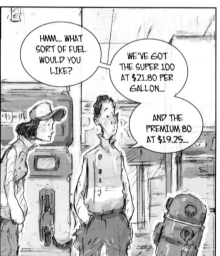

HMM... WHAT SORT OF FUEL WOULD YOU LIKE?

WE'VE GOT THE SUPER 100 AT $21.80 PER GALLON...

AND THE PREMIUM 80 AT $19.25....

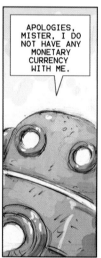

APOLOGIES, MISTER, I DO NOT HAVE ANY MONETARY CURRENCY WITH ME.

ER... THEN...

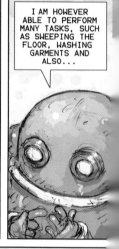

I AM HOWEVER ABLE TO PERFORM MANY TASKS, SUCH AS SWEEPING THE FLOOR, WASHING GARMENTS AND ALSO...

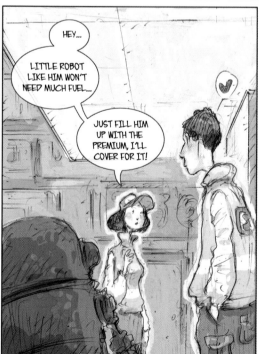

HEY...

LITTLE ROBOT LIKE HIM WON'T NEED MUCH FUEL...

JUST FILL HIM UP WITH THE PREMIUM, I'LL COVER FOR IT!

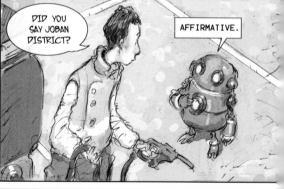

DID YOU SAY JOBAN DISTRICT?

AFFIRMATIVE.

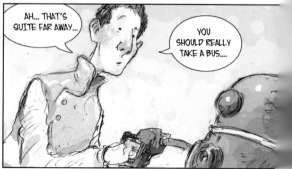

AH... THAT'S QUITE FAR AWAY...

YOU SHOULD REALLY TAKE A BUS....

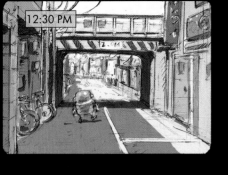

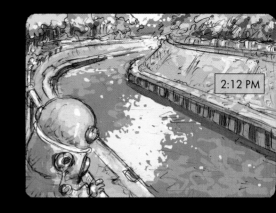

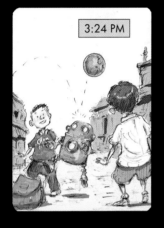

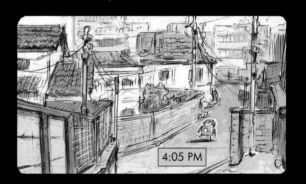

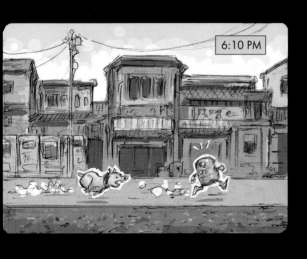

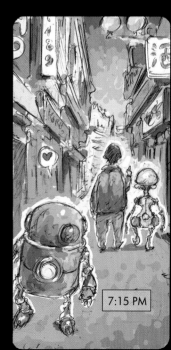

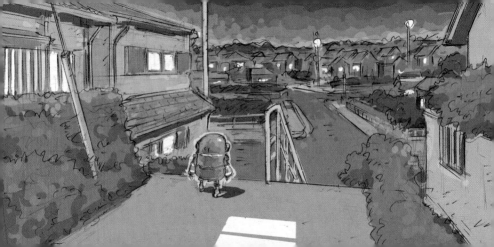

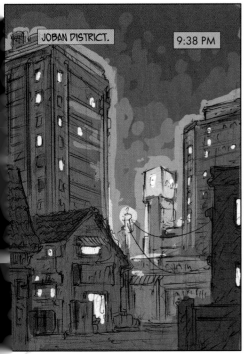

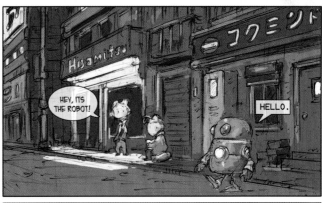

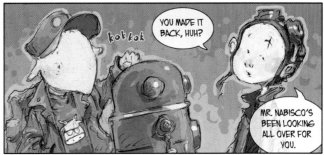

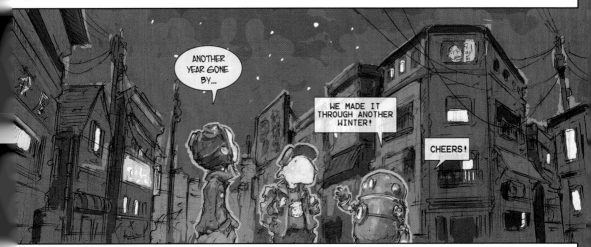

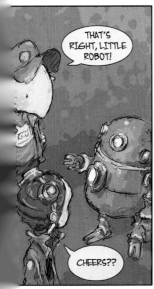

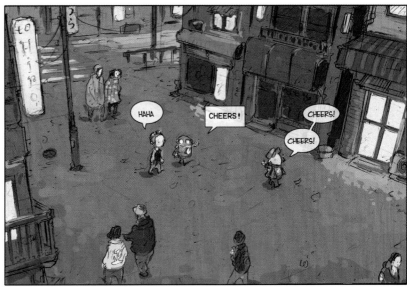

END

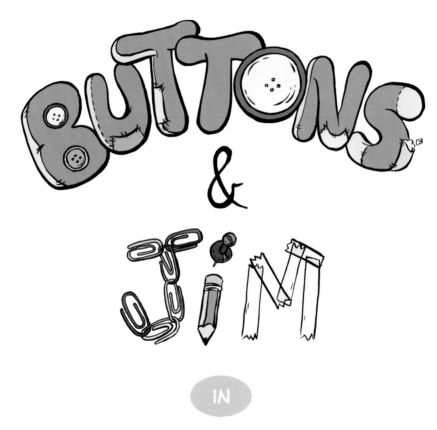

WHAT'S STOPPING THE GRAVY TRAIN?

BY:

KATIE (ART) AND STEVEN (STORY)

SHANAHAN

SPECIAL (COLOR MAGIC) THANKS TO:

GERRY DUCHEMIN AND JASON CAFFOE

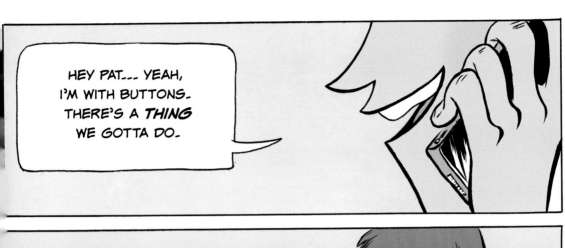

HEY PAT... YEAH, I'M WITH BUTTONS. THERE'S A *THING* WE GOTTA DO.

ANYONE ASKS....AH.... TELL THEM THAT I TOOK AN EARLY LUNCH.

NO, SHOULDN'T BE MORE THAN AN HOUR. RIGHT. THANKS MAN, SEE YA.

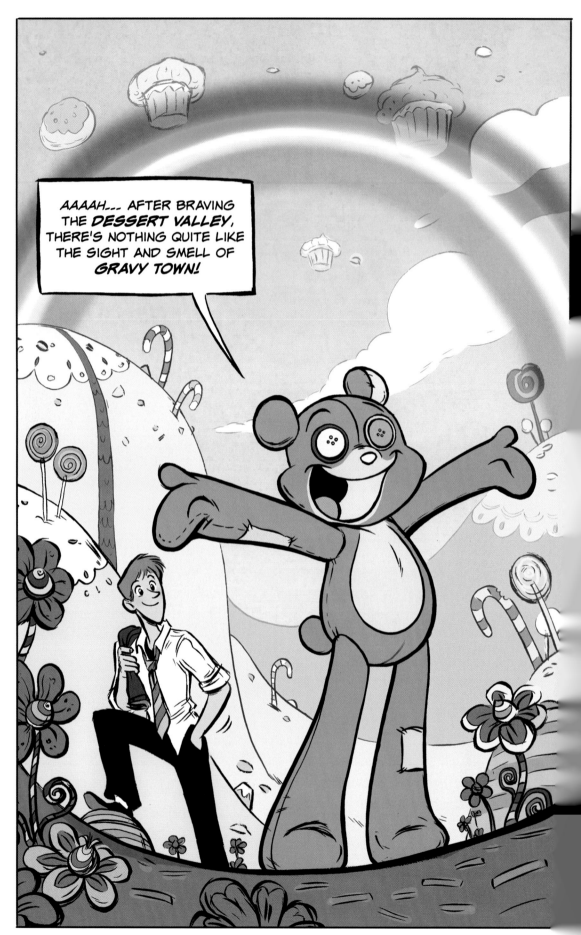

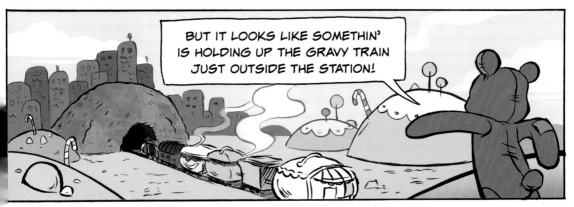

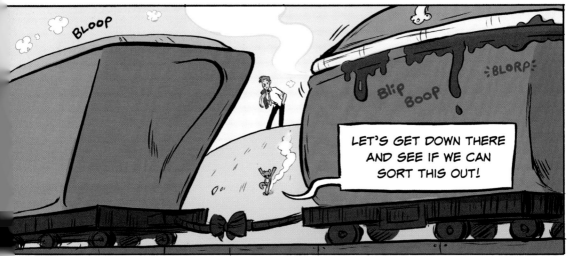

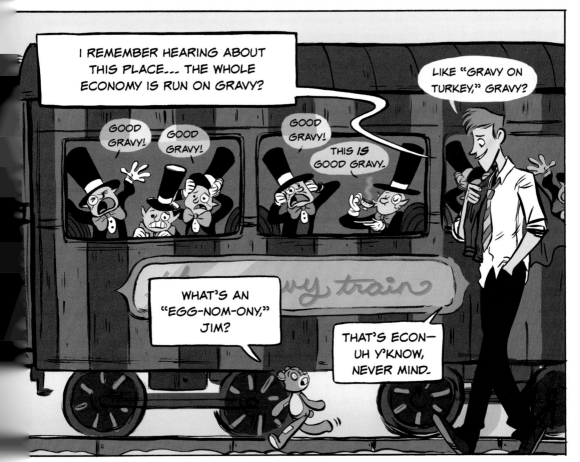

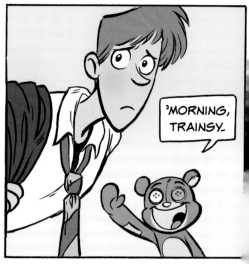

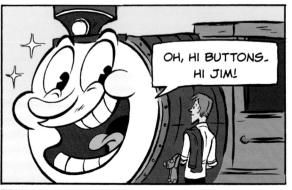

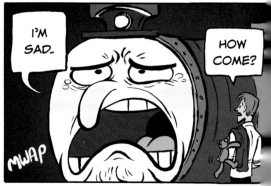

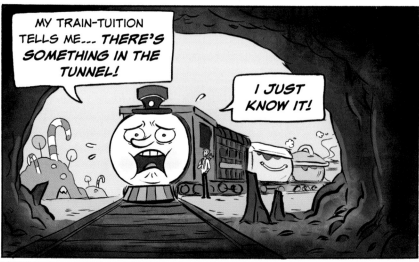

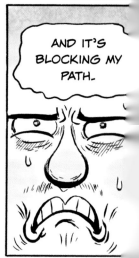

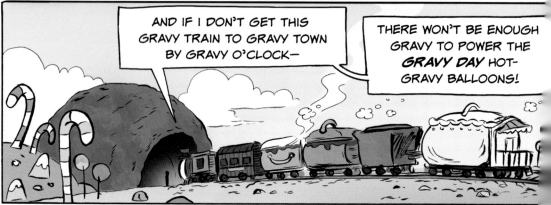

THAT'S ROUGH, DUDE.

sniff!

WHATCHA THINK IS IN THERE?

AN ELE-PHANT?

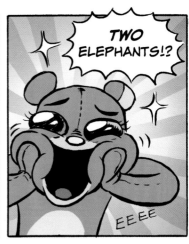

TWO ELEPHANTS!?

EE EE

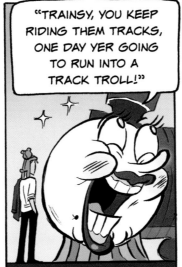

KNOWING MY LUCK IT'S PROBABLY A *TRACK TROLL.* MOTHER ALWAYS SAID...

"TRAINSY, YOU KEEP RIDING THEM TRACKS, ONE DAY YER GOING TO RUN INTO A TRACK TROLL!"

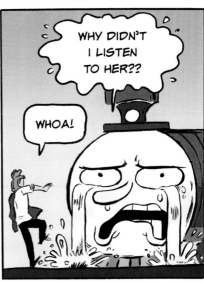

WHY DIDN'T I LISTEN TO HER??

WHOA!

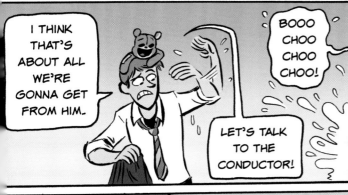

I THINK THAT'S ABOUT ALL WE'RE GONNA GET FROM HIM.

BOOO CHOO CHOO CHOO!

LET'S TALK TO THE CONDUCTOR!

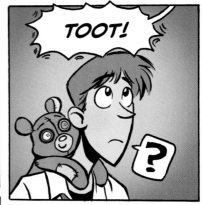

TOOT!

?

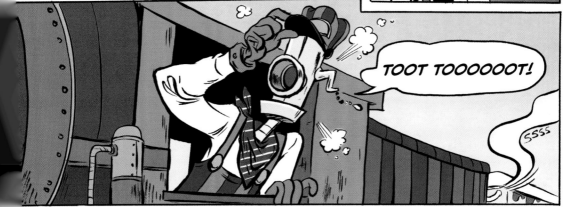

TOOT TOOOOOOT!

SSSS

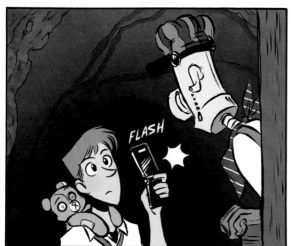

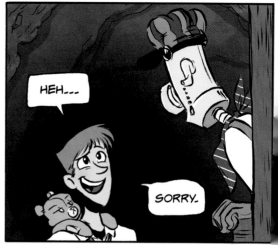

HEH...

SORRY.

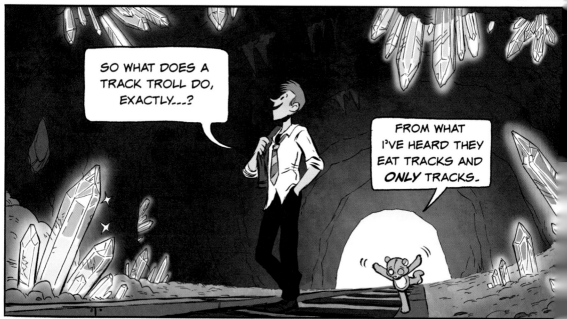

SO WHAT DOES A TRACK TROLL DO, EXACTLY...?

FROM WHAT I'VE HEARD THEY EAT TRACKS AND *ONLY* TRACKS.

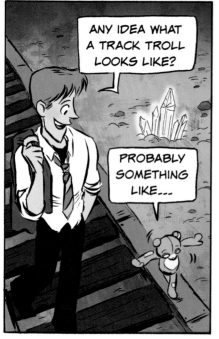

ANY IDEA WHAT A TRACK TROLL LOOKS LIKE?

PROBABLY SOMETHING LIKE...

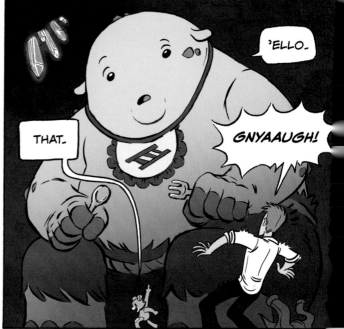

'ELLO.

THAT.

GNYAAUGH!

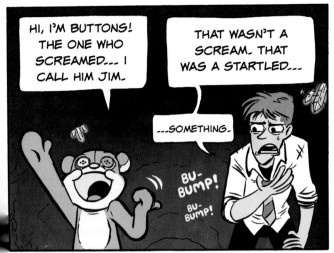

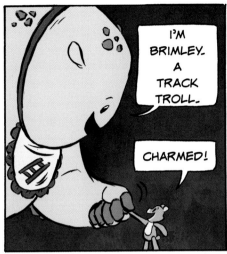

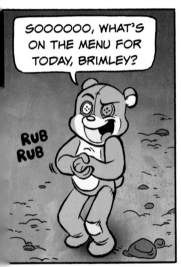

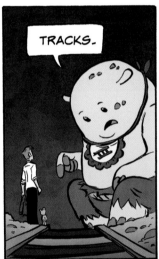

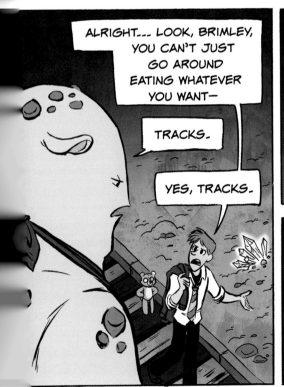

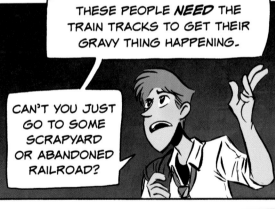

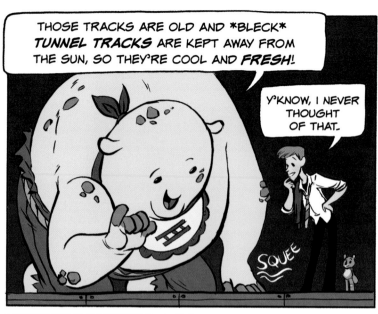

THOSE TRACKS ARE OLD AND *BLECK* *TUNNEL TRACKS* ARE KEPT AWAY FROM THE SUN, SO THEY'RE COOL AND *FRESH!*

Y'KNOW, I NEVER THOUGHT OF THAT...

SQUEE

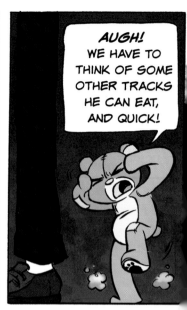

AUGH! WE HAVE TO THINK OF SOME OTHER TRACKS HE CAN EAT, AND QUICK!

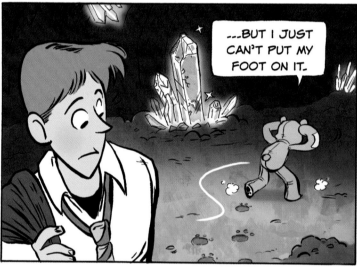

...BUT I JUST CAN'T PUT MY FOOT ON IT...

HMM...

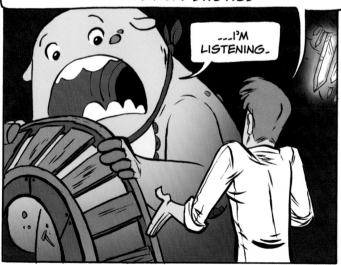

SAY, BRIMLEY, BEFORE YOU FILL YOURSELF ON THOSE *BORING* OLD STEEL TRACKS, COULD I INTEREST YOU IN CONSIDERING SOMETHING A LITTLE MORE *EXOTIC?*

...I'M LISTENING...

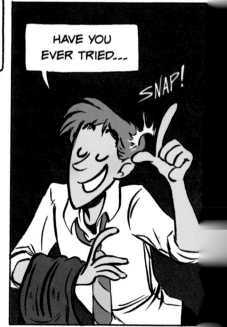

HAVE YOU EVER TRIED...

SNAP!

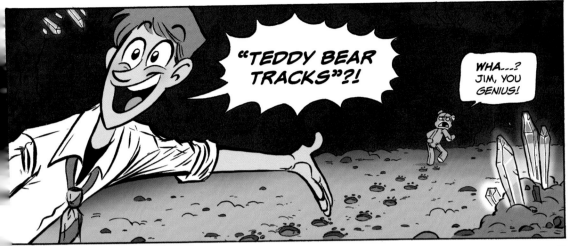

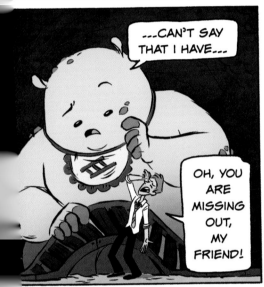

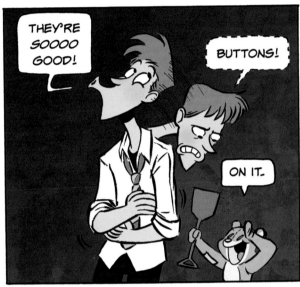

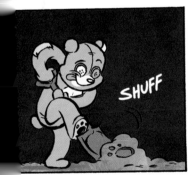

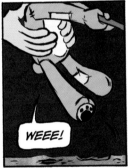

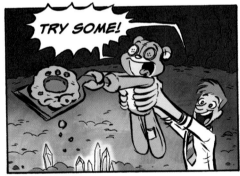

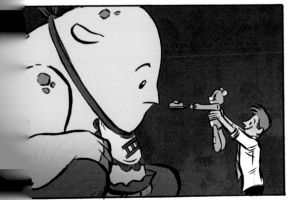

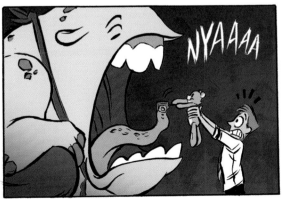

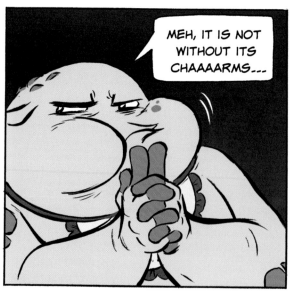

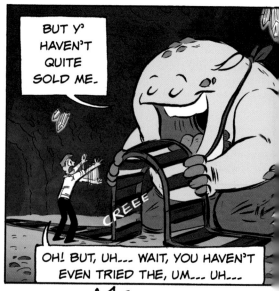

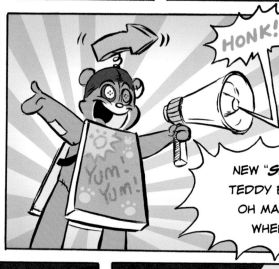

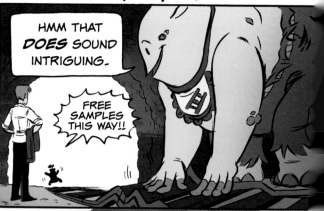

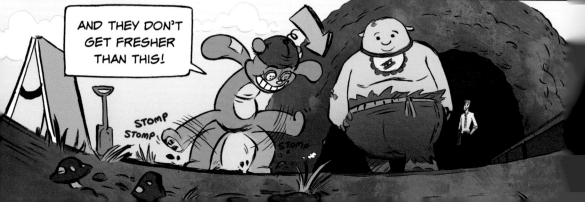

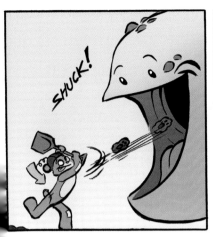

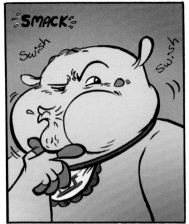

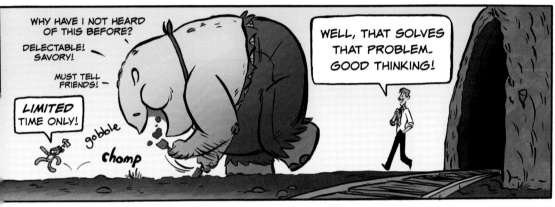

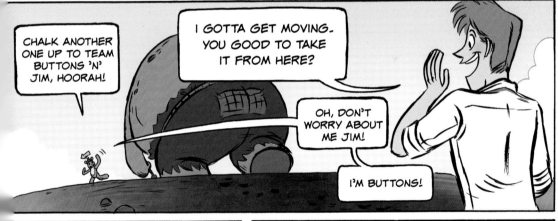

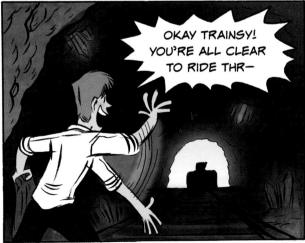

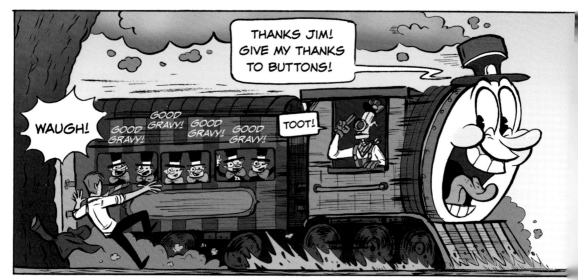

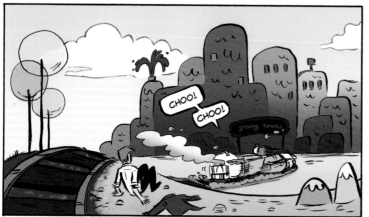

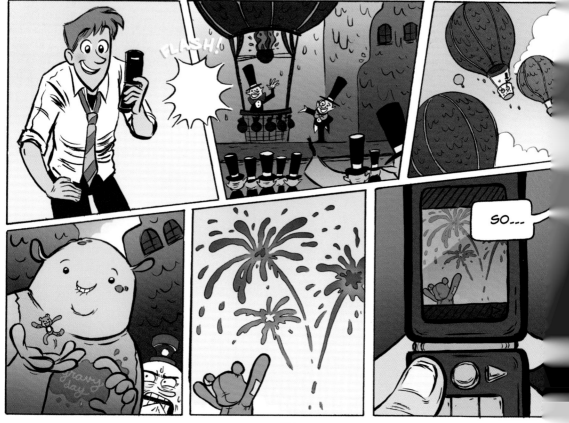

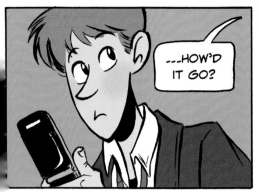

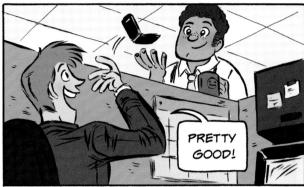

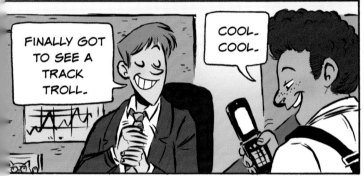

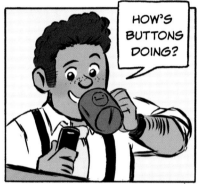

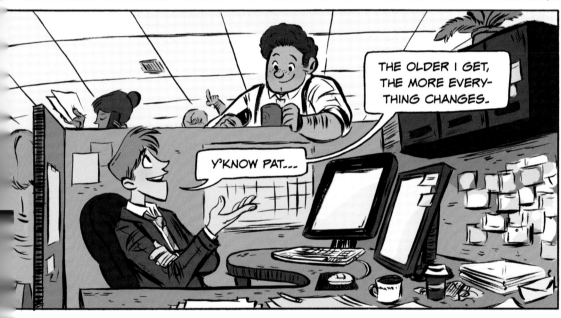

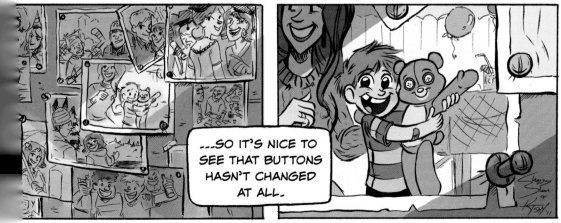

Who Needs Friends?

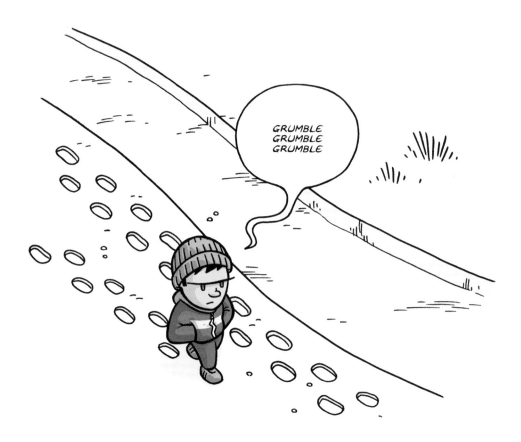

Kean Soo

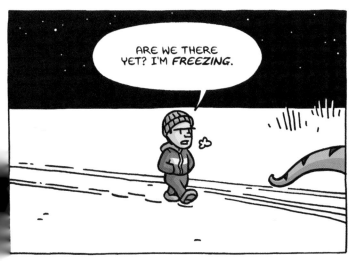

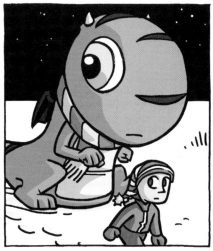

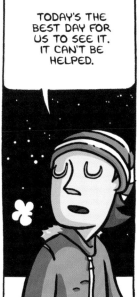

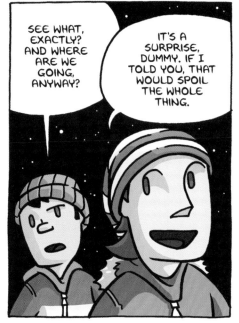

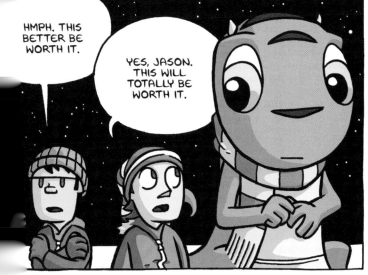

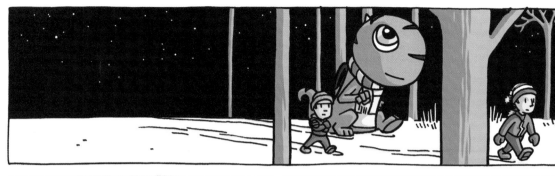

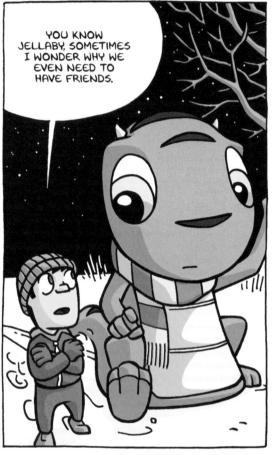

YOU KNOW JELLABY, SOMETIMES I WONDER WHY WE EVEN NEED TO HAVE FRIENDS.

I MEAN, WOULDN'T IT BE GREAT, ON A COLD NIGHT LIKE THIS, TO BE CURLED UP AT HOME WITH A CUP OF HOT CHOCOLATE IN FRONT OF THE TV?

AAAH.

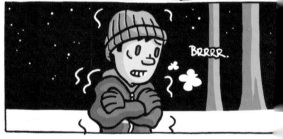

BRRRR.

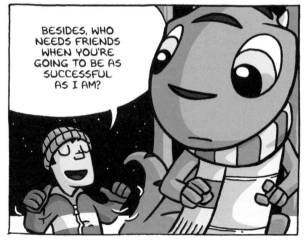

BESIDES, WHO NEEDS FRIENDS WHEN YOU'RE GOING TO BE AS SUCCESSFUL AS I AM?

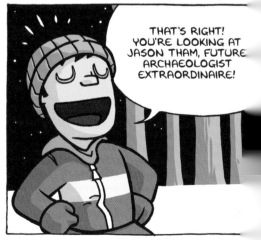

THAT'S RIGHT! YOU'RE LOOKING AT JASON THAM, FUTURE ARCHAEOLOGIST EXTRAORDINAIRE!

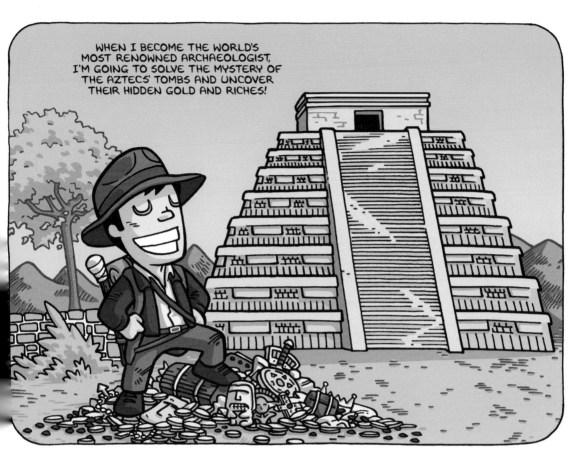

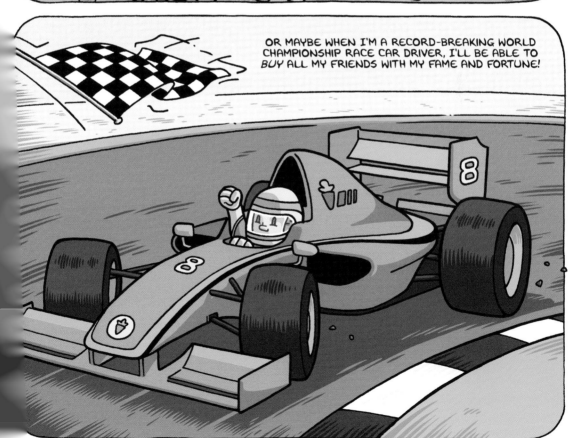

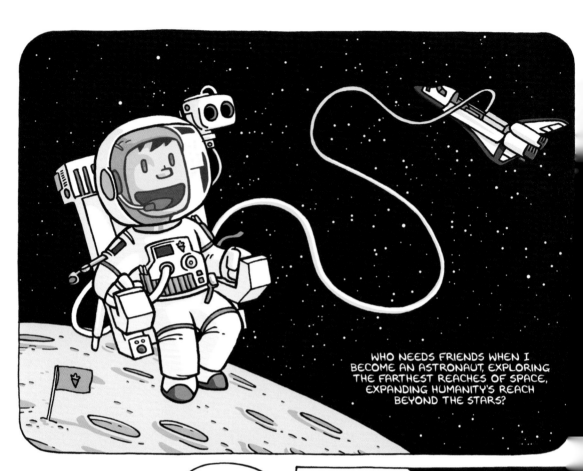

WHO NEEDS FRIENDS WHEN I BECOME AN ASTRONAUT, EXPLORING THE FARTHEST REACHES OF SPACE, EXPANDING HUMANITY'S REACH BEYOND THE STARS?

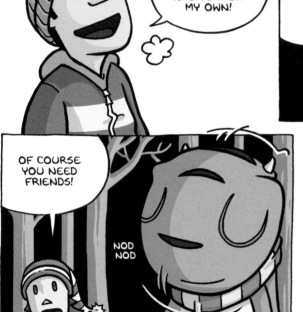

MAN, I CAN'T WAIT! THINGS WILL BE SO MUCH BETTER WHEN I'M ON MY OWN!

OF COURSE YOU NEED FRIENDS!

NOD NOD

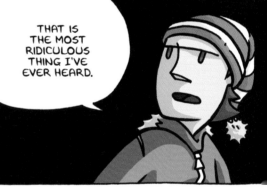

THAT IS THE MOST RIDICULOUS THING I'VE EVER HEARD.

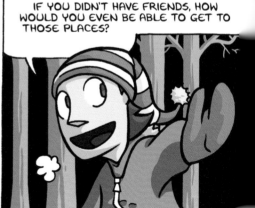

IF YOU DIDN'T HAVE FRIENDS, HOW WOULD YOU EVEN BE ABLE TO GET TO THOSE PLACES?

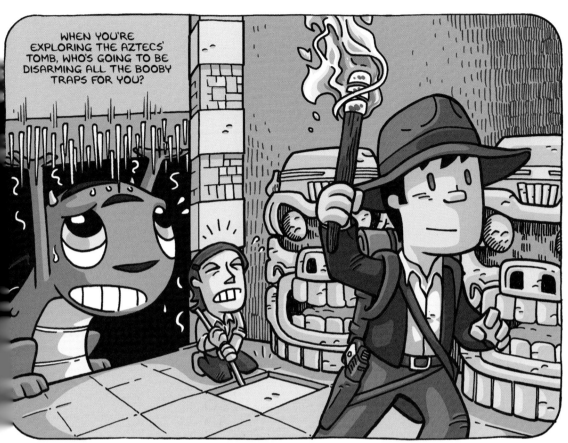

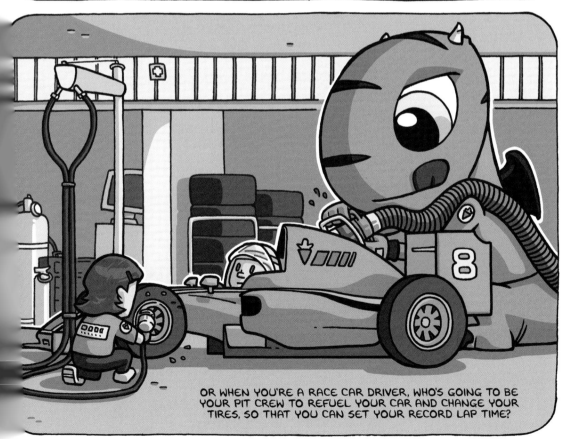

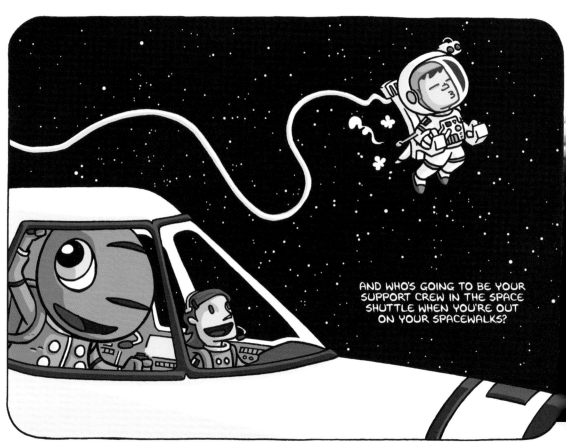

AND WHO'S GOING TO BE YOUR SUPPORT CREW IN THE SPACE SHUTTLE WHEN YOU'RE OUT ON YOUR SPACEWALKS?

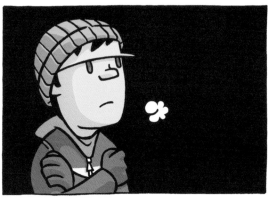

EVERYBODY NEEDS FRIENDS.

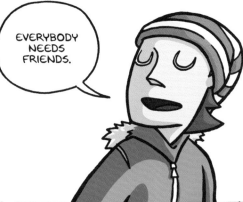

YOUR FRIENDS ARE THERE TO PICK YOU UP WHEN YOU'RE DOWN -- AND SOMETIMES THEY'RE THERE TO SHOW YOU THINGS YOU'D NEVER THINK TO SEE.

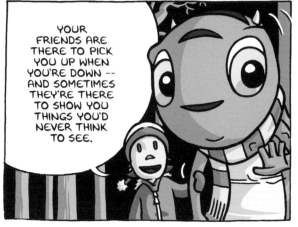

SPEAKING OF WHICH, HERE WE ARE.

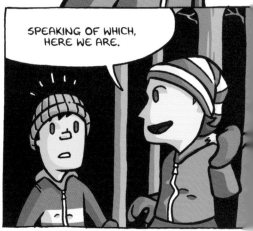

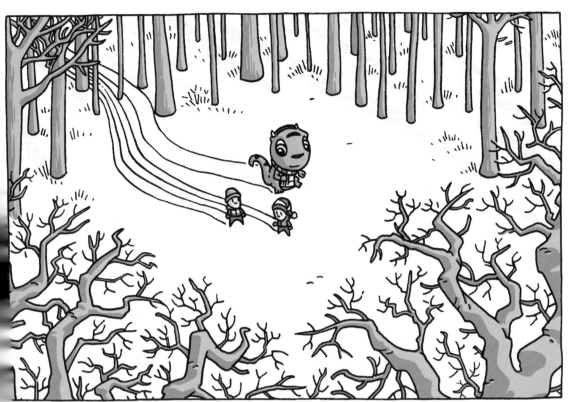

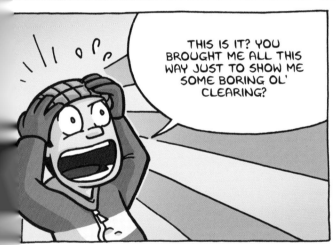

THIS IS IT? YOU BROUGHT ME ALL THIS WAY JUST TO SHOW ME SOME BORING OL' CLEARING?

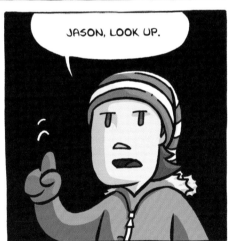

JASON, LOOK UP.

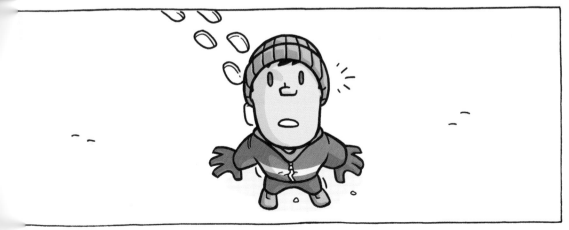

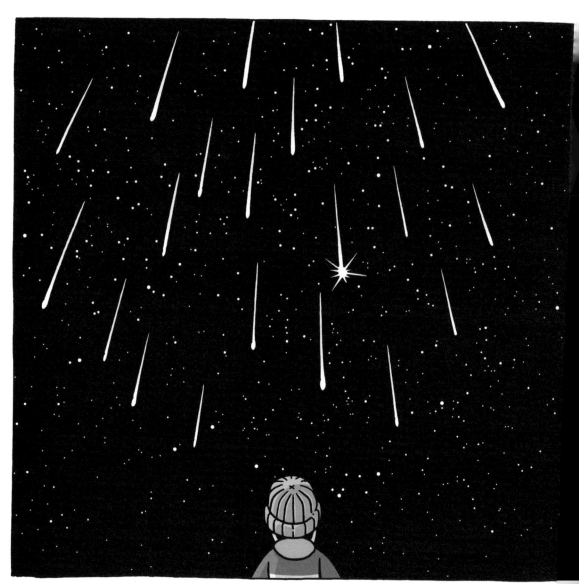

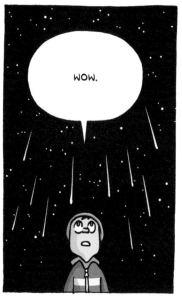

WOW.

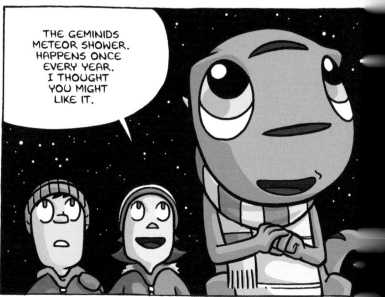

THE GEMINIDS
METEOR SHOWER.
HAPPENS ONCE
EVERY YEAR.
I THOUGHT
YOU MIGHT
LIKE IT.

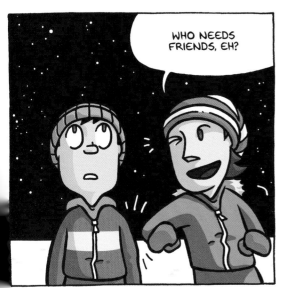

WHO NEEDS FRIENDS, EH?

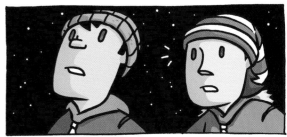

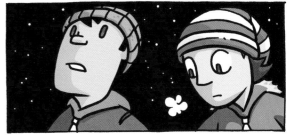

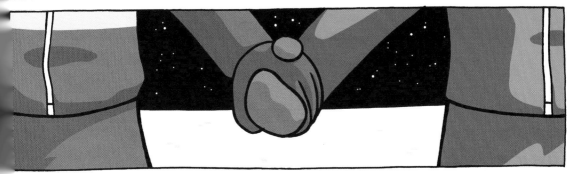

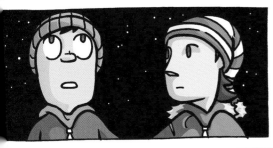

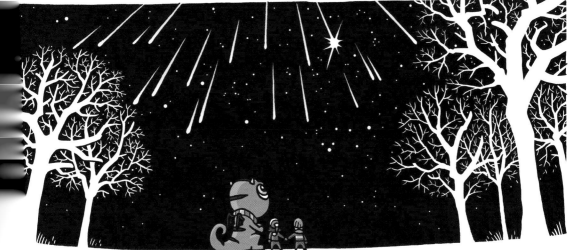

IGLOO
Head
and
Tree
Head

in

"Accomplishments"

by
Scott C.

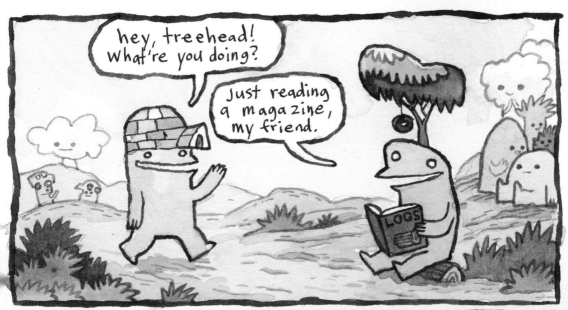
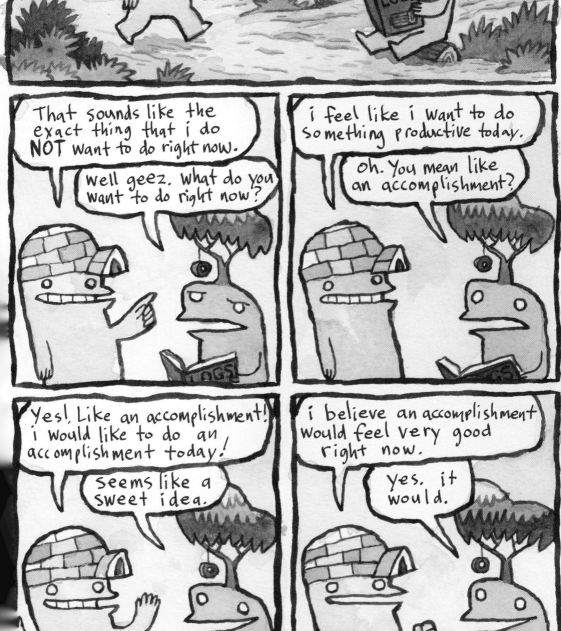

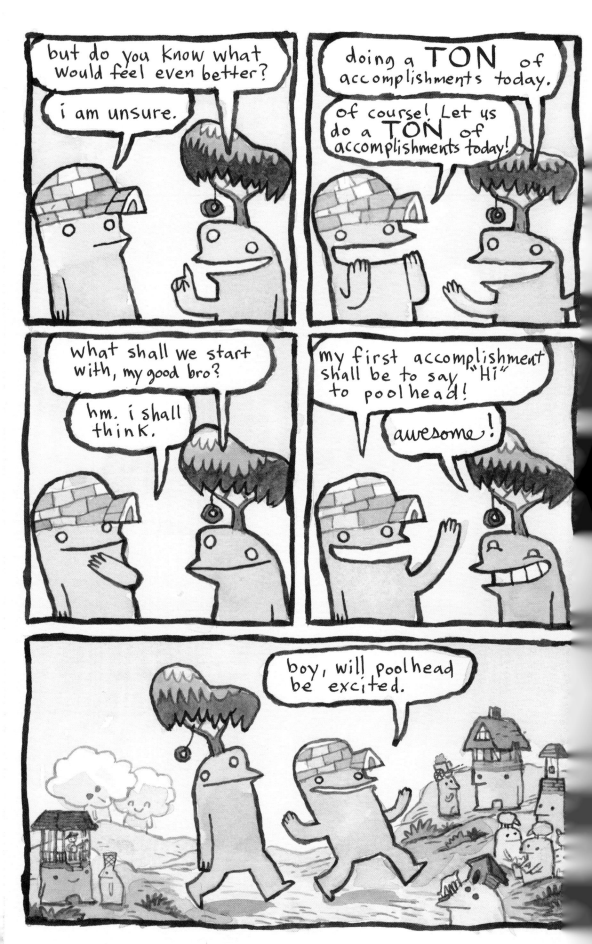

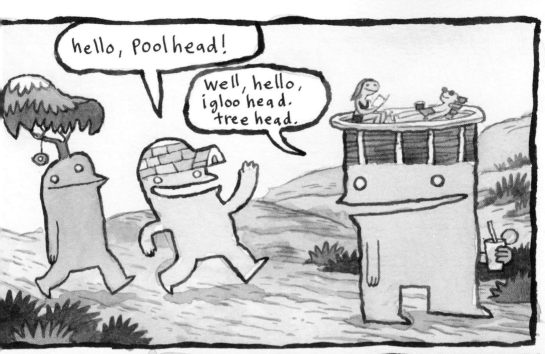

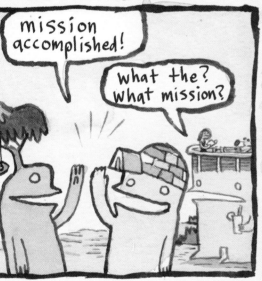

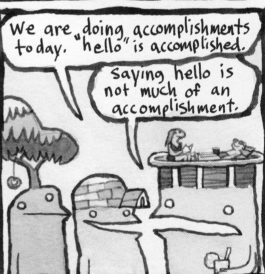

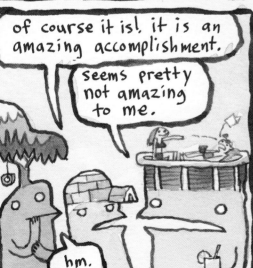

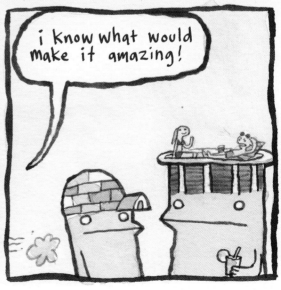

199

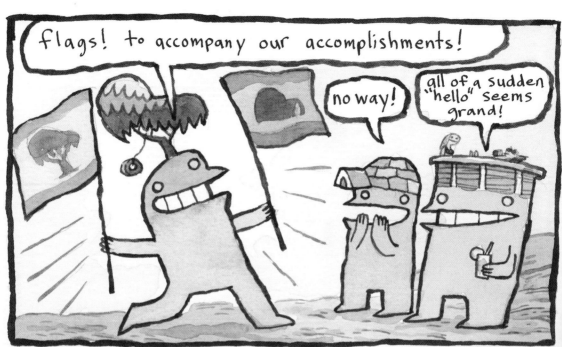

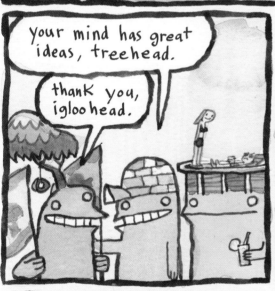

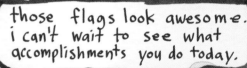

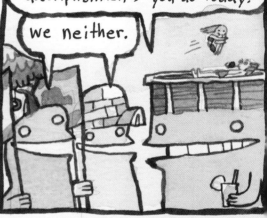

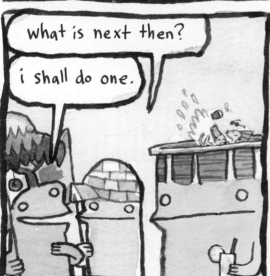

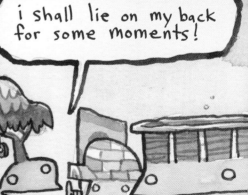

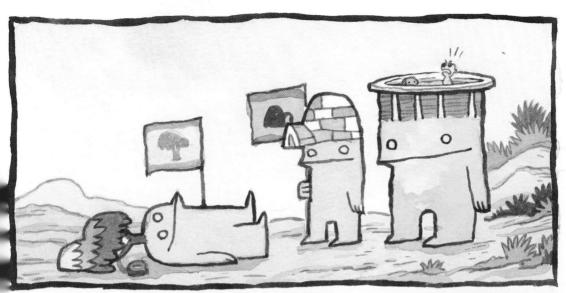

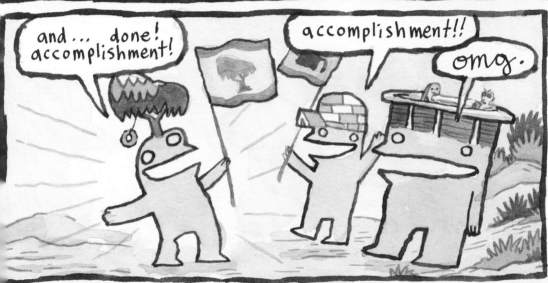

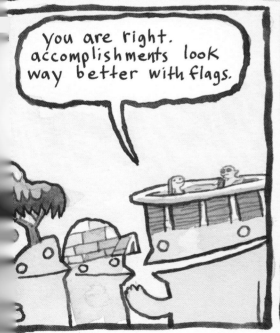

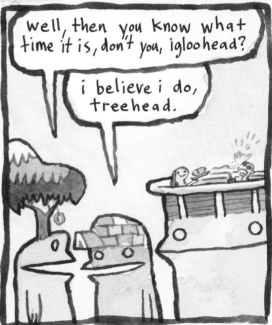

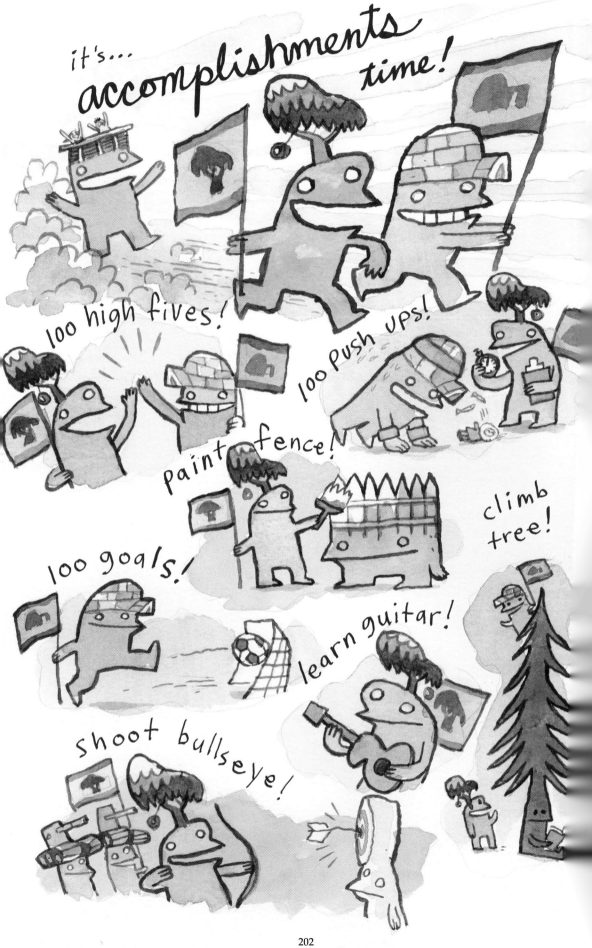

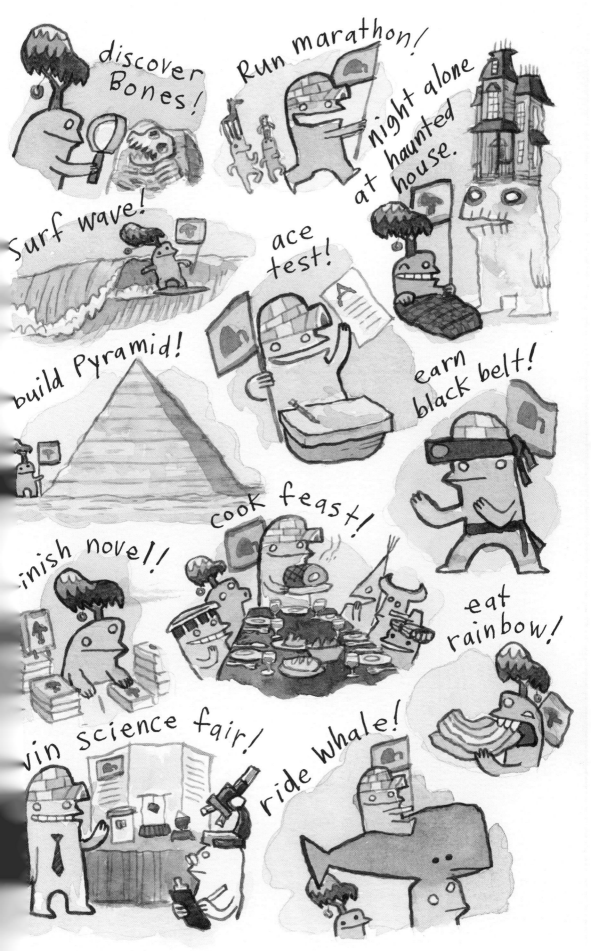

203

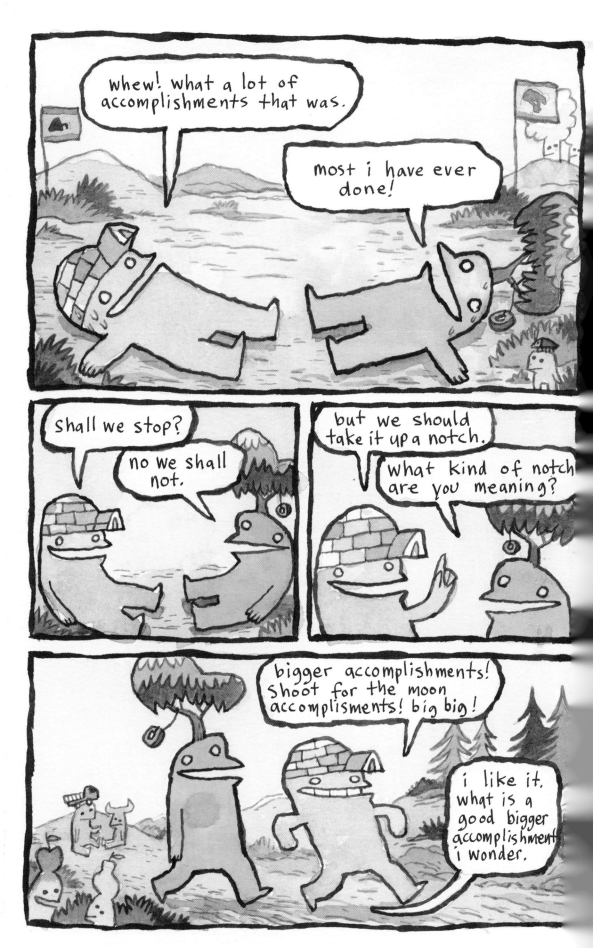

204

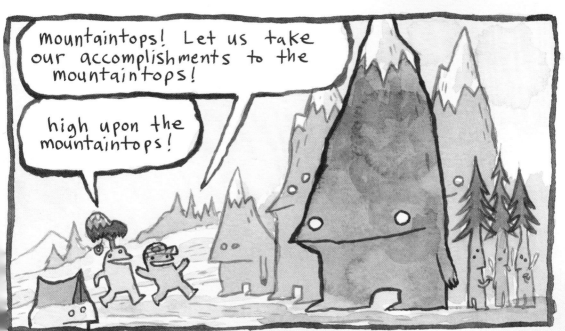

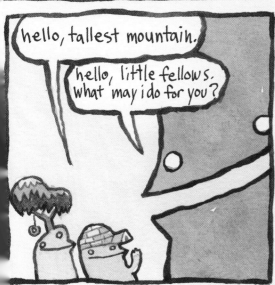

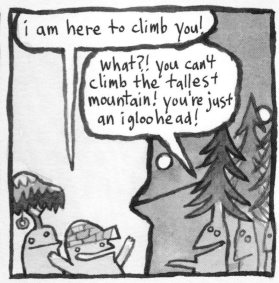

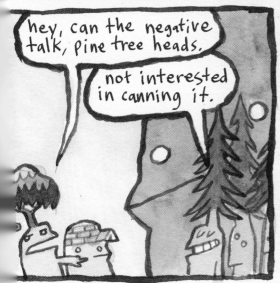

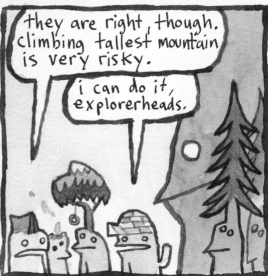

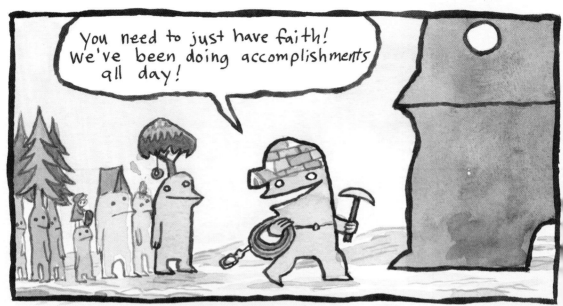

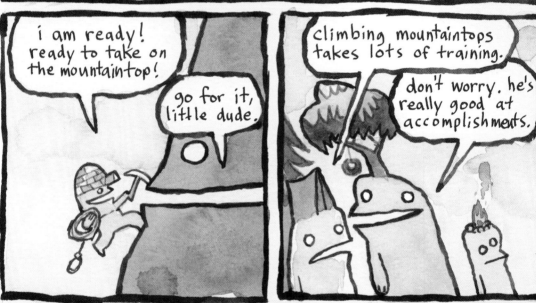

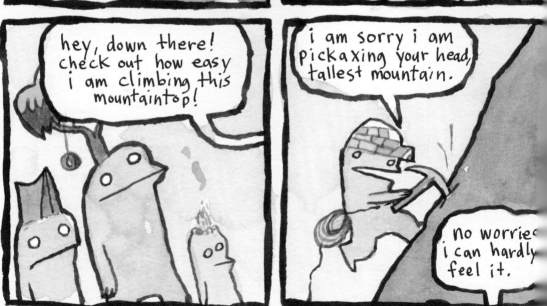

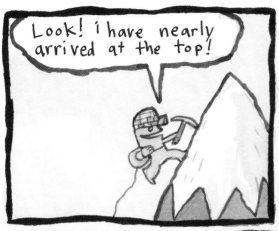

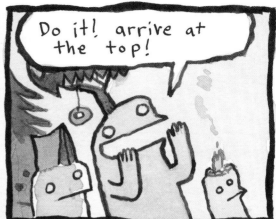

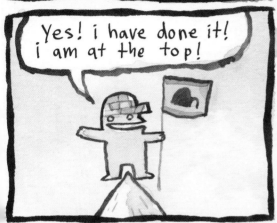

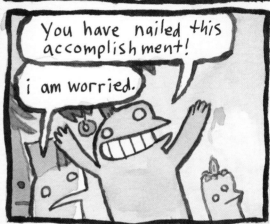

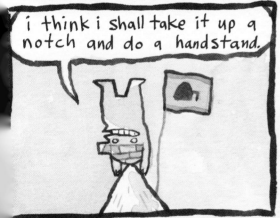

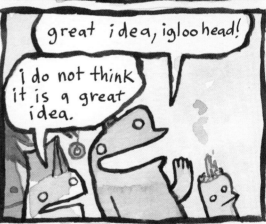

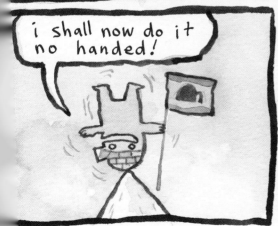

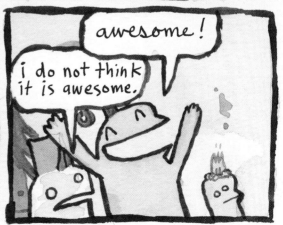

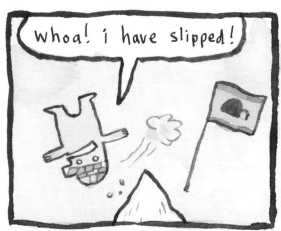
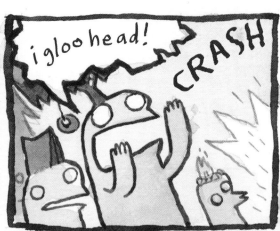
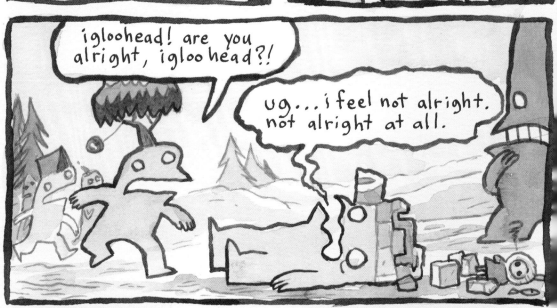
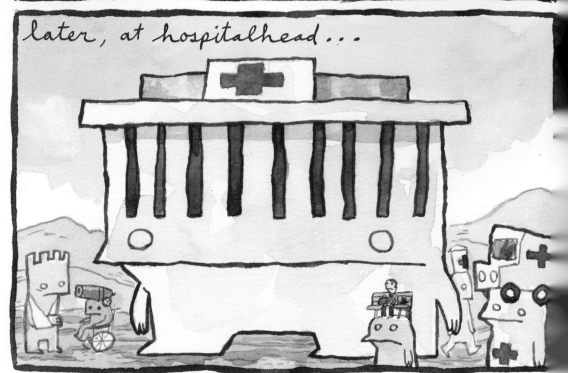

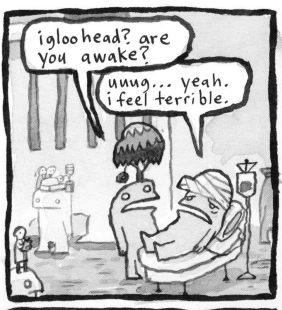

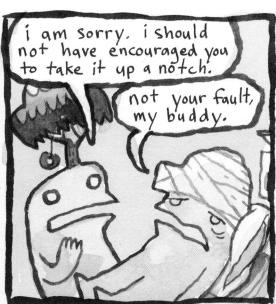

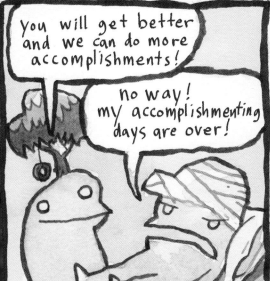

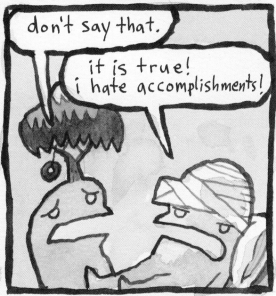

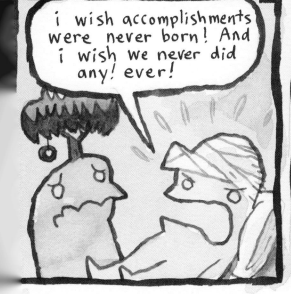

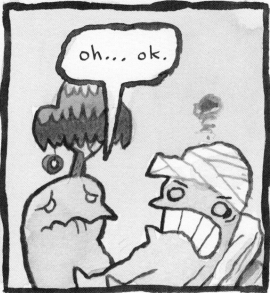

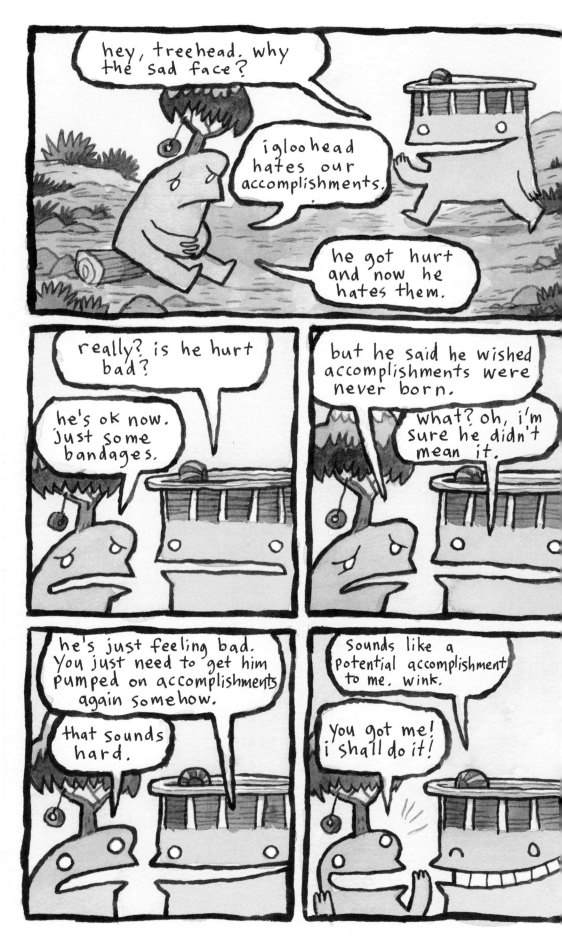

210

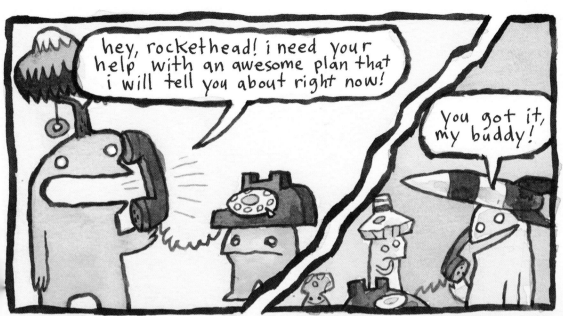

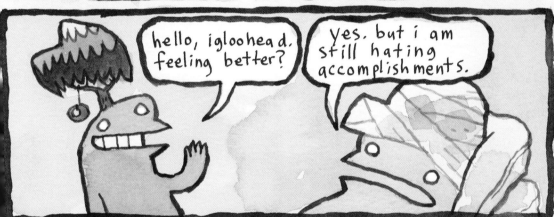

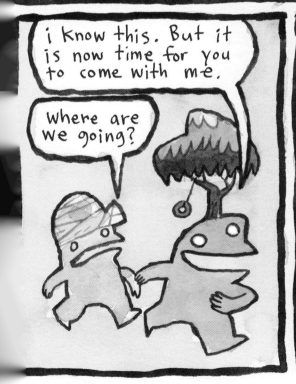

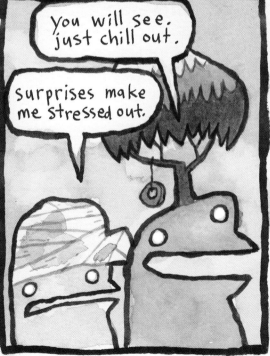

211

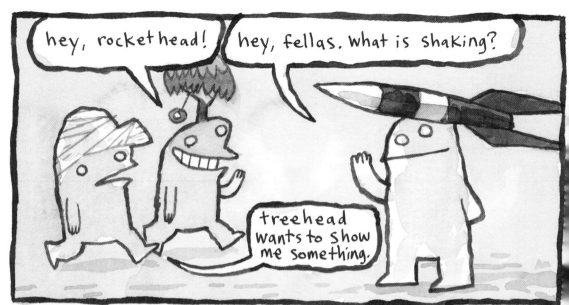

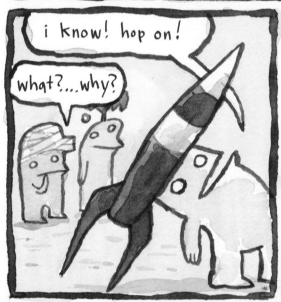

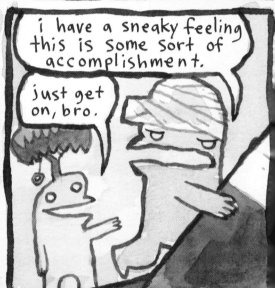

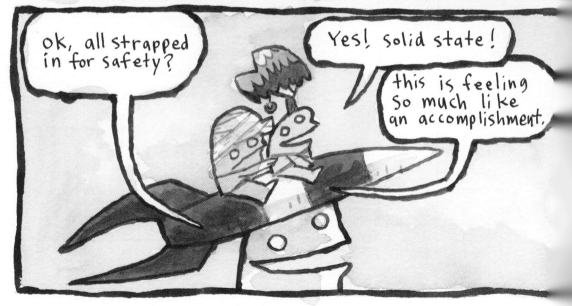

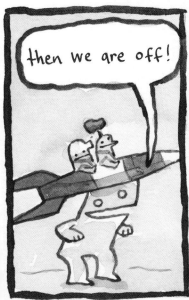

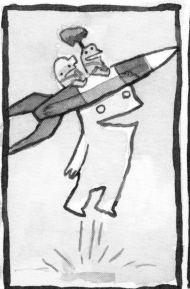

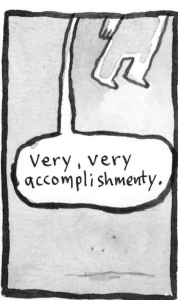

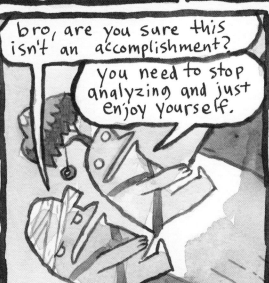

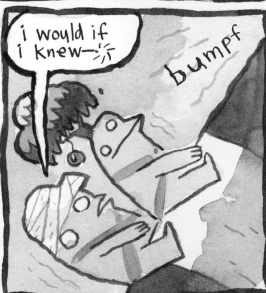

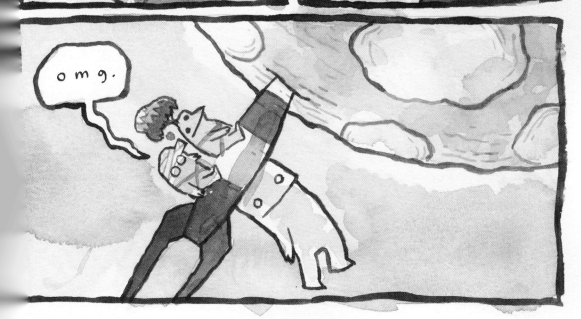

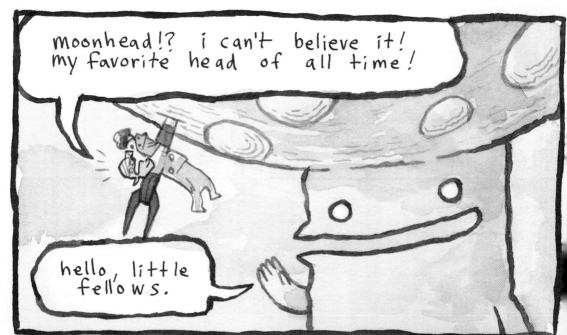

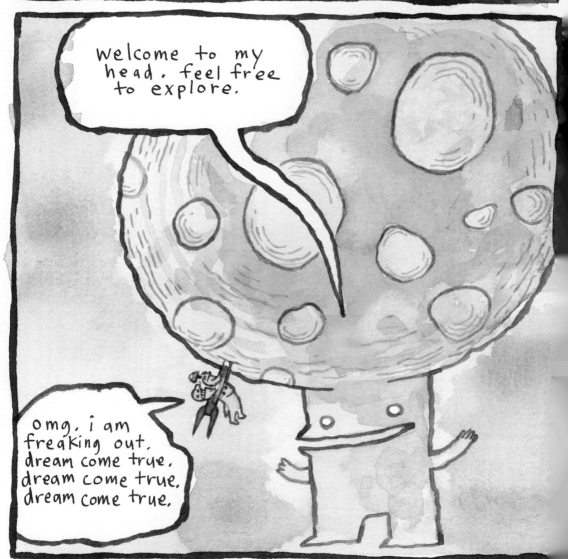

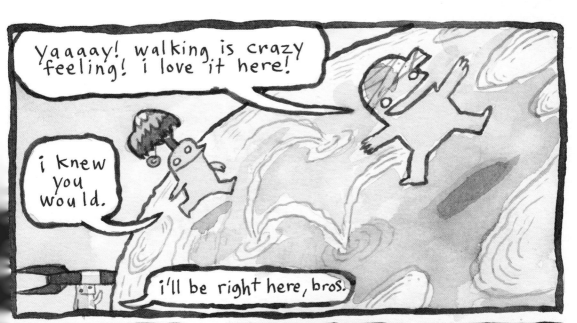

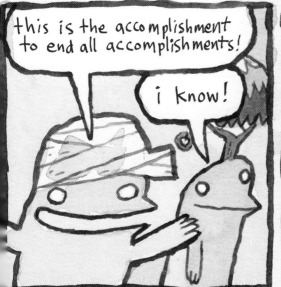

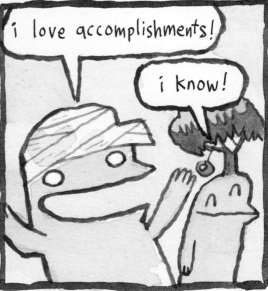

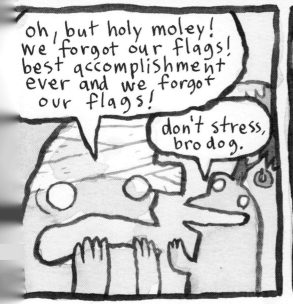

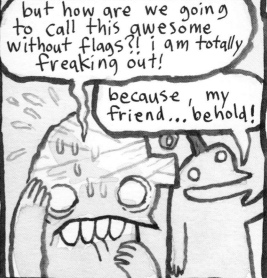

accomplishment monument!

IGLOOHEAD & TREE HEAD #1 ACCOMPLISHMENT

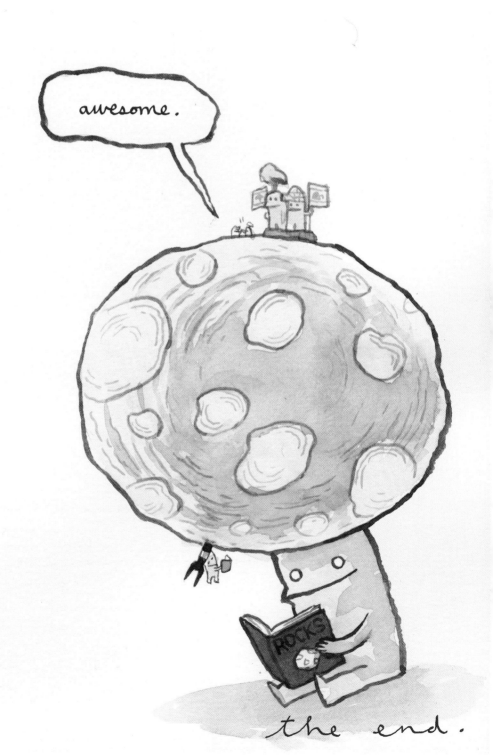

DO YOU REMEMBER THE STORY OF THE SPEEDY LITTLE RABBIT THAT CHALLENGED A SLOW-MOVING TURTLE TO A RACE? AS THE TALE GOES, THE RABBIT WAS A BIT OF A SHOW-OFF, RUNNING AHEAD BUT THEN STOPPING FOR A SHORT NAP. THE LITTLE TURTLE WAS INDEED SLOW, BUT IN THE END HE WALKED RIGHT ON PAST THE SNOOZING RABBIT AND ACTUALLY WON THE RACE!

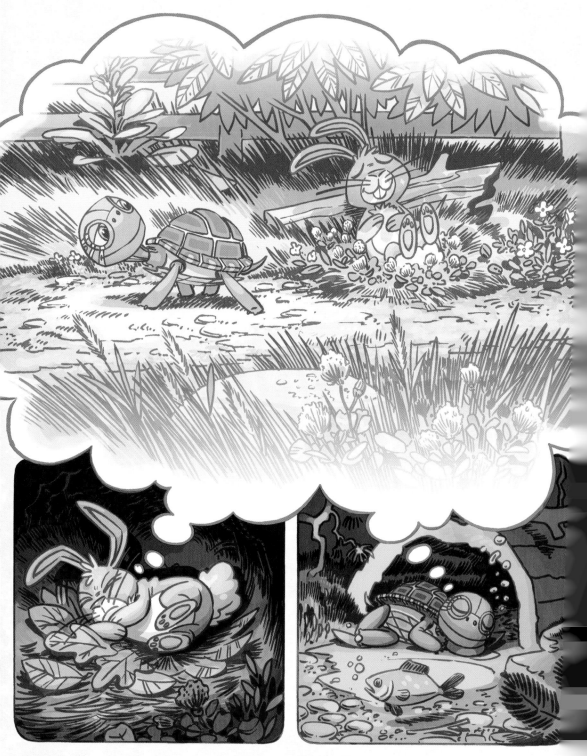

WELL, SOME TIME HAD GONE BY SINCE THAT MEMORABLE RACE; AND YET, AS CAN OFTEN HAPPEN, THE DETAILS OF THAT HISTORIC EVENT WERE NOT QUITE CLEAR ANYMORE. THERE WERE STILL QUITE A FEW ARGUMENTS AND DISAGREEMENTS OVER THE MANY WHAT-IFS AND COULD-HAVE-BEENS. RABBIT STILL COULD NOT QUITE ACCEPT HE HAD BEEN BEATEN.

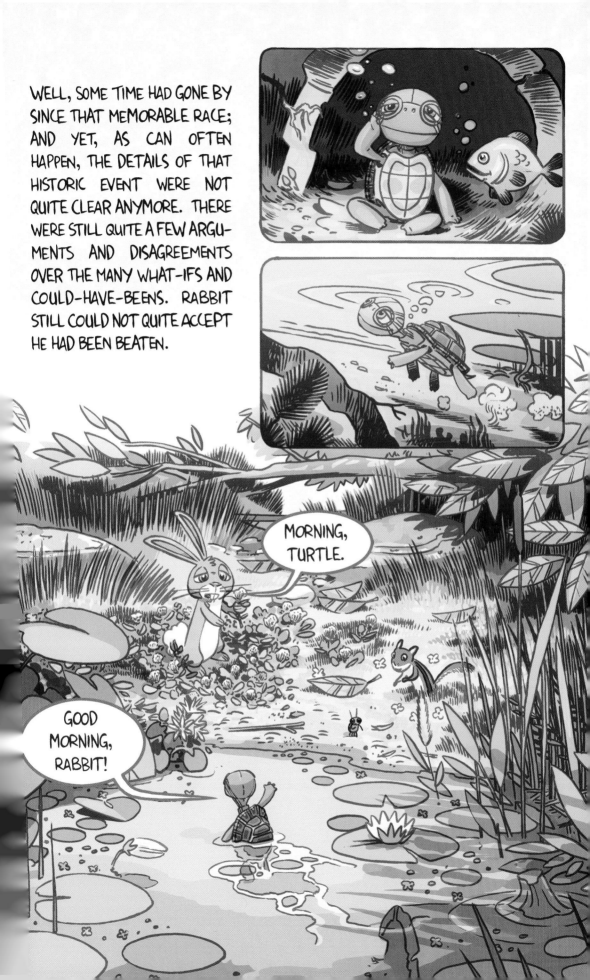

MORNING, TURTLE.

GOOD MORNING, RABBIT!

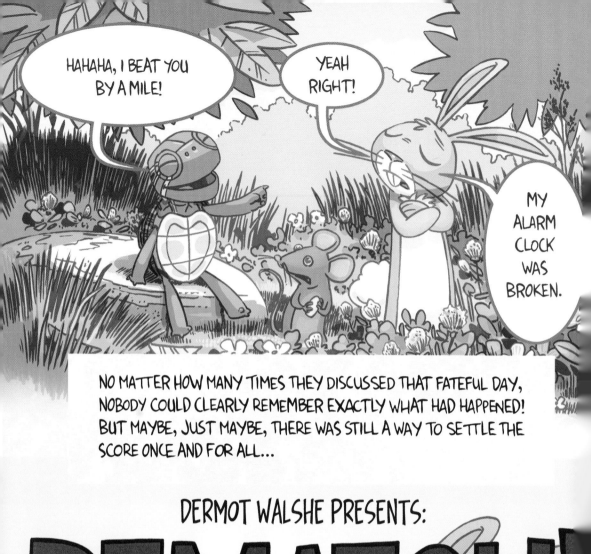

NO MATTER HOW MANY TIMES THEY DISCUSSED THAT FATEFUL DAY, NOBODY COULD CLEARLY REMEMBER EXACTLY WHAT HAD HAPPENED! BUT MAYBE, JUST MAYBE, THERE WAS STILL A WAY TO SETTLE THE SCORE ONCE AND FOR ALL...

DERMOT WALSHE PRESENTS:

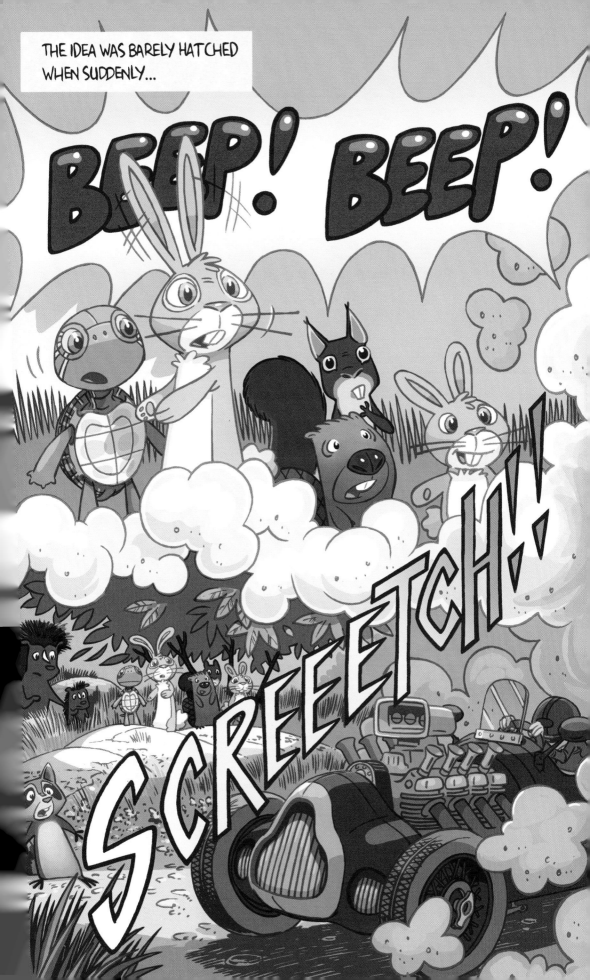

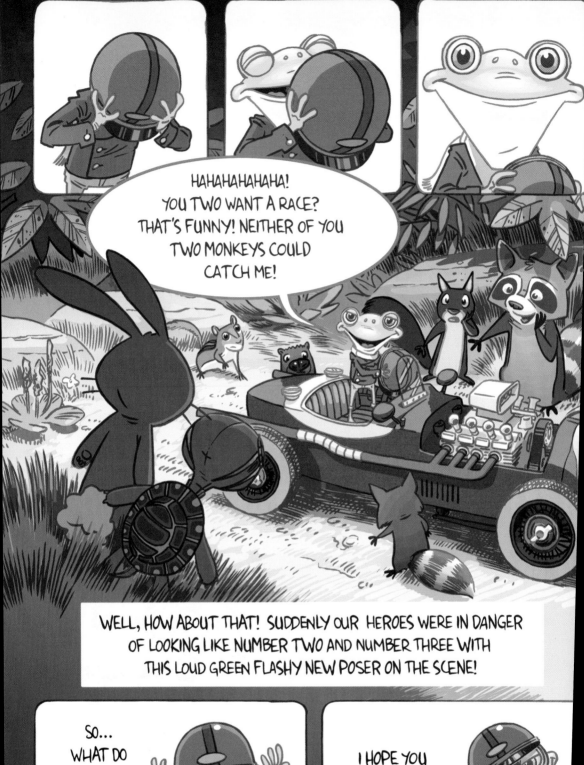

HAHAHAHAHAHA! YOU TWO WANT A RACE? THAT'S FUNNY! NEITHER OF YOU TWO MONKEYS COULD CATCH ME!

WELL, HOW ABOUT THAT! SUDDENLY OUR HEROES WERE IN DANGER OF LOOKING LIKE NUMBER TWO AND NUMBER THREE WITH THIS LOUD GREEN FLASHY NEW POSER ON THE SCENE!

SO... WHAT DO YOU SAY?

NOON TOMORROW?

I HOPE YOU TWO LOSERS CAN FIND SOME WHEELS BY THEN!

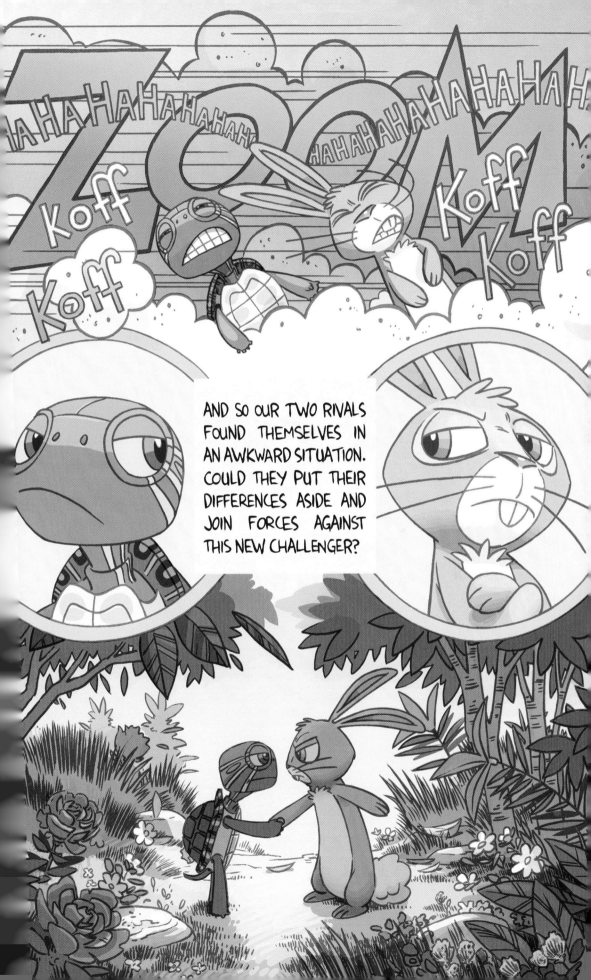

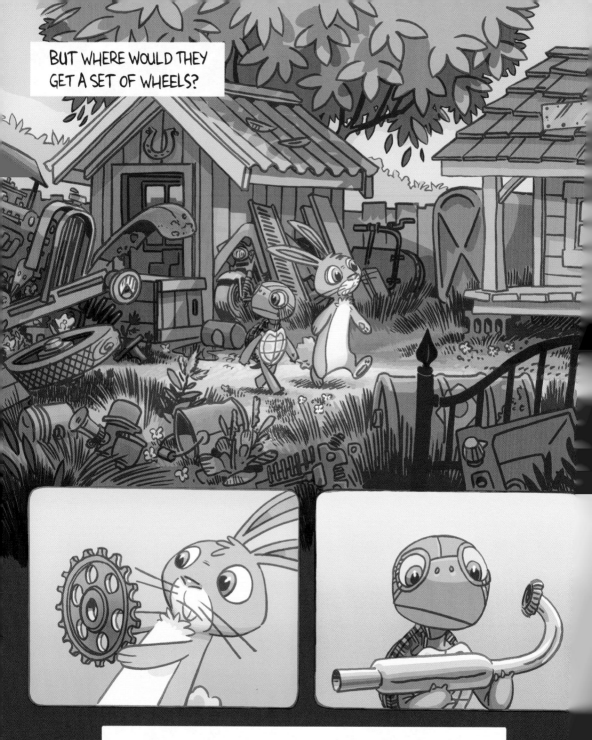

BUT WHERE WOULD THEY GET A SET OF WHEELS?

THE TWO DECIDED TO SEE IF OLD MR. PENNY HAD SOMETHING HIDING IN HIS GARDEN OF RECYCLED WONDERS THAT COULD WORK. RABBIT AND TURTLE DIDN'T REALLY KNOW VERY MUCH ABOUT THINGS MECHANICAL. IF THEY WERE GOING TO HAVE ANY KIND OF A CHANCE IN A RACE AGAINST YOUNG MR. FROGGY AND HIS AMAZING RACING MACHINE THEY WOULD NEED THE HELP OF A REAL EXPERT!

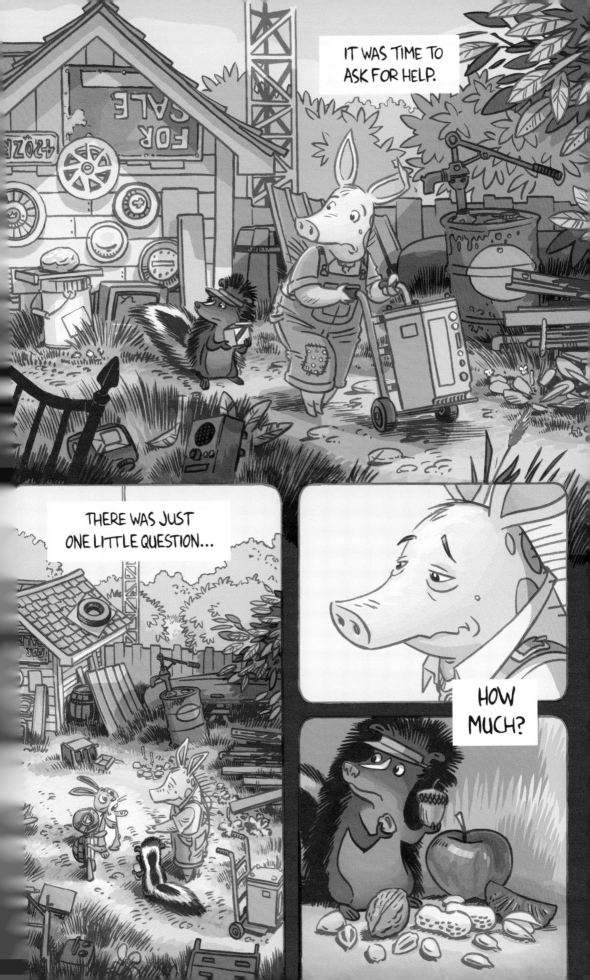

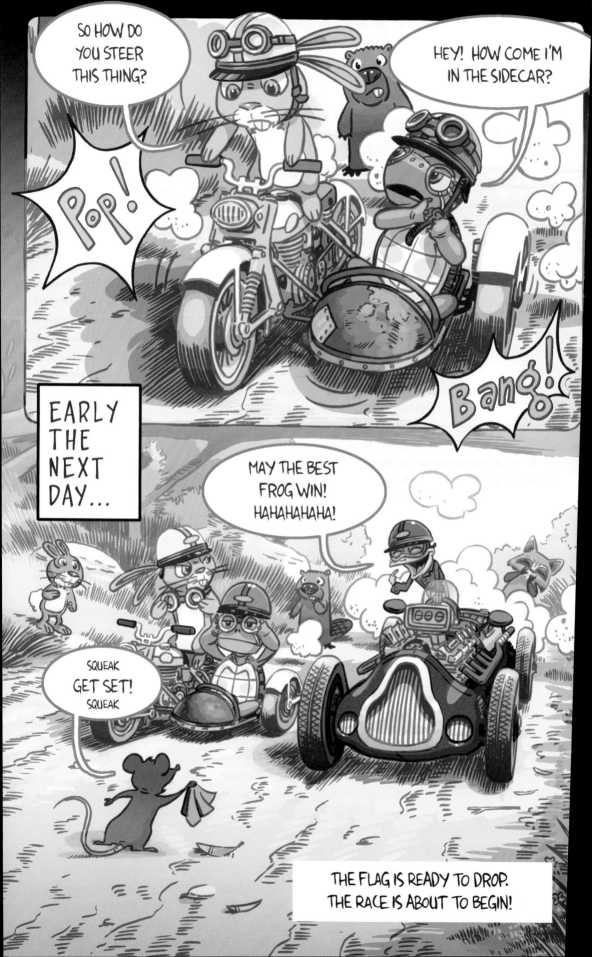

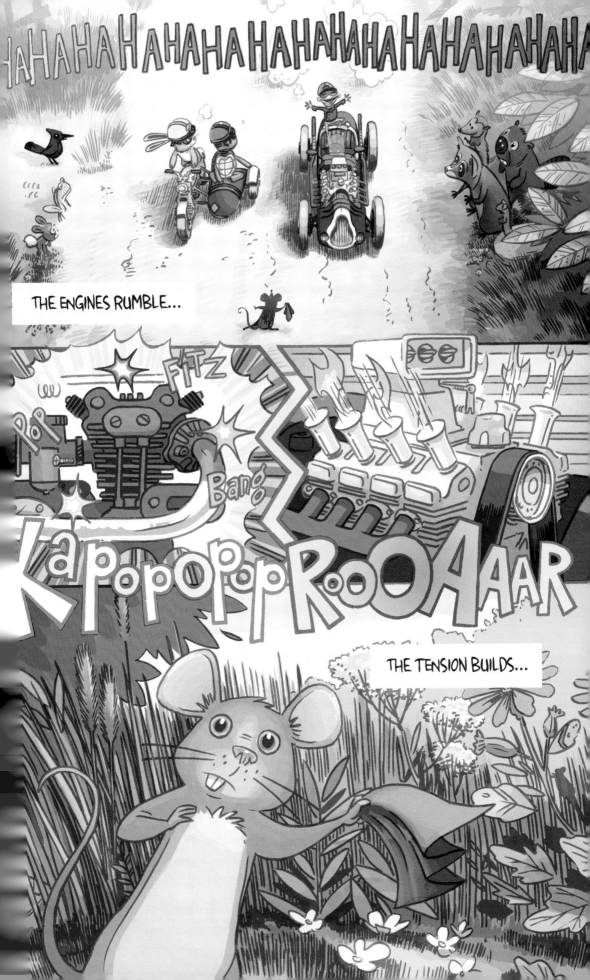

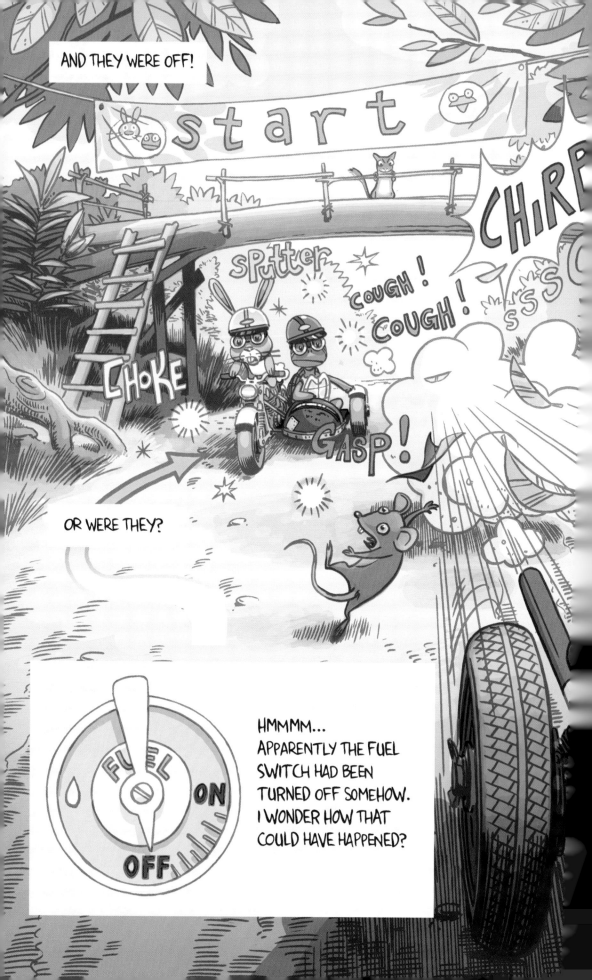

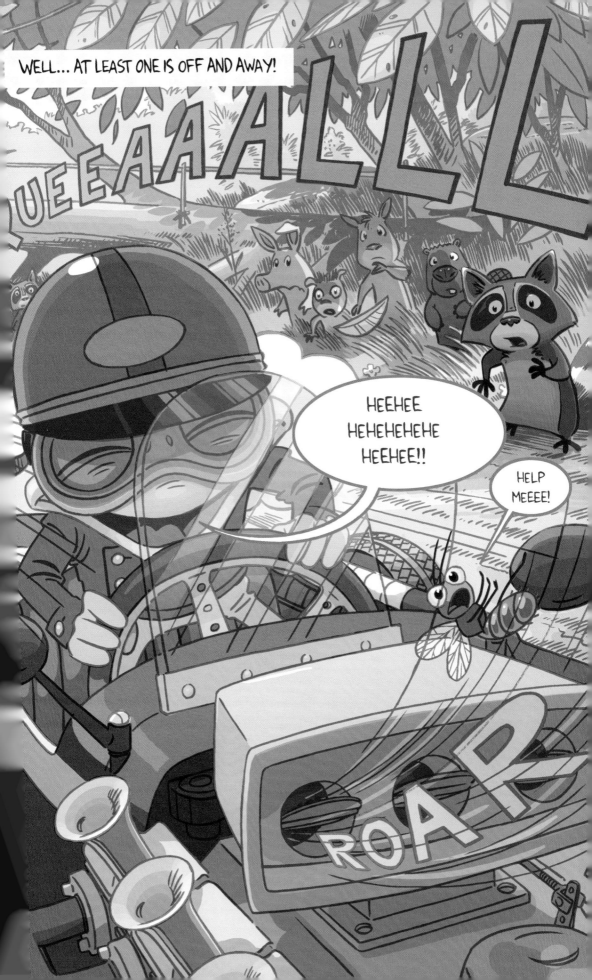

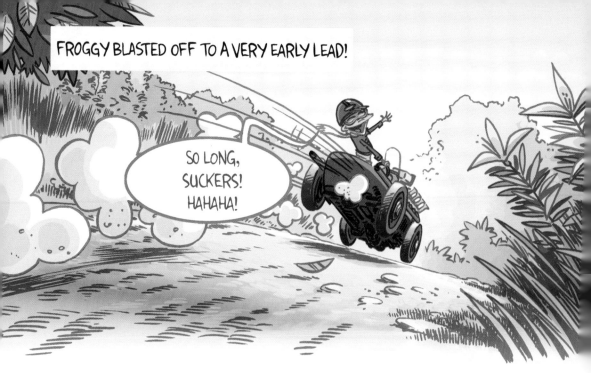

FROGGY BLASTED OFF TO A VERY EARLY LEAD!

SO LONG, SUCKERS! HAHAHA!

UNFORTUNATELY, THINGS WEREN'T GOING NEARLY AS WELL FOR RABBIT AND TURTLE...

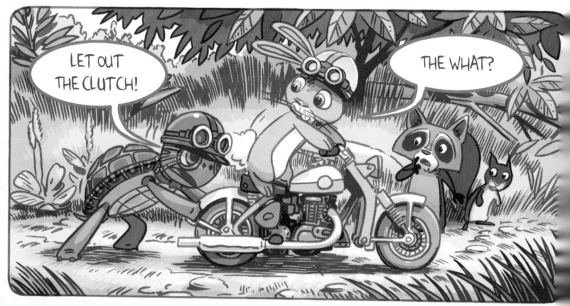

LET OUT THE CLUTCH!

THE WHAT?

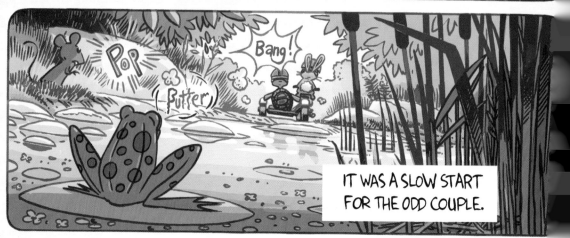

POP

(Putter)

Bang!

IT WAS A SLOW START FOR THE ODD COUPLE.

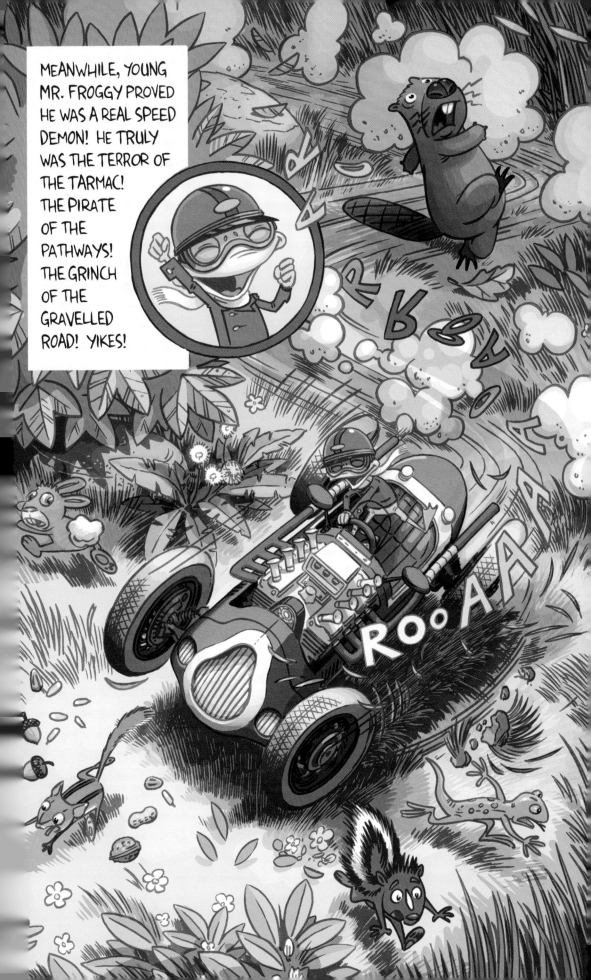

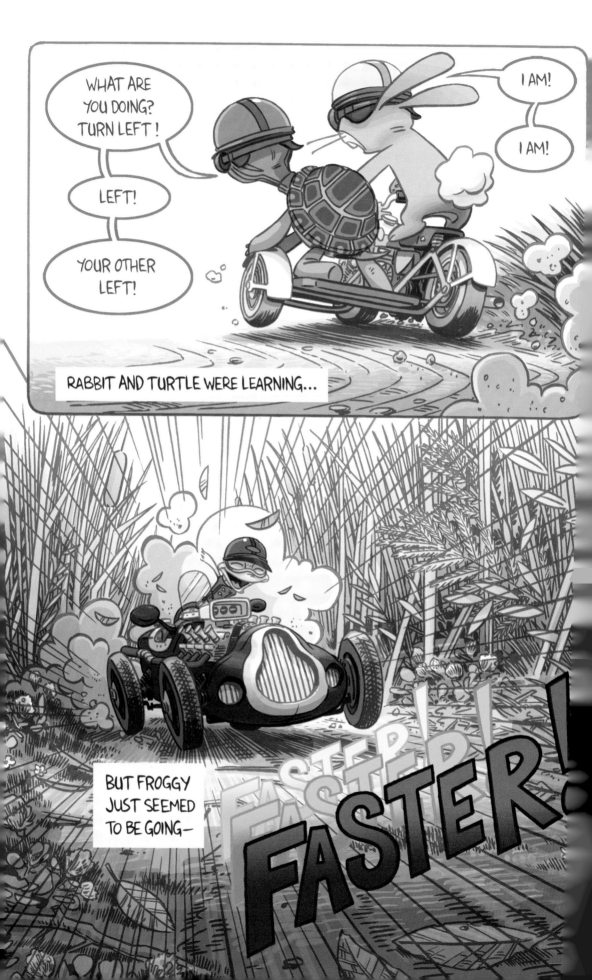

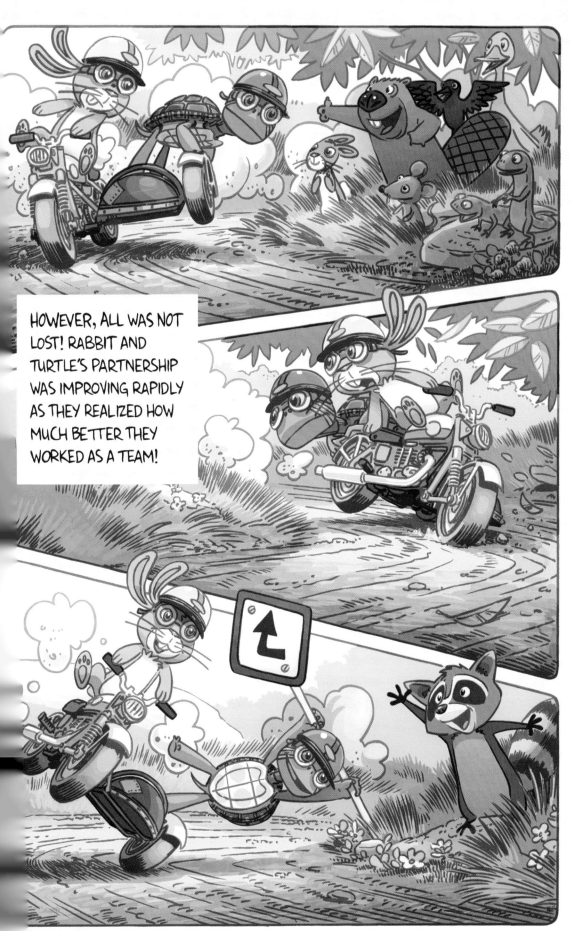

HOWEVER, ALL WAS NOT LOST! RABBIT AND TURTLE'S PARTNERSHIP WAS IMPROVING RAPIDLY AS THEY REALIZED HOW MUCH BETTER THEY WORKED AS A TEAM!

BUT COULD RABBIT AND TURTLE CATCH MR. FROG?

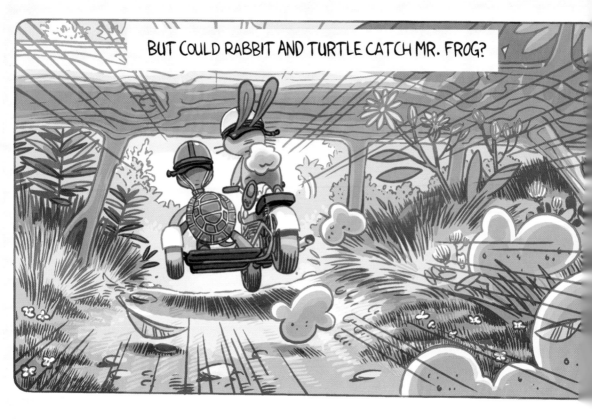

FROGGY HAD QUITE A HEAD START... BUT RABBIT AND TURTLE
LOOKED LIKE THEY WERE GOING TO MAKE THINGS CLOSE!

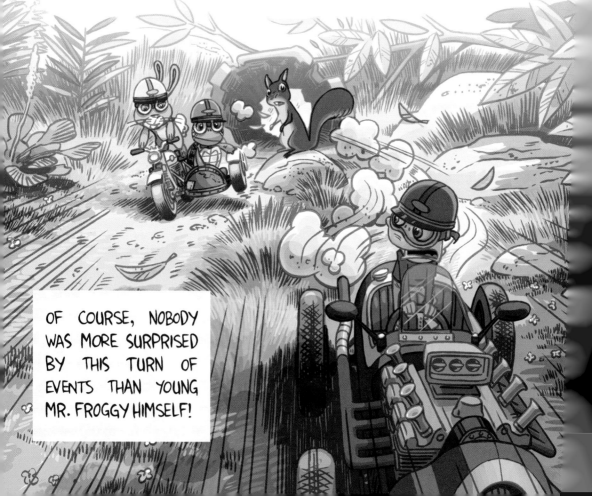

OF COURSE, NOBODY
WAS MORE SURPRISED
BY THIS TURN OF
EVENTS THAN YOUNG
MR. FROGGY HIMSELF!

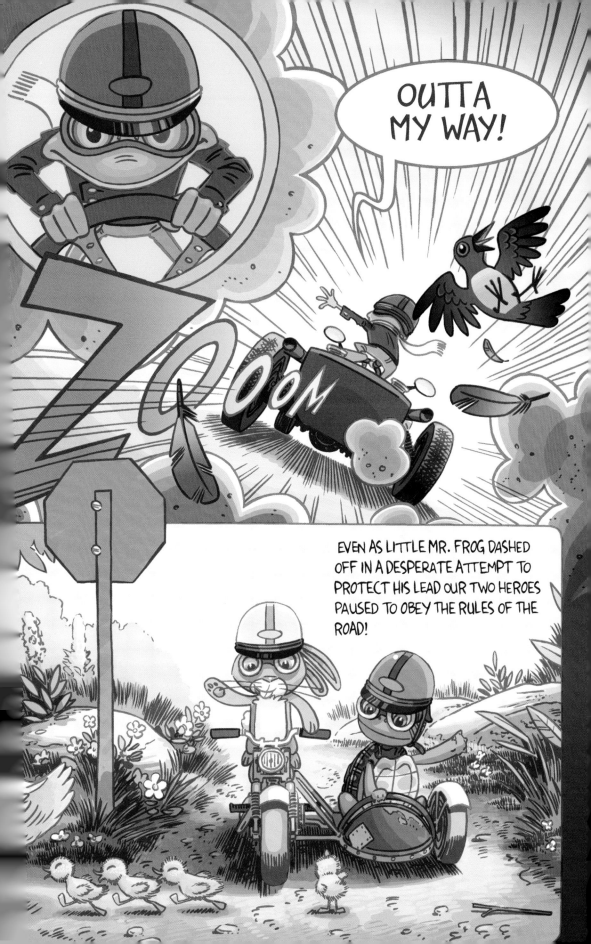

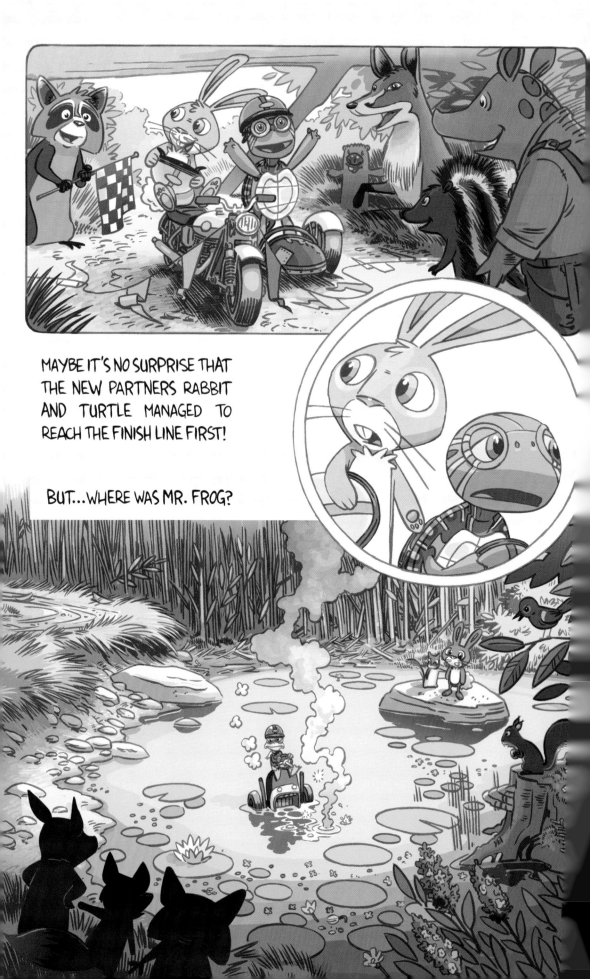

MAYBE IT'S NO SURPRISE THAT THE NEW PARTNERS RABBIT AND TURTLE MANAGED TO REACH THE FINISH LINE FIRST!

BUT...WHERE WAS MR. FROG?

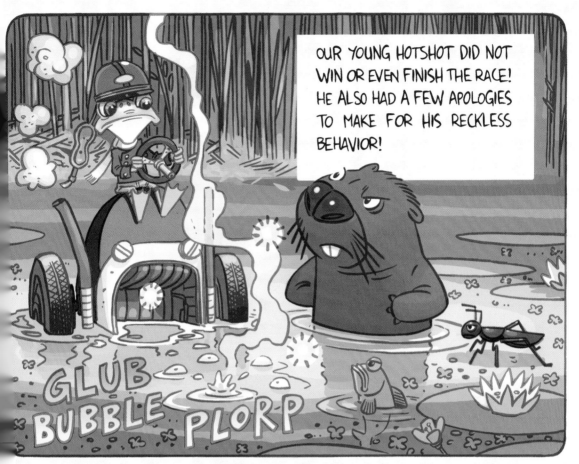

IN THE END, WHILE LITTLE MR. FROG REALIZED THERE WAS MUCH MORE TO WINNING THAN JUST HAVING THE BEST MACHINE, RABBIT AND TURTLE LEARNED THE IMPORTANCE OF TEAMWORK AND COOPERATION!

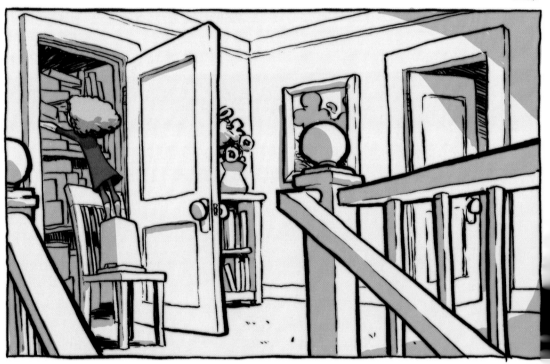

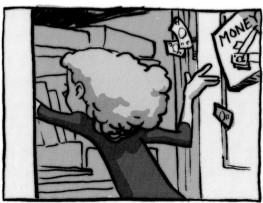

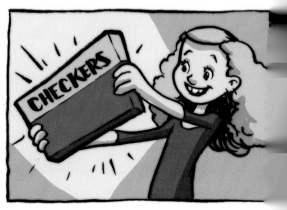

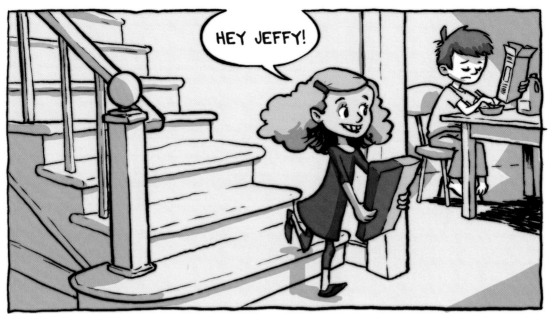

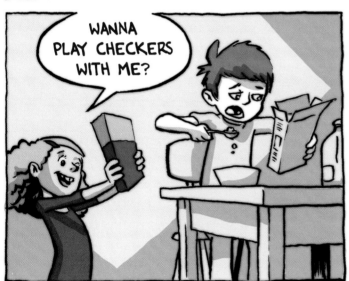

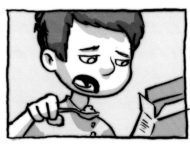

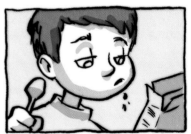

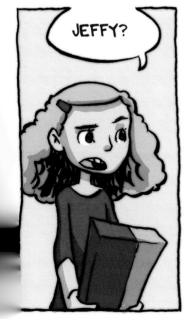

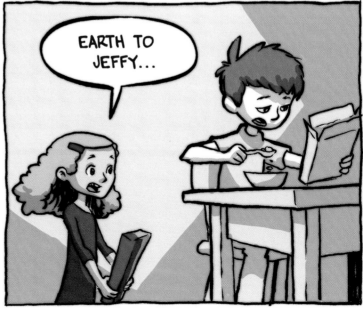

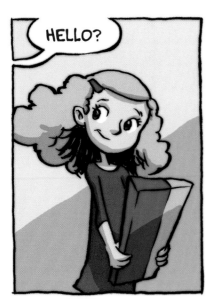

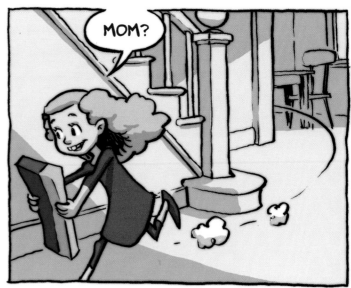

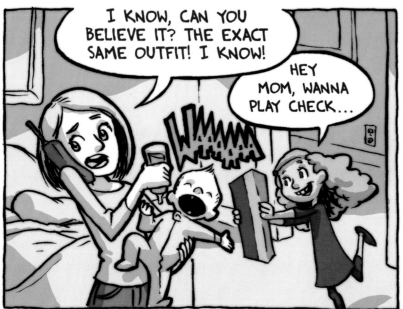

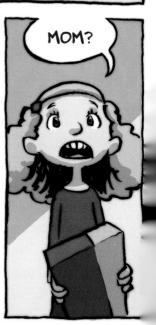

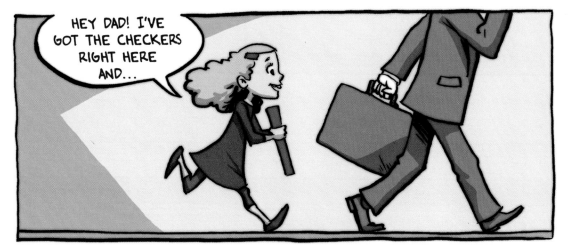

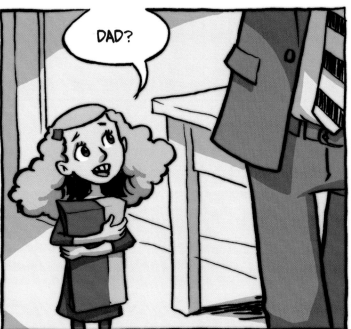

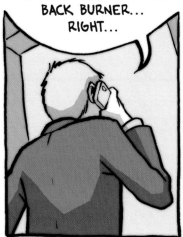

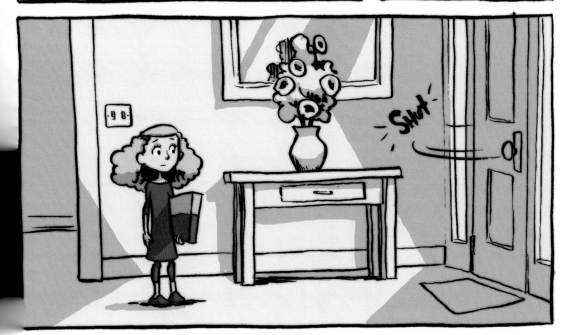

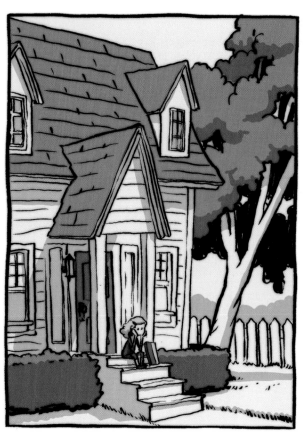
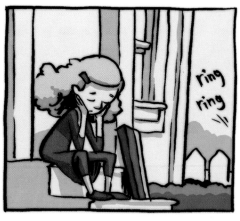
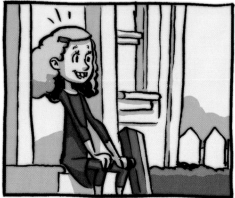
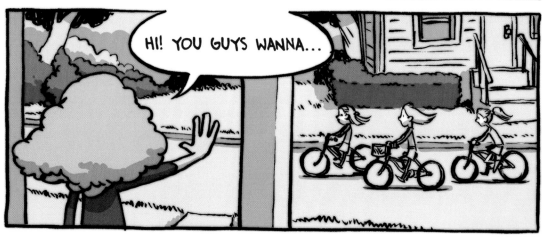
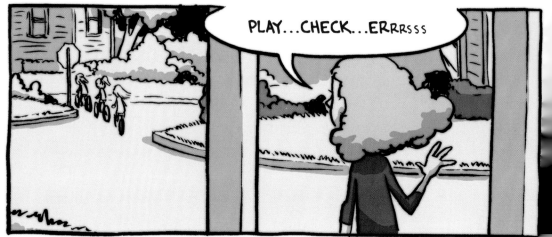

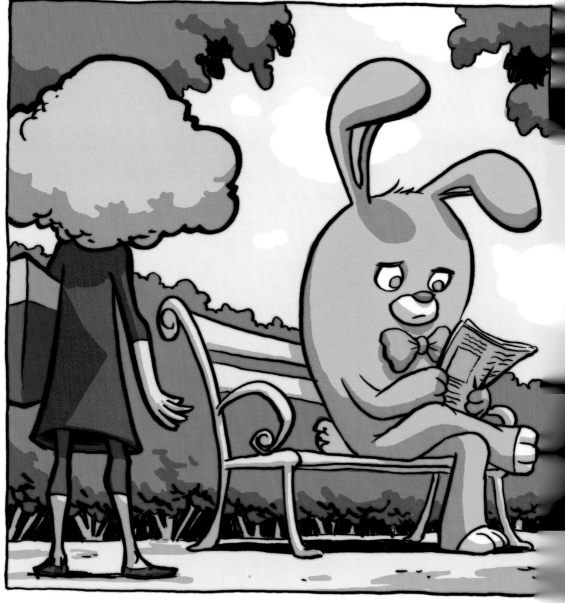

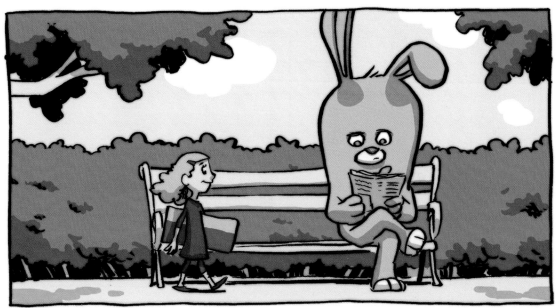

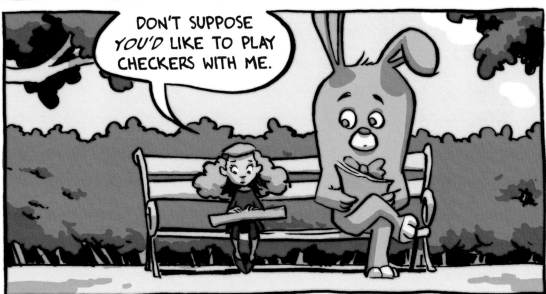

DON'T SUPPOSE *YOU'D* LIKE TO PLAY CHECKERS WITH ME.

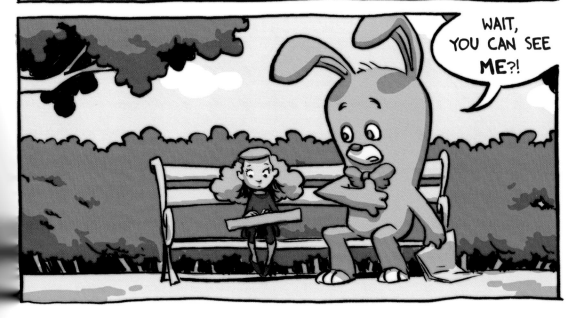

WAIT, YOU CAN SEE **ME**?!

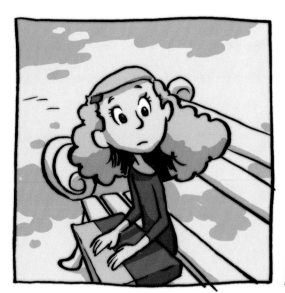
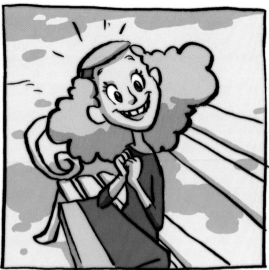
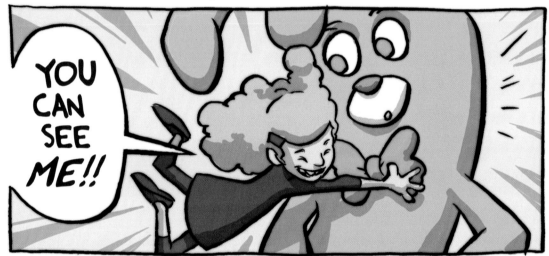

YOU CAN SEE ME!!

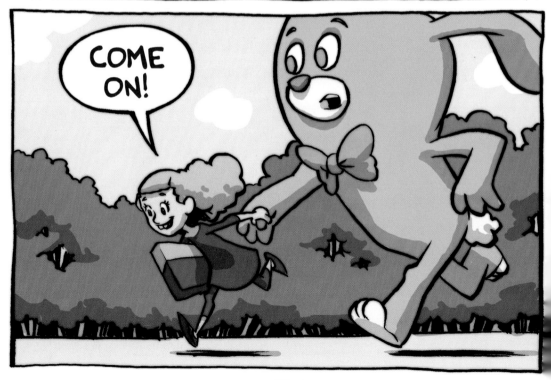

COME ON!

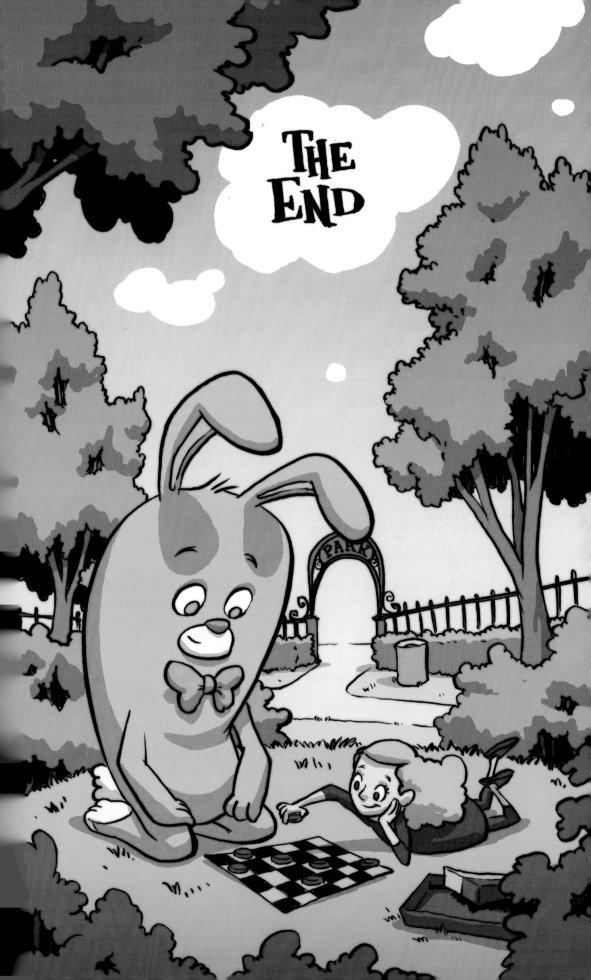

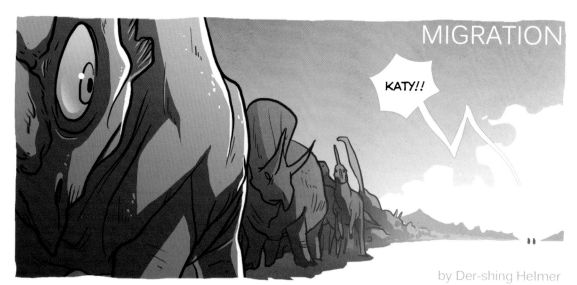

MIGRATION

KATY!!

by Der-shing Helmer

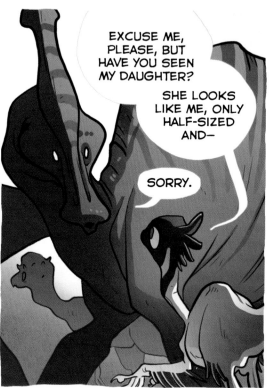

EXCUSE ME, PLEASE, BUT HAVE YOU SEEN MY DAUGHTER?

SHE LOOKS LIKE ME, ONLY HALF-SIZED AND—

SORRY.

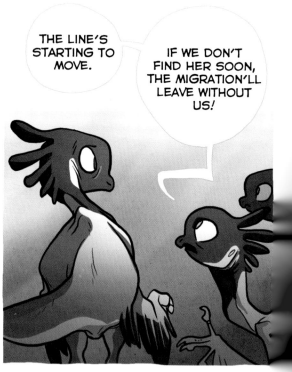

THE LINE'S STARTING TO MOVE.

IF WE DON'T FIND HER SOON, THE MIGRATION'LL LEAVE WITHOUT US!

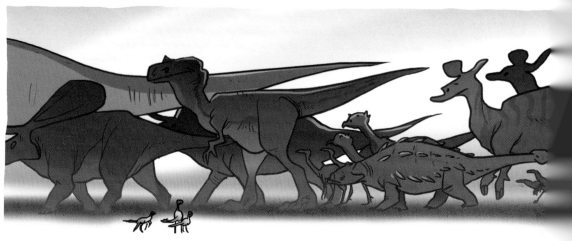

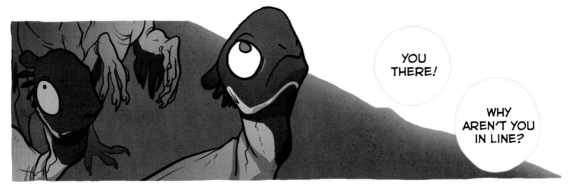

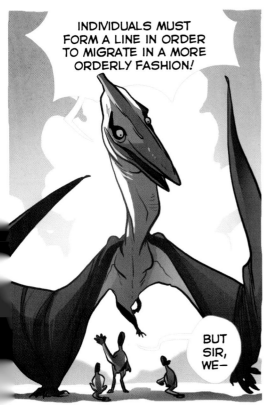

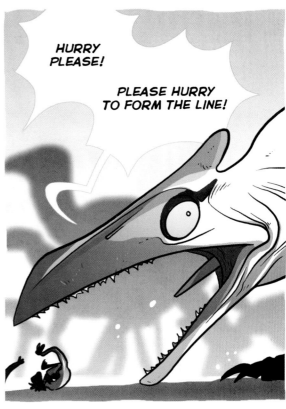

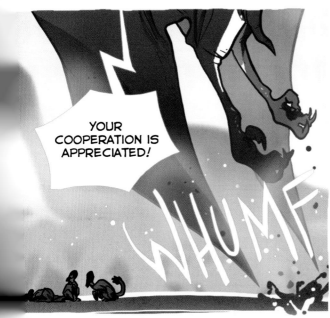

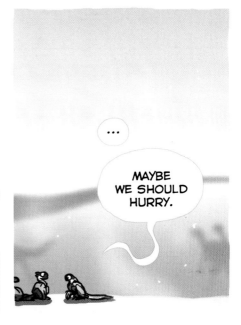

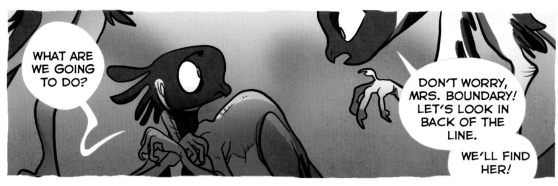

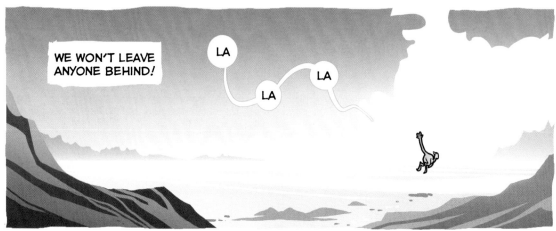

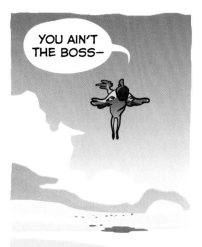

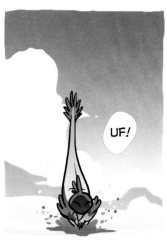

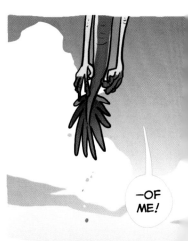

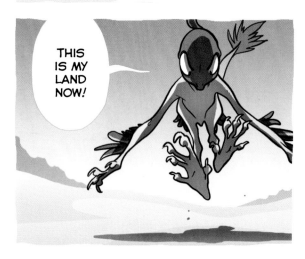

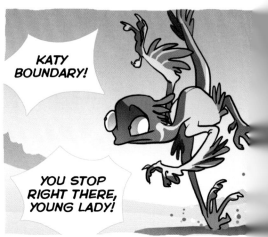

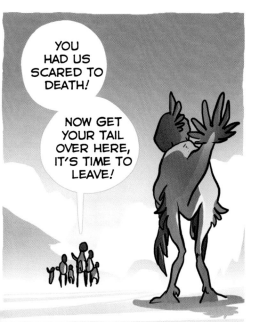

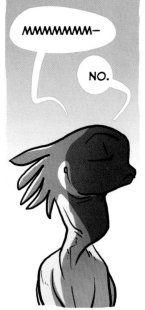

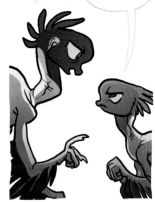

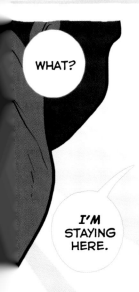

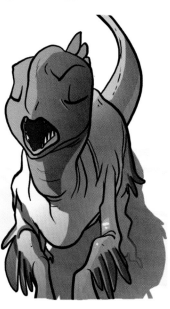

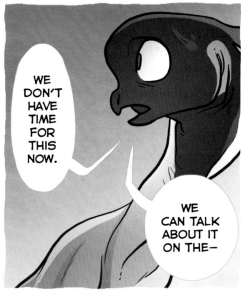

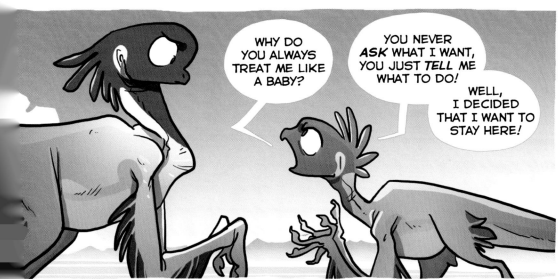

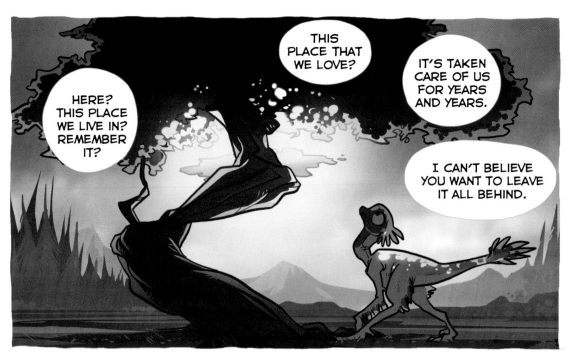

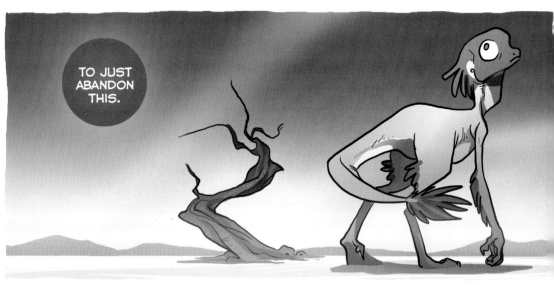

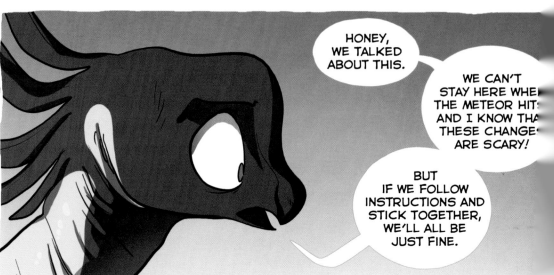

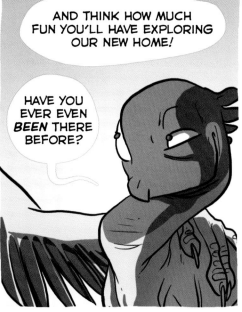

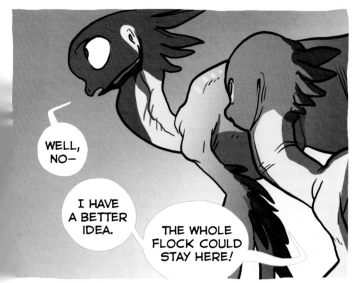

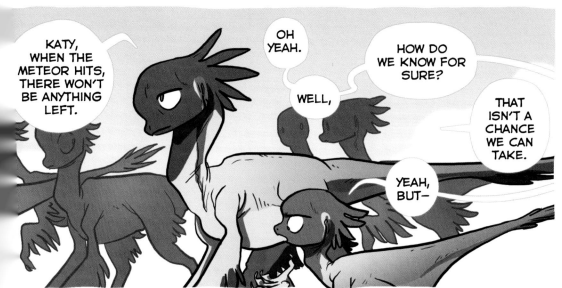

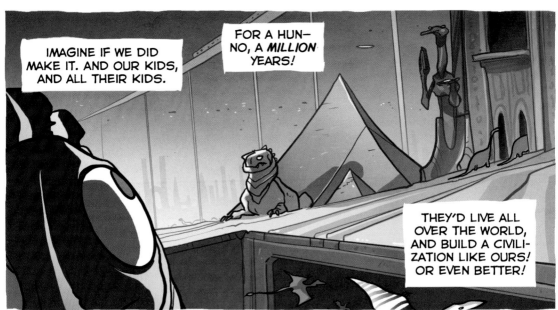

IMAGINE IF WE DID MAKE IT. AND OUR KIDS, AND ALL THEIR KIDS.

FOR A HUN— NO, A *MILLION* YEARS!

THEY'D LIVE ALL OVER THE WORLD, AND BUILD A CIVILIZATION LIKE OURS! OR EVEN *BETTER!*

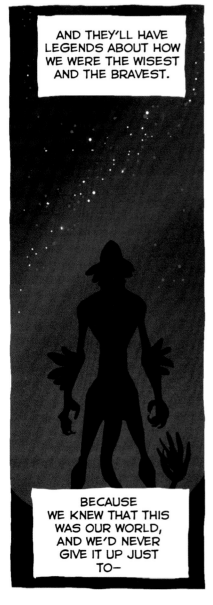

AND THEY'LL HAVE LEGENDS ABOUT HOW WE WERE THE WISEST AND THE BRAVEST.

BECAUSE WE KNEW THAT THIS WAS OUR WORLD, AND WE'D NEVER GIVE IT UP JUST TO—

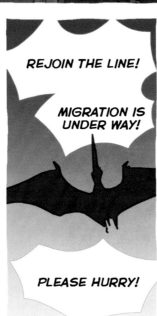

REJOIN THE LINE!

MIGRATION IS UNDER WAY!

PLEASE HURRY!

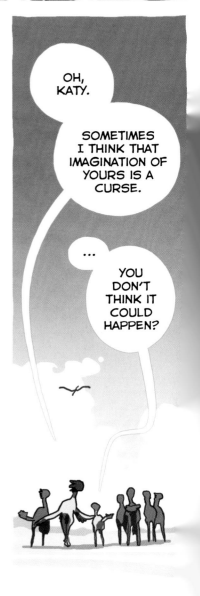

OH, KATY.

SOMETIMES I THINK THAT IMAGINATION OF YOURS IS A CURSE.

...

YOU DON'T THINK IT COULD HAPPEN?

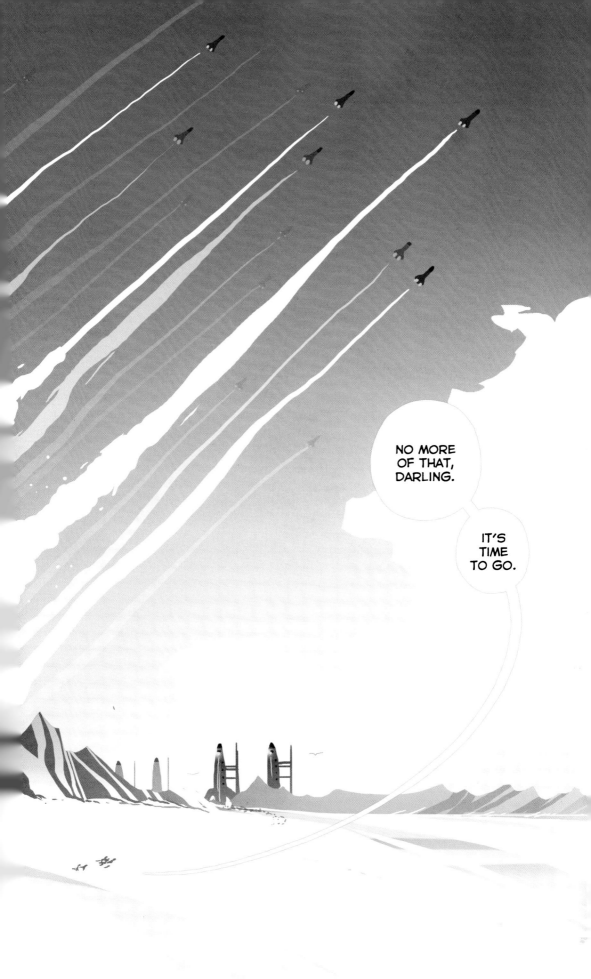

Winged !

Story
Grimaldi

Art
Bannister

Colors
Steve Hamaker

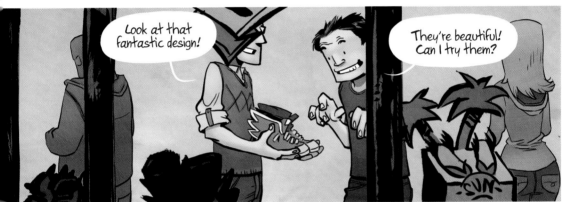

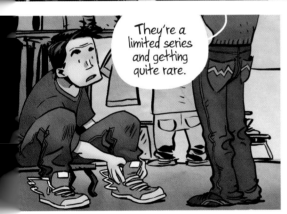

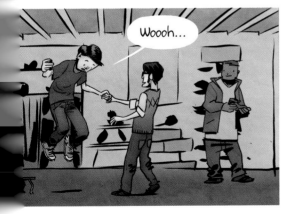

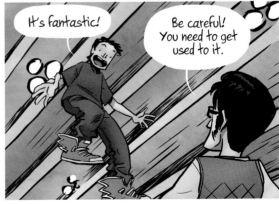

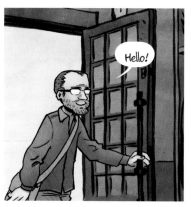

Hello!

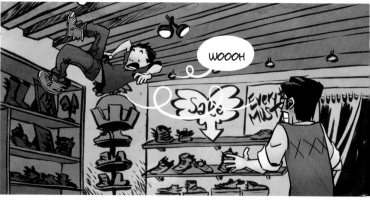

WOOOH

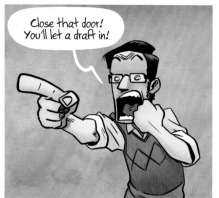

Close that door! You'll let a draft in!

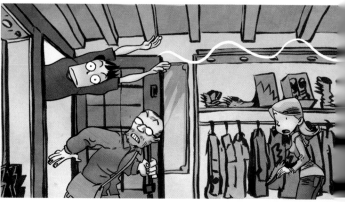

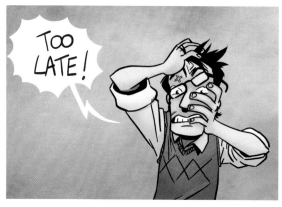

TOO LATE!

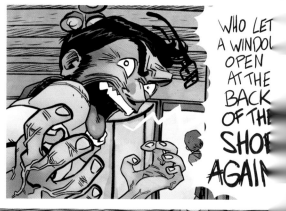

WHO LET A WINDOW OPEN AT THE BACK OF THE SHOP AGAIN

I did, sorry. It was smelling like feet...

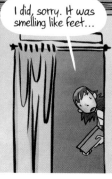

FLY AWAY

GONE WITH THE WIND

GIRL FL

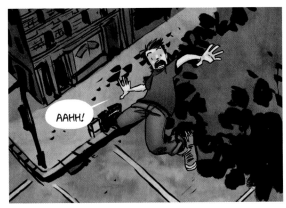

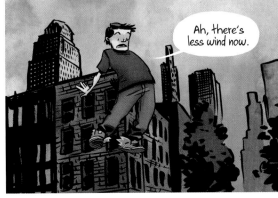

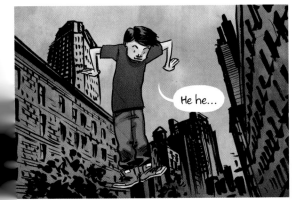

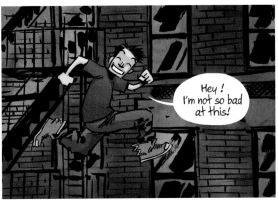

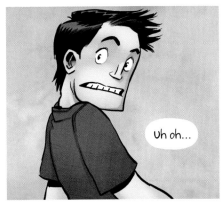

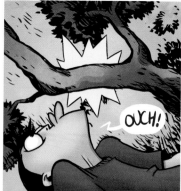

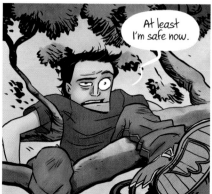

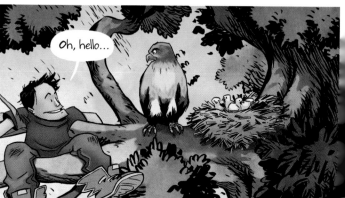

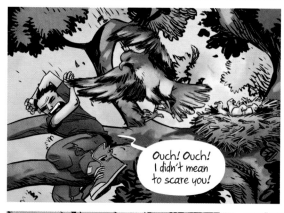

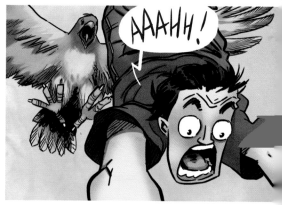

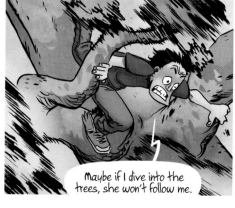

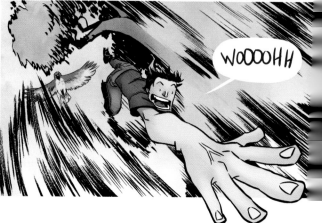

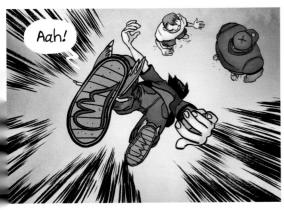

Aah!

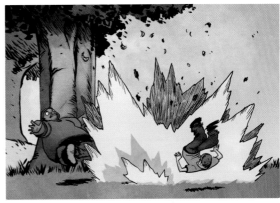

Oops.

Sorry, guys.

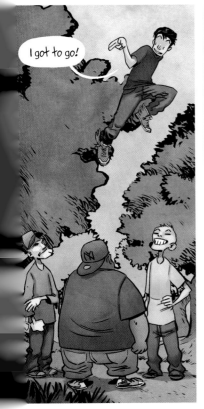

I got to go!

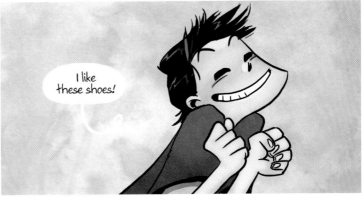

I like these shoes!

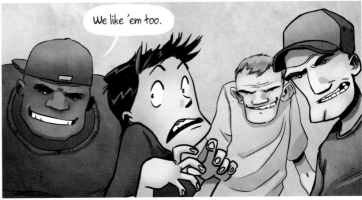

We like 'em too.

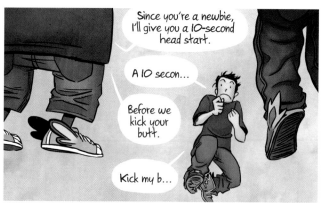

Since you're a newbie, I'll give you a 10-second head start.

A 10 secon...

Before we kick your butt.

Kick my b...

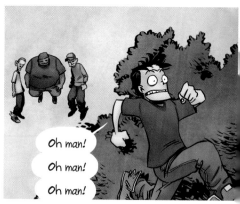

Oh man!

Oh man!

Oh man!

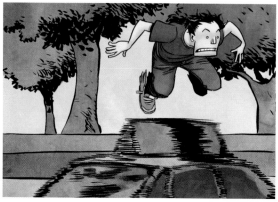

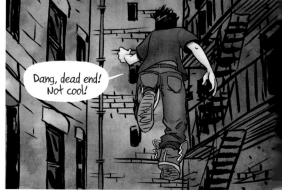

Dang, dead end! Not cool!

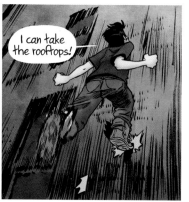

I can take the rooftops!

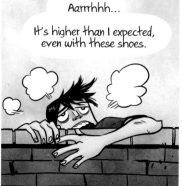

Aarrrhhh...

It's higher than I expected, even with these shoes.

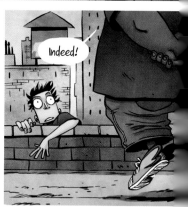

Indeed!

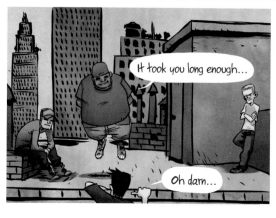

It took you long enough...

Oh darn...

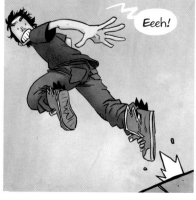

Eeeh!

PHWEEET

262

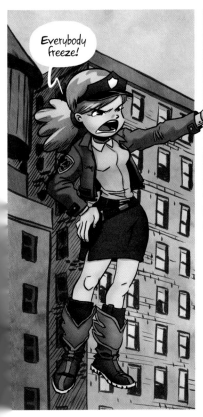

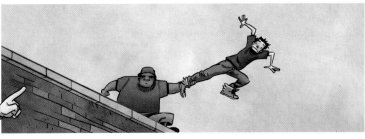

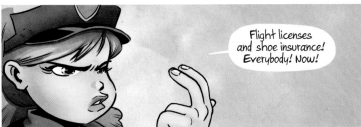

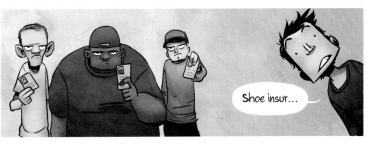

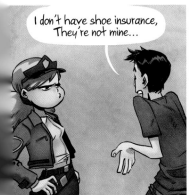

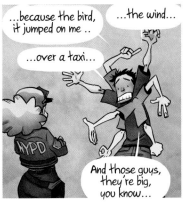

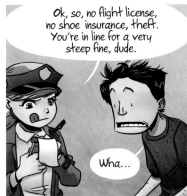

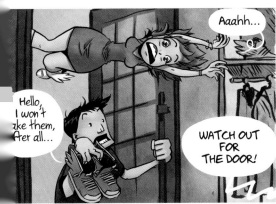

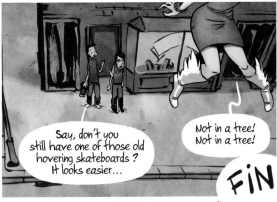

BANNISTER - GRIMALDI - HAMAKER 2011

PERIWINKLE

in

Try, Try again

Try

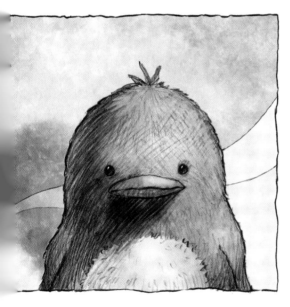

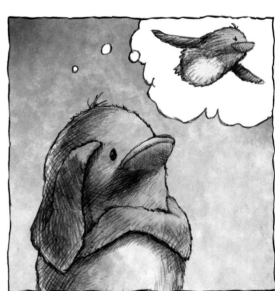

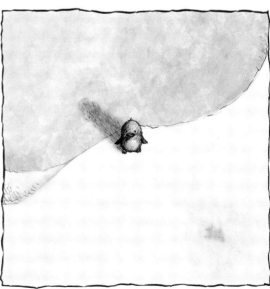

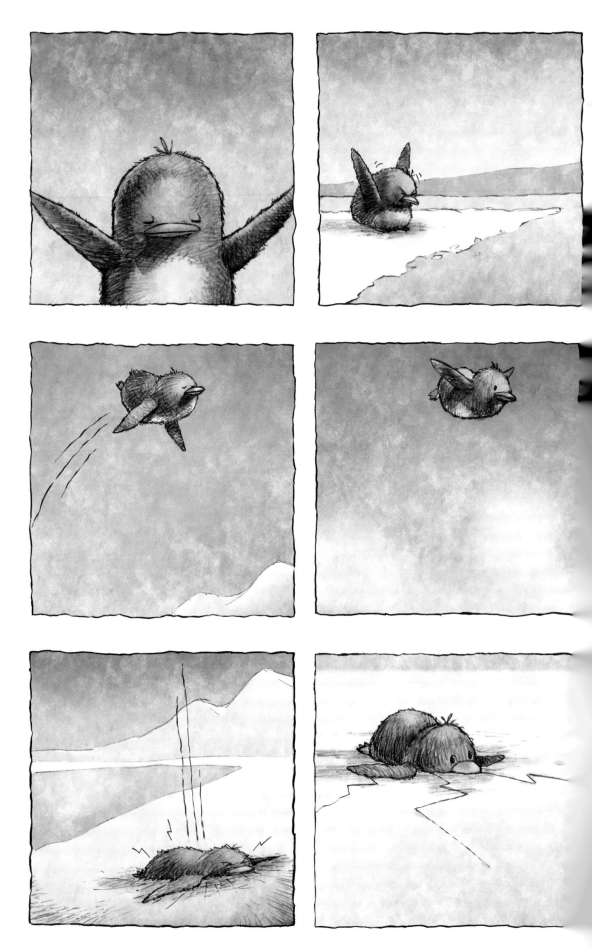

Try,

Try

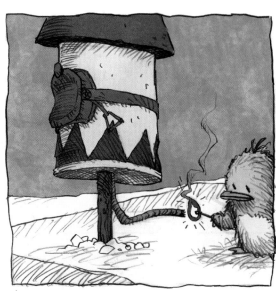

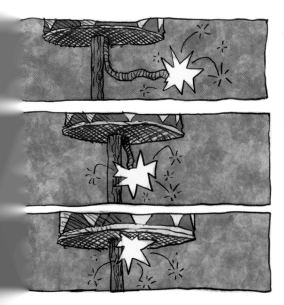

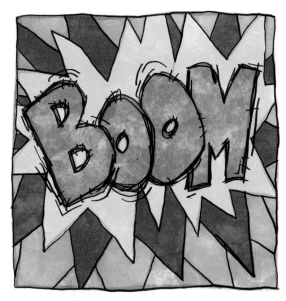

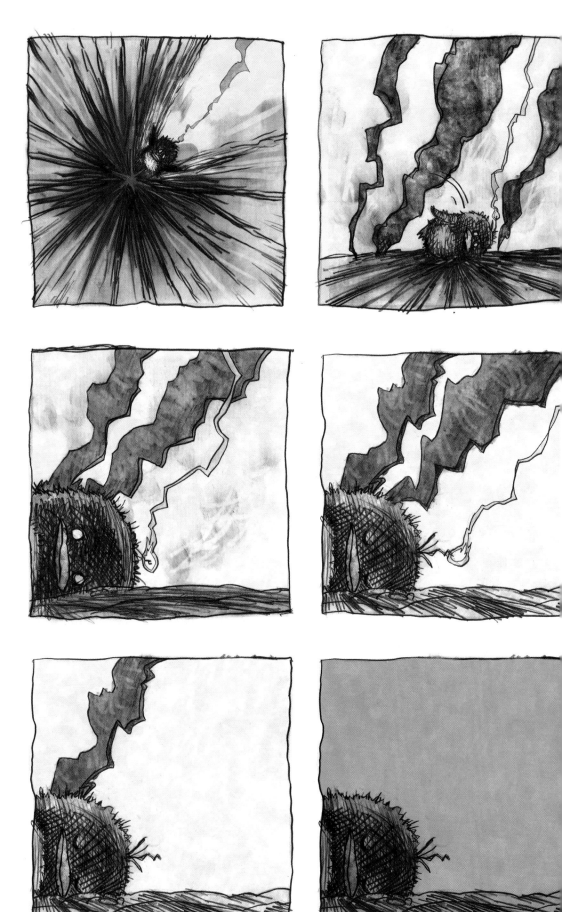

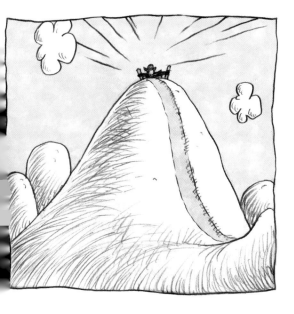
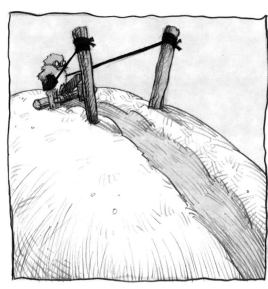

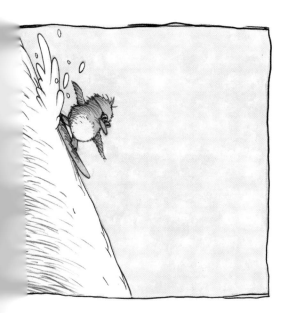
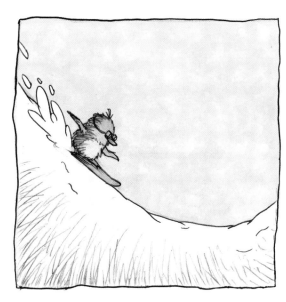

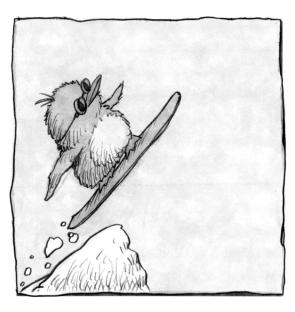
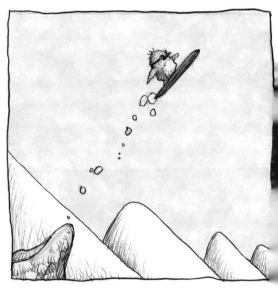
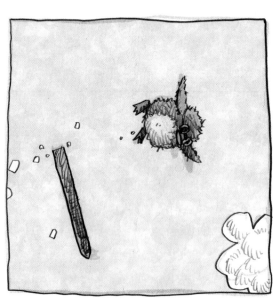
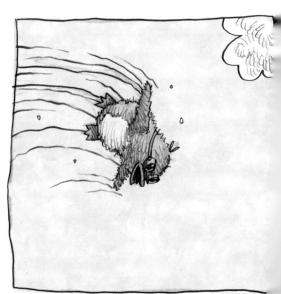
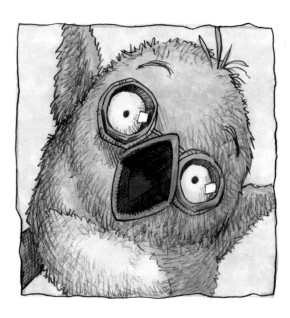
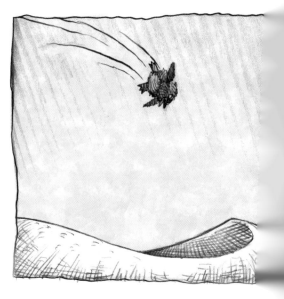

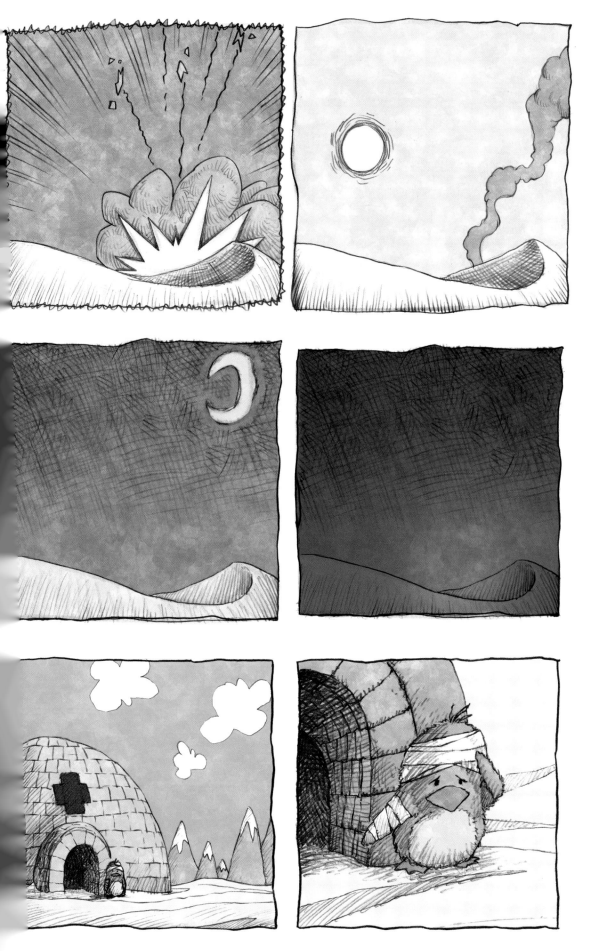

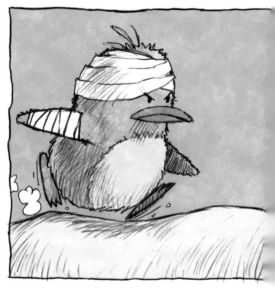

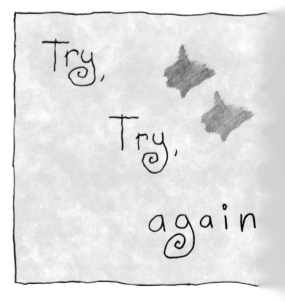

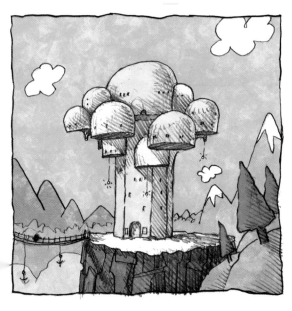

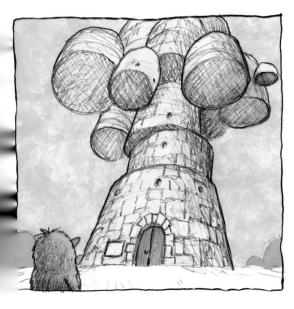
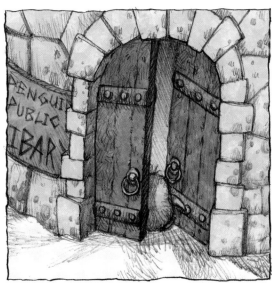
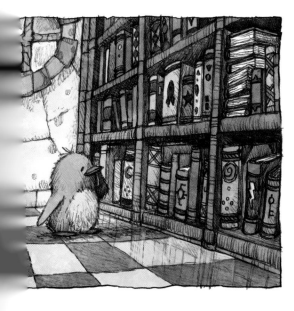
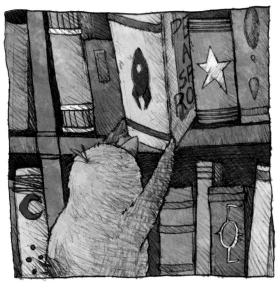

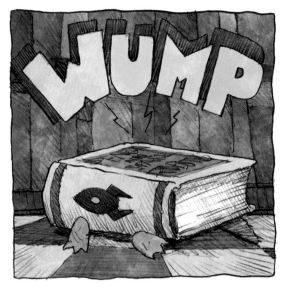

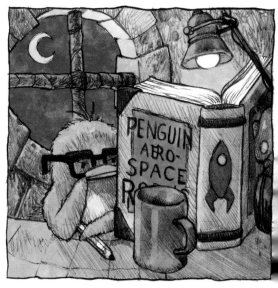

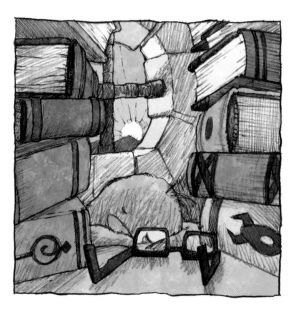

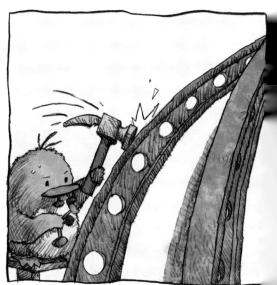

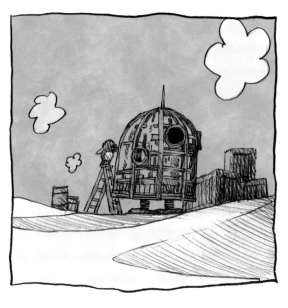

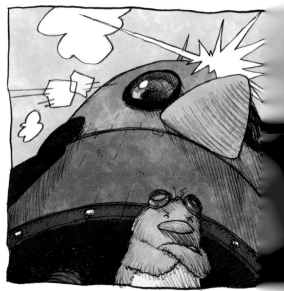

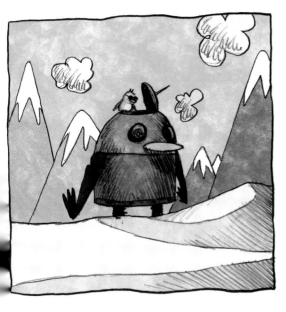
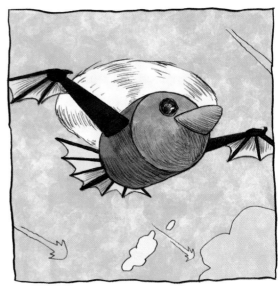

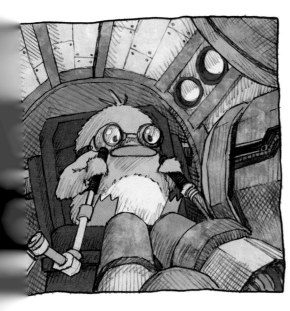
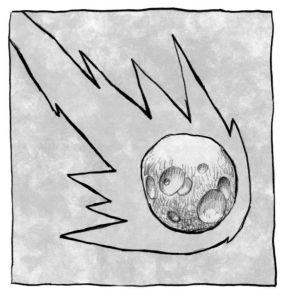

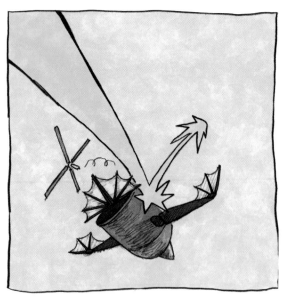
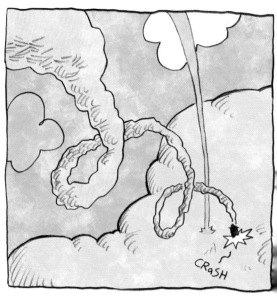

CRaSH

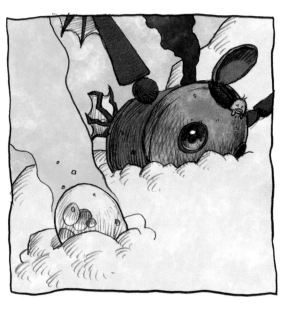
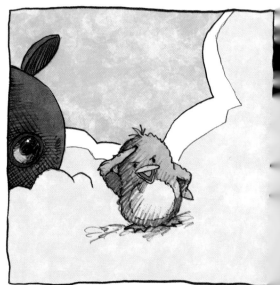
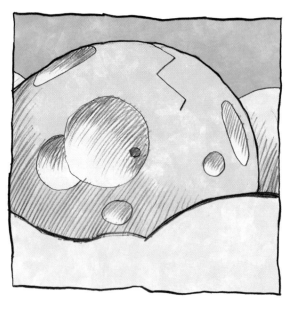
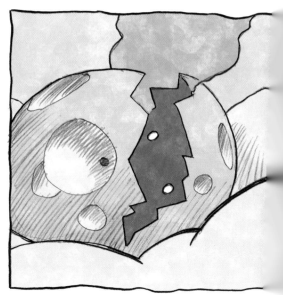

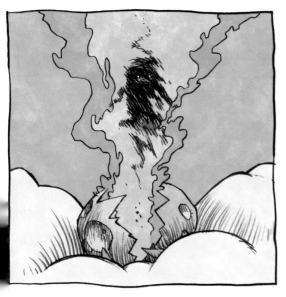
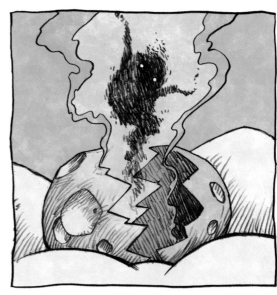
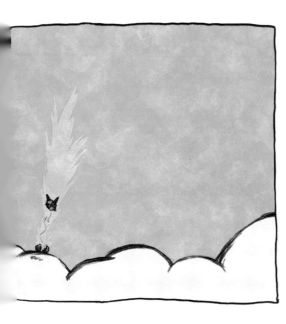

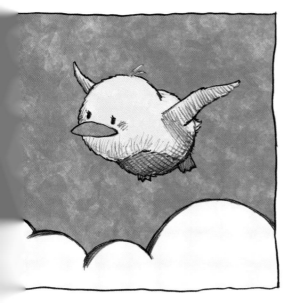
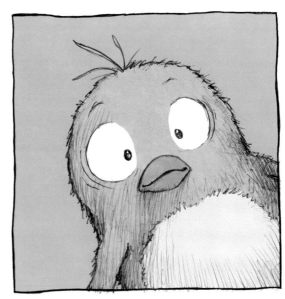

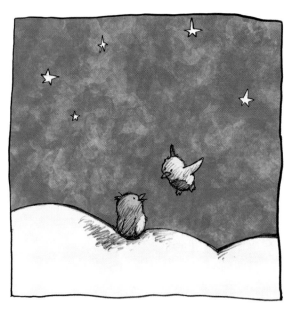
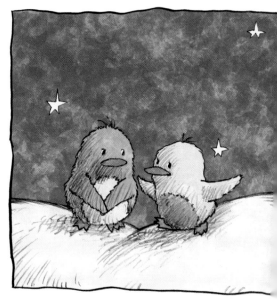
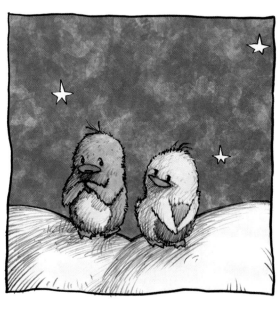
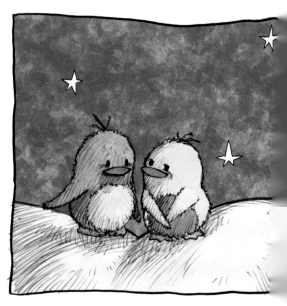
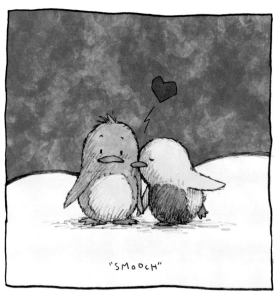

"SMOOCH"

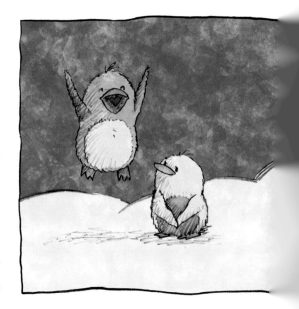

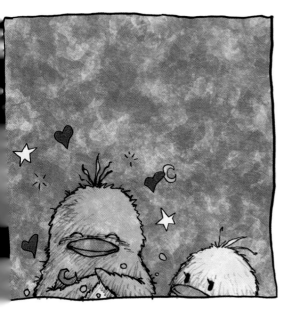
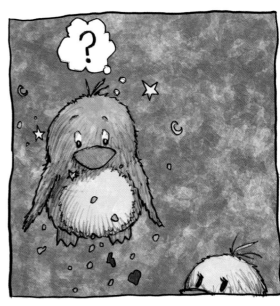
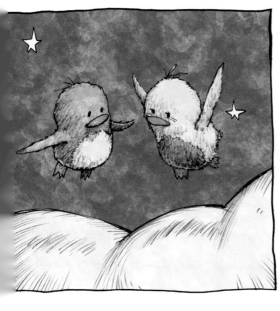
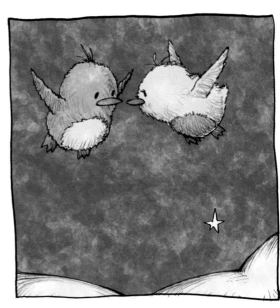

the
END

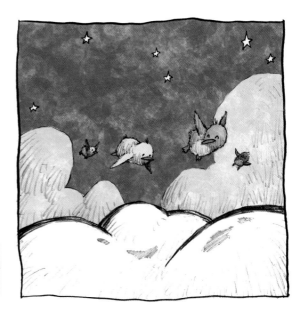

FLIGHT: VOLUME EIGHT
CONTRIBUTORS

Flight: Volume Eight Contributors

(from left to right)
Top Row: Scott Campbell, Leland Myrick, Jake Parker, Kean Soo
2nd Row: Kazu Kibuishi, JP Ahonen, Bannister and Grimaldi, Katie and Steven Shanahan
3rd Row: Kyla Vanderklugt, Jason Caffoe, Tony Cliff, Der-shing Helmer
4th Row: Nicholas Kole, Cory Godbey, Dermot Walshe, Kostas Kiriakakis
Bottom Row: Sonny Liew, Matthew S. Armstrong

Having had the chance to work aside all his idols, **JP Ahonen** considers himself the happiest comic creator on Earth (see pic). He wants to thank the whole *Flight* family for their love and support. www.jpahonen.com

Matthew S. Armstrong is the author of *Jane and Mizmow,* published by Harper Collins. His friend knitted him that cute Periwinkle plushee (pictured). Farewell *Flight,* we'll never forget you. www.matthewart.com

Bannister and **Grimaldi** live in France and make comics for a living. Bannister is co-author of the award-winning series *Les enfants d'ailleurs* (published in the United States as *The Elsewhere Chronicles*). Grimaldi is a story writer and colorist, and she works together with Bannister on their new series *Tib & Tatoum.* Both of them would like to thank Kazu and the *Flight* artists for these amazing years that have changed their lives forever. www.bannister.fr bdgrimaldi.livejournal.com www.elsewherechronicles.com

Jason Caffoe lives in Alhambra, California, where he spends his days writing stories, drawing comics, and coloring pages for the *Amulet* series as lead production assistant for Kazu Kibuishi. He is honored to have been a part of *Flight,* as both the books and the people will forever be his greatest sources of inspiration. www.jasoncaffoe.com

Scott Campbell (Scott C) is a painter, illustrator, and creator of comics, children's books, and videogames. Some of his notable projects include the *Great Showdowns* series at greatshowdowns.com, *Double Fine Action Comics* at doublefine.com/comics/Scott_C, lickee Comics, Psychonauts and Brütal Legend with Double Fine Productions, and the upcoming children's book *Zombie in Love* from Simon & Schuster. Scott lives in New York City and has been super pumped to be a part of the *Flight* family.

Tony Cliff is the Eisner-nominated author of *Delilah Dirk and the Treasure of Constantinople,* among other things. Any success he's had is thanks to the constant help and friendship of the *Flight* comics crew. For more stories, tutorials, and delightful eye-treats, see www.tonycliff.com.

Cory Godbey has illustrated picture books, covers, and other projects for clients such as Harper Collins, Random House, and the Jim Henson Co. He has worked on animated shorts and commercials with clients including Prudential Insurance and Microsoft Zune, and the documentary film *The Last Flight of Petr Ginz.* Cory seeks to tell stories with his work. He also likes to draw monsters. There is now a *Flight*-sized hole in his heart. www.corygodbey.com

Der-shing Helmer is a Bay Area biologist, science teacher, and comics creator, which is pretty weird when you think about it. Without inspiration from the artists of *Flight,* it is very unlikely she would have tried making comics at all; so being in this book is like the most ultimate crazy dream come true. You can read lots more of Der's comics and find out about upcoming projects at www.meekcomic.com and www.shingworks.com.

Tatu Hurme is a young Finnish art student who dreams of becoming a comic book artist. He's now one small step closer to reaching it.

Kazu Kibuishi is the editor and art director of the *Flight* comics anthology. He is also the writer and artist of the *Amulet* graphic novel series for Scholastic Publishing. His first graphic novel, *Daisy Kutter,* was chosen as a winner of the YALSA Best Books for Young Adults Award. He recently released *Copper,* which collects his long-running web comic into a single volume. He lives and works in Alhambra, California, along with his wife, Amy, and his son, Juni. www.boltcity.com

Kostas Kiriakakis was just enjoying the breathtaking view on this extraordinary *Flight* like everyone else. He had no idea at the time that he would get the chance to see the view from the cockpit as well before landing. Nothing but an ocean of gratitude! He has currently landed in Athens, where he keeps drawing pictures for a living. www.kiriakakis.net

Nicholas Kole graduated in 2009 from the Rhode Island School of Design with an illustration degree. Though he has had comparatively little professional experience, it has included work for MIT, Dark Horse, and Disney Publishing. He currently resides in

Massachusetts where he is rounding out his second year as a videogame character artist for 38 Studios. His faith, friends, and family got him through this project, which has been a blessing and a dream come true. This is his first and last appearance in *Flight*. He misses it already; now he'll need a new dream. www.nicholaskole.blogspot.com

Sonny Liew has done comics work for DC's Vertigo, Marvel, and Disney Press, on titles such as *Sense & Sensibility* and *Wonderland*. He is the editor of the Liquid City comics anthology, and a collection of his Malinky Robot comics is due out in 2011. He lives in Singapore, where he sleeps with the fishes and dreams of never-ending *Flight*.

Leland Myrick is the Ignatz and Harvey Award–nominated author and illustrator of *Missouri Boy, Bright Elegy,* and *The Sweet Collection.* His writing and illustrations have appeared in a diverse assortment of publications from First Second Books, Dark Horse Comics, *GQ* Japan, and *Vogue* Russia. He recently finished illustrating *Feynman!* for First Second Books. He would like to thank Kazu and the *Flight* crew for the chance to be a part of such a wonderful venture. www.lelandmyrick.com

Jake Parker has worked on animated films and is the creator of the *Missile Mouse* graphic novels published by Graphix. This is his fourth contribution to the *Flight* books, and he is extremely grateful to have been a part of it. www.agent44.com

Katie and **Steven Shanahan** are twenty-something-year-olds from Toronto, Canada. Katie draws for fun and works in animation as a story artist and designer. Steven (Shaggy) writes and makes videos and audio plays. They are full of glee (so much glee!) to have been a part of the final chapters of *Flight* and to have met so many amazing people through these wonderful books. Huge thanks and much admiration to the *Flight* crew, and lots of love and gratitude to our fabulous fans and readers! For more from us pop on over to ktshy.com and youtube.com/user/ShaggyShan.

Kean Soo is the author of the *Jellaby* series of graphic novels, published by Disney-Hyperion Books. He is eternally grateful for having been a part of *Flight*. It's been one wild and fantastic ride. www.secretfriendsociety.com

Kyla Vanderklugt is a drawer of drawings, painter of paintings, walker of dogs, and wrangler of chickens, working out of her studio in rural Ontario, Canada. This is her first published comic, and she's eternally grateful for the chance to be a part of *Flight* on its final voyage! See more of her work at www.kylavanderklugt.com.

Dermot Walshe has been making ends meet as a freelance artist in TV and feature animation for over twenty years, and is an accomplished vintage motorcycle racer and a capella harmony singer! He is currently designing for an animated CG film about a squirrel and his nuts. Dermot lives in Oakville, Ontario, with his wife, Affee, and three wonderful daughters: Sara, Paige, and Lauren. He still likes frogs and turtles a lot, and would like to thank everyone at *Flight* for a wonderful ride! www.zoomfrog.blogspot.com

LET YOUR IMAGINATION TAKE FLIGHT!

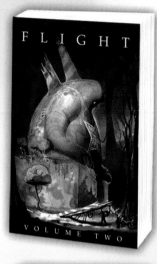

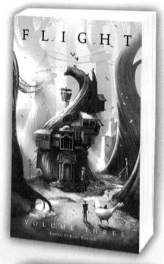

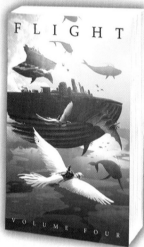

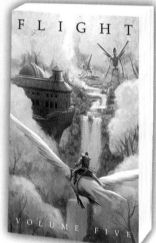

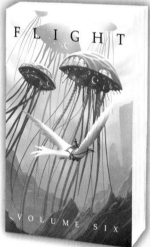

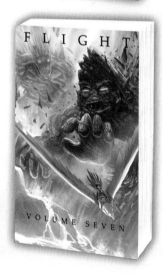

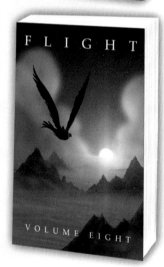

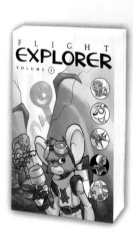

Savor the work of today's top illustrators—
complete your FLIGHT library today.

Available from Villard Books everywhere books or comics are sold.